The 8 Brokens

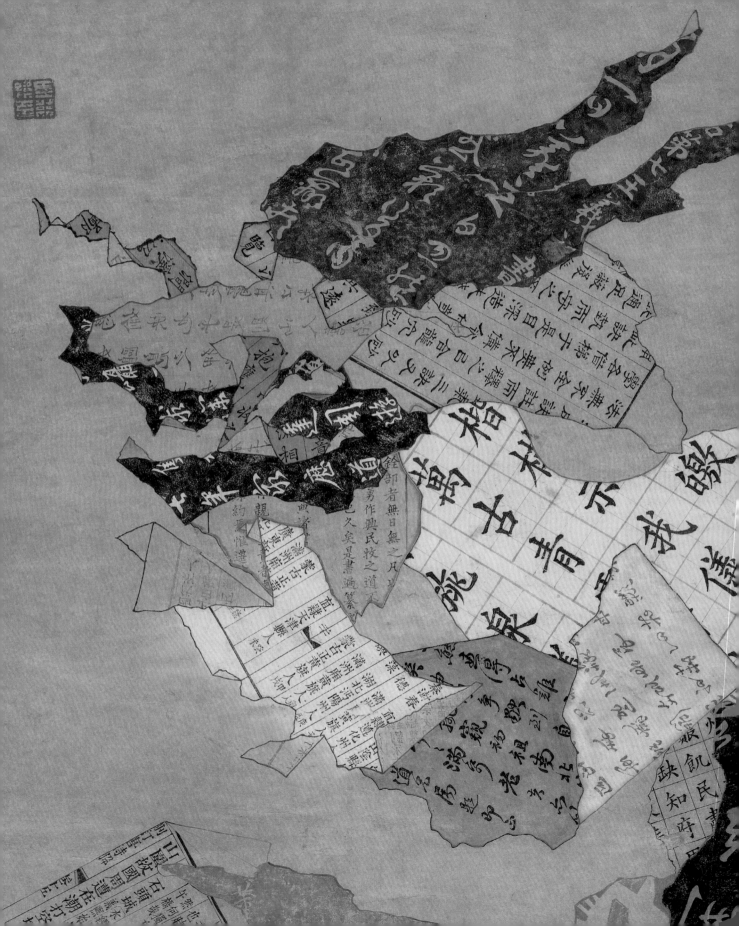

The 8 Brokens

Chinese Bapo Painting

Nancy Berliner

MFA Publications
Museum of Fine Arts, Boston

名賢手札序

自咸豐初元

非常之才手

立政通顯

介弗而

張公花縣

莫府軍

東征諸

轉滬之

一節討賊天下智謀雄

法帖

奏為請

恩派署察哈爾副都統於同治十二年四月十一日到

任署理副都統杜嘎爾之缺查辦理軍務人員本

任廉俸例應全數支領其署缺之人若無本任應

旨事竊查奴才昌蒙

奴才慶春李昌跪

司馬忠先生

業師

田舊

寅字

恒和銀

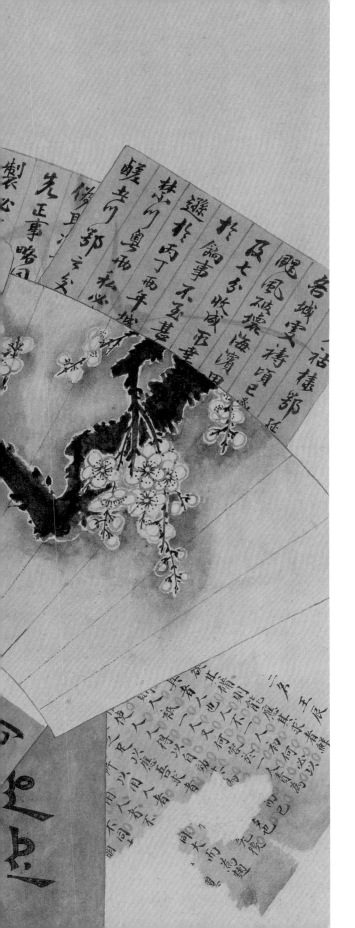

CONTENTS

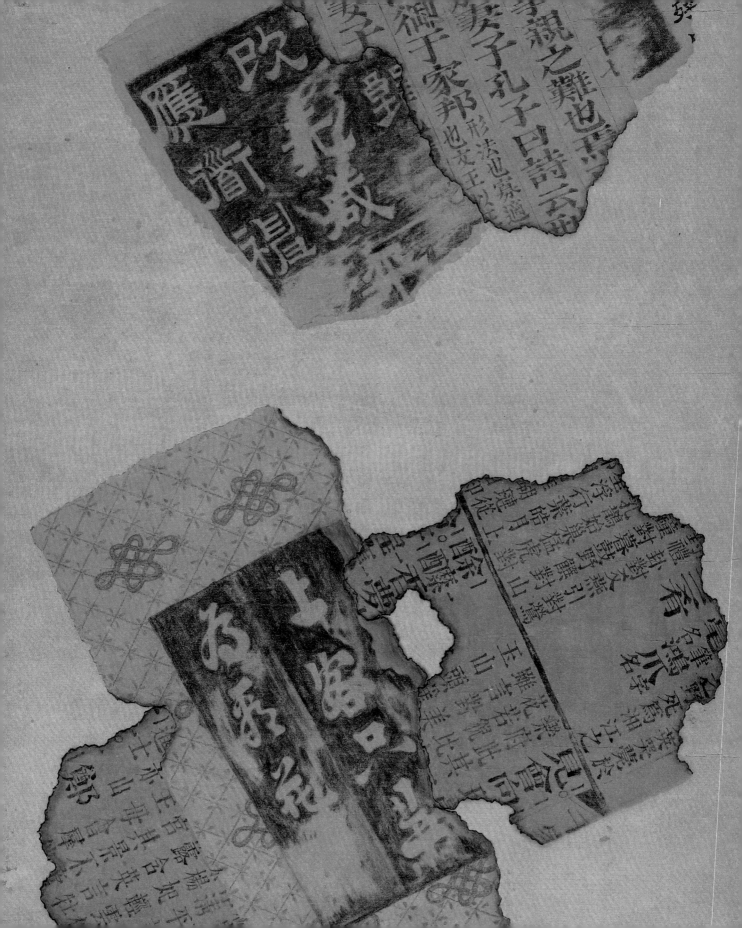

Director's Foreword

This book and its associated exhibition aim to bring to light an aesthetic innovation by late nineteenth-century Chinese artists, known as *bapo* ("eight brokens") painting. Using exquisite skill with brush and ink to reproduce assemblages of old papers, these artists created strikingly modern compositions filled with hidden meanings and messages. To contemporary viewers, the paintings seem to foretell the collages of Picasso, Braque, and Rauschenberg. Beyond their intriguing appearance, these works can be decoded to reveal lyrical homages to Chinese culture and history, along with expressive personal and political messages.

The Museum of Fine Arts, Boston, has long been renowned for its outstanding collection of Chinese painting masterpieces from the Song and Yuan dynasties. The recent acquisition of a significant group of bapo paintings gives the Museum the largest public holding of works in this genre, adding a new dimension to the collection and contributing an important chapter in the history of Chinese art. Previously overlooked by Chinese art historians, this radical and innovative art form can now take its rightful place. We are proud to have presented the first museum exhibition of bapo, and we thank the sponsors and lenders who made it possible. The museum is deeply grateful for the generous support for this publication provided by Edward A. Studzinski and Anne G. Studzinski.

I invite you to delve into the puzzles of these paintings, to enjoy the beauty of their daring depictions and ponder the layers of meaning hidden within. They will reward you with glimpses of the richness of Chinese art, a sense of the transience of life, and even the occasional moment of lightness.

Matthew Teitelbaum
Ann and Graham Gund Director
Museum of Fine Arts, Boston

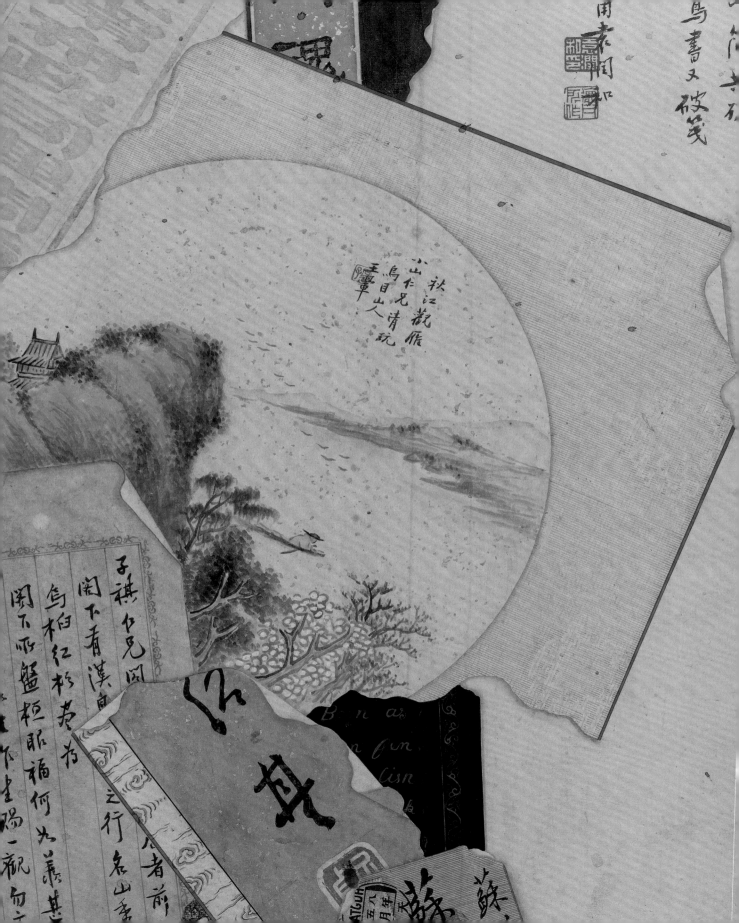

Roots and Branches of Bapo

What is this that is called *jinhuidui*? It is a work of artists' play. It doesn't matter if it is an old book, a half damaged rubbing, official documents, personal letters, discarded contracts, invitations, anything can be copied in a lifelike manner. It is called "turned-over inscribed-papers wastebasket" (*dafan zizhilou*). But if you turn a wastepaper basket over completely, then you get a random mess. That which is called *jinhuidui* is having taken those items and added an intricate arrangement to them. Some are right side up and some are upside down; some are cut in half; some have corners folded, or are burnt or wrinkled. *Jinhuidui* completely performs the service of art and gives people something to enjoy. If one doesn't have much cultivation, it is impossible to create.

—Zheng Yimei[1]

This book endeavors to excavate and investigate an art form that has nearly disappeared—a genre of Chinese painting known colloquially as *bapo*, "eight brokens," and as *jinhuidui*, "a pile of brocade ashes." The paintings depict culturally significant sheets of calligraphy, represented realistically, even illusionistically, to appear as if scattered haphazardly and pasted onto the surface of the work, and usually in a state of decay.[2]

Widespread in the late nineteenth and early twentieth centuries, bapo was never popular with the upper echelons of the Chinese art world—and, as a result, was never recorded in art history texts or mentioned by cultural critics. It became a lost branch of Chinese art—almost completely forgotten for the past sixty years. Up until now, the lack of written records beyond the paintings themselves has shrouded the history and origins of bapo in mystery. This survey of works left behind by bapo artists includes an examination of the aspects of traditional Chinese art and culture that contributed to the emergence of bapo—its roots—and an exploration of the multiple styles and expressions into which individual artists molded the form—its branches.

ORIGIN STORIES: FROM ORDER TO DISORDER

The most radical aspect of bapo paintings is the placement of objects in disorderly compositions, as if a stack of papers was tossed randomly onto the floor—a demonstration of disorganization that would have left a cultured Chinese asking, "Why?"

Panels, screens, and painted walls from the Tang dynasty through the eighteenth century had displayed multiple paintings or calligraphies on a

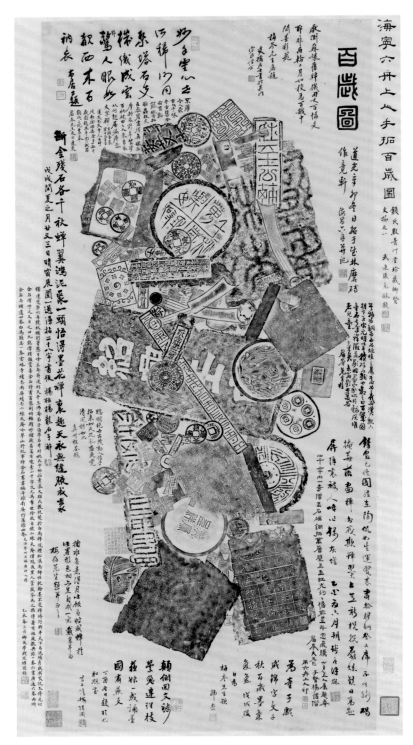

Fig. 1 Liuzhou (1791–1858), *Picture of One Hundred Years*, 1831

single surface, but in orderly compositions. With the emergence of bapo paintings in the mid-nineteenth century, the pages, paintings, calligraphies, and other papers depicted have not only deteriorated but are in a confounding disarray. Who first tossed the papers into the air? Who first turned their compositions into haphazard heaps? There are many apocryphal tales of the origination of bapo, but to date no one individual has been identified. It's more likely that the works of these "founders" of bapo reflect developmental steps along the evolution from order to chaos.

One celebrated artist that writers have linked to the origin of bapo is the eighteenth century's Gao Xiang (1688–1753), one of the Eight Eccentrics of Yangzhou.[3] According to these narratives Gao, unsatisfied with a series of paintings he had created, tore them up and tossed them to the ground. Upon examination, he realized that the scattered bits had their own sense of beauty. He picked up a few, spread them out on a white piece of paper, picked up his brush, created a painting of them—and hung it in his studio. Delighted with his work, he then continued to produce works depicting broken objects, eventually influencing other artists in the region. No known primary source provides evidence for this event, however, and it is probably apocryphal.

Another legend stretches to give bapo a glorious imperial origin. An elderly gentleman in Beijing, Li Zhenjiang, originally from Wuyi County in Hebei, had been a respected scroll mounter who had worked for Pu Xinyu (1896–1963), a well-known artist in the first half of the twentieth century. Li related a bapo origin story that he had heard from his master: A military official of the Kangxi era asked a clerk to write up a petition. The officer was smoking a pipe while he read over the completed document. Unfortunately, a spark fell and burnt a hole in the paper. The official was upset by the damage and ordered the clerk to recopy the petition. The clerk didn't understand that the hole was not part of the copying job

and faithfully copied it as well. When the official handed the paper over to the emperor, the emperor was surprised and asked to see the original. When he saw how well the clerk had copied the manuscript, including the burnt hole, he ordered him to create more pictures of burnt papers. A charming story, with delightful visual elements, but, again, with no credible documentation.

One of the most commonly suggested originators of bapo is the artist Qian Xuan (1235–1305), whose life spanned the transition from the golden Song dynasty culture to the rule of the foreign Mongol Yuan dynasty. Painting archives record a no-longer-extant work by him titled *Jinhuidui*, or "A pile of brocade ashes."[4] Qian Xuan had adopted the phrase from a Tang-period poem, written from an imperial woman's point of view, describing the ruins of the palace storage after its obliteration by invaders.[5] Today, scholars interpret the poem and Qian Xuan's now-lost painting as expressions of mourning for the loss of China to foreign conquerors.[6] The actual subject of Qian Xuan's painting is unknown, but the word *jinhuidui* became an alternate name for bapo paintings—most commonly used in southern China.

A more likely candidate for spurring the bapo aesthetic and its tendency for disorderly composition is the Buddhist monk Liuzhou (lay name Yao Dashou, 1791–1858). He was an artist and passionate enthusiast of epigraphy—the art of collecting ancient inscriptions and calligraphy—and a talented innovator in the arts.[7] In 1831 he created a sensational work that turned Chinese visual culture on its head. This masterpiece contained rubbings of eighty-six randomly arranged objects—ranging from ancient bronzes and stone carvings to tiles, coins, and seals (fig. 1). With images of "broken" antiquities, and a disorderly composition, it is one of the earliest examples of bapo-like work, anticipating the mature bapo style. Interestingly, Liuzhou, for his part, noted that he made this work using Qian Xuan's "jinhuidui painting method."

Liuzhou was an expert in epigraphy and the rubbing techniques used to reproduce ancient artifacts and calligraphy. Not only was he able to transfer images of flat objects—like mirrors or coins—onto paper, but he was also skilled at the newly developed method of "entire form rubbing," known as *quanxingta*, which captured the three-dimensionality of, for instance, a bronze vessel. These three-dimensionally conceived rubbings of objects would later appear over and over again in bapo paintings. While most images of ancient bronzes or other inscriptions featured one object or occasionally a few objects, Liuzhou created his masterpiece as a mass of rubbings on a single sheet of paper. It was an extraordinary achievement, considering the number of overlapping images. In his inscription, he claims that the effort took him five years to complete.

Looking over the array of Liuzhou's rubbings spread across the paper, we see the range of what interested him. There are numerous coins from a variety of time periods, an ink stick, a square bronze seal, a section from a bronze burner, bronze vessel inscriptions, a crossbow, two roof-tile ends with auspicious characters, three bricks inscribed with the dates of manufacture, six stone texts, ink slabs, and thirty-six different seals. Intrigued by any and all writing systems, Liuzhou also included an 1808 five-kopek coin. This impressive stockpiling of text-related imagery demonstrates the wide range of calligraphic inscriptions that were capturing the attention of scholars in the early nineteenth century.

The title of Liu's work is *Baisui tu* (or *Picture of One Hundred Years*), and Liuzhou created it as a birthday gift for a fellow epigraphy enthusiast, Yan Fuji (dates unknown). The character *sui* here means "age" or "year," but it is also a homonym with another character *sui*, meaning "broken." To make a pun, and provoke a chuckle among his viewers, Liuzhou uses the phrase "baisui" to express the wish "May you live to be one hundred years old," but also to suggest a

picture of, approximately, one hundred broken bits. The artist—like later bapo artists—was focused on the "broken" aspect of the objects he was depicting.

There are numerous parallels between Liuzhou's painting and bapo: the presentation of a large number of objects treasured by the literati; the aged and even deteriorated state of many of the objects; and, most important, the scrambled, seemingly random composition—as if the objects were tossed on the floor. How and why did Liuzhou dream up such a composition? Was it a spontaneous moment of inspiration, like Jackson Pollock spattering paint on a canvas? Can we consider Liuzhou the originator of bapo?

The numerous inscriptions on Liuzhou's painting attest that friends and associates of the artist and the recipient viewed this masterpiece many times over the years. Knowledge of this unusual work—and others like it by Liuzhou—certainly would have spread. And we know he was capable of innovations that could extend throughout the community of artists. For example, he also pioneered a technique combining paintings and rubbings, although his name is rarely associated with it. This "mixed media" form became popular among nineteenth- and twentieth-century artists, as in an example by Lin Fuchang from about 1860 that adds painted flowering branches and leaves to a rubbing of a bronze vessel (fig. 2).

Liuzhou created *Baisui tu* in 1831. The earliest known bapo imagery to survive is from the 1870s. These works from the 1870s—a painting by the artist Sun Mingqiu from 1876, and decorations on porcelain—show mature forms of bapo composition. They depict paintings as well as rubbings—suggesting that the style had been evolving for decades. Since Liuzhou lived until 1858, and presumably continued to make haphazard compositions of rubbings, it is entirely possible that his work played a leading role in the origination of the genre. Moreover, we know that his title, *Baisui tu*—the first known instance where this expression was used as the title of a painting—

Fig. 2 Lin Fuchang (died after 1877), rubbings from bronzes with painted flowers, about 1860

was repeated again and by later bapo artists (see, for example, cats. 7 and 8). This repetition suggests that his work had a primary role in instigating this short-lived genre.

ROOTS

But the art of bapo did not spring wholly from Liuzhou's artistic imagination. There are also a number of critical antecedents in Chinese art and culture that made his imaginative leap possible. Let's look at some of the elements in Chinese culture that—after developing for centuries in some cases—came together in the mid-nineteenth century to provide the "roots" for the innovations of bapo.

Antiquities

The title slips on numerous bapo paintings label the works as belonging to the category of *bogu*— "plentiful antiquities."[8] It's essential to consider the influence of the bogu motif on the development of bapo. Bogu paintings of the nineteenth and twentieth centuries typically depict ancient bronzes, ceramics, and other treasured collectibles in still-life arrays. The form first emerged during the Northern Song dynasty (960–1127). Chinese rulers, scholars, and the well-to-do had developed a strong interest in collecting ancient Shang and Zhou dynasty bronzes. This interest inspired the creation of visual reproductions. The connoisseur-collector-emperor Song Huizong (1082–1135), for example, completed an illustrated woodblock-printed book recording his collection of ancient bronzes, the *Illustrated Catalogue of Plentiful Antiquities of the Xuanhe Period* (*Xuanhe bogu tulu*), in 1123 (fig. 3). From that time on, paintings and depictions of ancient bronzes were referred to as *bogu*.

With the further development of the printing industry, and the availability of printed books depicting these bronzes, the genre grew in popularity, with reproductions of these ancient artifacts appearing in paintings but also as decorative elements on lacquer

surfaces, ceramics, and even textiles. By the late Ming and early Qing dynasties, bogu imagery flourished—perhaps due to a growing interest in collecting and displaying these objects. Bogu works also came to encompass far more than just ancient bronzes, depicting a variety of classically cherished antiques, including the great texts of antiquity. A Kangxi-era (1661–1722) lacquer screen uses bogu decorations as a visual border and includes ancient jades, stone chimes, a scroll pot, and a European armillary sphere as well as ancient bronze vessels (see fig. 7). And in bogu woodblock prints and paintings of the seventeenth and eighteenth centuries, piles of books, scrolls, and papers begin to appear alongside the vases and bronzes (fig. 4).

Bogu paintings evolved from documentary replications of ancient bronzes into paintings that carried auspicious messages. Because the word for vase—*ping*—sounds like the word for "peace," an image of a vase implied a wish for peace. Bogu paintings would eventually display many items representing wishes for good fortune, including coins, fruits, and flowers, each with a designated meaning. Bapo paintings that presented precious antique paper objects were therefore just one step beyond bogu paintings. A number of bapo paintings even included small, almost vestigial images of bronzes or vases beside their flurries of papers (see cat. 29).

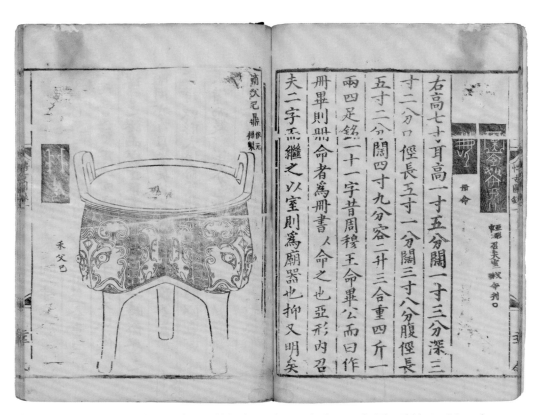

Fig. 3 Wang Fu (1079–1126), page from *Zhida chongxiu Xuanhe bogu tulu* (The Zhida Revision of Illustrated Catalogue of Plentiful Antiquities of the Xuanhe Period), 1528 edition

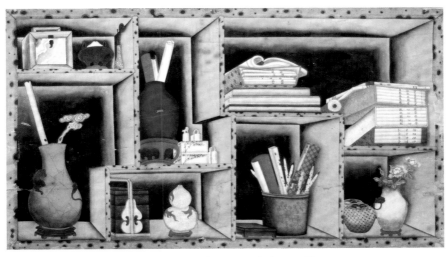

Fig. 4 Unidentified artist, *bogu* bookshelf painting, before 1778

Epigraphy

Another undeniable root of bapo was the enthusiasm among China's intellectuals for epigraphy, *jinshixue* in Chinese. The literal meaning of *jinshixue* is the "study of metal and stone." Important texts and revered calligraphy had long been carved into stone as a means of long-term preservation. *Jinshixue* refers to the study, preservation, and collection of the textual inscriptions and engravings on these ancient metal and stone objects.

By the Song dynasty, scholars, officials, and the emperor were focusing on antiquities—and were captivated by the study of the ancient characters preserved on them. Ink rubbings taken from calligraphy carved in stone had already become a basic form of reproduction during the Tang dynasty. These rubbings became the primary method for preserving, duplicating, and sharing the inscriptions with friends and fellow enthusiasts. During the Song dynasty, the creation of these rubbings from antiquities increased.

To make a rubbing of this kind, the fabricator places and presses flat moist paper onto the selected carved stone or metal, making sure that the paper is pressed into all the carved depressions on the stone. Once the paper has almost dried, the fabricator takes an inked ball—made by wrapping cotton around a ball of raw silk or cotton—and tamps it across the entire surface until the image or characters incised into the stone emerge as white on a black background.

In time these rubbings became treasured collectibles as well. When the early Ming author Cao Zhao published his tome on art connoisseurship, *Essential Criteria of Antiquities* (*Gegu yaolun*), in the late fourteenth century, he devoted a large section of the book to calligraphic rubbings.[9]

One hundred and fifty years after the mid-seventeenth-century defeat of the Ming dynasty by the foreign Manchu Qing dynasty, a growing interest in epigraphy began to coincide with increasing disenchantment with these non-Chinese rulers. Historians have proposed that the scholarly interest in ancient scripts and texts arose partly as a reaction to corruption in the Qing court. Many scholars retreated from government service, and turned to intellectual pursuits, in particular the study of ancient texts and calligraphy.

This trend intensified as scholars reacted to the Qing emperor's own passion for ancient Chinese treasures. During the prosperous and culturally rich years of the eighteenth century, the Qianlong emperor's appetite for collecting ranged from calligraphy and painting to ancient ceramics and bronzes. Such collections would enhance his stature as a "Chinese" emperor despite his Manchu background. Because of his ravenous intentions for acquiring every available ancient bronze vessel, scholars and connoisseurs had no choice but to turn to other remnants of the past for well-preserved specimens of ancient characters. These characters could be found molded or inscribed into bricks, steles, roof tiles, and coins from the Shang, Zhou, Qin, and Han dynasties. All of these objects, whether whole or broken, carried inscriptions in a wide variety of inventive and inspiring calligraphic styles. Scholars pronounced these older, but perhaps more quotidian objects as "purer" Chinese than the fourth-century Wang Xizhi calligraphy styles so beloved by the Manchu Qing rulers. Liuzhou's game-changing composition—his collection of rubbings from many sources and many eras—was an extreme expression of this developing interest in epigraphy.

Assemblage

Another key visual antecedent of the bapo form began to appear over one thousand years ago, with the custom of pasting multiple inscribed or painted sheets onto a single flat surface. A minute background detail of a mural in the remote Buddhist temple caves of Dunhuang illustrates this decorative technique.[10] Among the Buddhas and Bodhisattvas filling the cave's surfaces is an illustration of a scene from the *Vimalakirti Sutra*. A wealthy, virtuous Buddhist layman, Vimalakirti, is pictured in discussion with Manjusri, the Bodhisattva of Wisdom. Vimalakirti sits on a low, canopied platform, a common Chinese type of seating during the Tang dynasty.

Behind him, and partially wrapping around the side of the platform, as though to shield him from drafts, is a multipaneled screen. A close inspection of the mural reveals many small sheets of calligraphy apparently pasted on the screen's panels. Lines and color variations differentiate the sheets of paper, which are organized in a gridlike composition, sometimes separated by blank rectangular spaces. The artist's decision to fill the screen with these "pasted" calligraphies may have been an attempt to portray Vimalakirti as a scholarly Chinese gentleman with access to a broad range of classic texts.

Documents from the Tang dynasty confirm the existence of this decorative custom. The Tang dynasty calligrapher and government official Xu Hao (703–782), for example, wrote about a high-ranking bureaucrat from a previous generation who had pasted a number of valuable calligraphies onto a screen: "In the reign of Zhongzong [656–710], the Director of Secretariat Zong Chuke once made a request to the emperor and was granted the favor. He had asked for the authentic masterpieces of the two Wangs' [Wang Xizhi and Wang Xianzhi] calligraphies as a granted reward. He received twelve volumes; each of the volumes consists of ten scrolls in various sizes. Chuke mounted them onto twelve panel screens. He also included Chu Suiliang's calligraphy of the essay *Living in Leisure* (*Xianju fu*) as well as *Withered Tree* (*Gushu fu*) and mounted them at the bottom of the screens. At a grand banquet, these screens were opened and shown to the guests."[11]

Did the practice of pasting cherished calligraphy and paintings on screens continue during the centuries that followed? There is no known further visual or textual evidence of this approach until almost half a millennium later. During the late Ming and early Qing dynasties, an ornamental convention of pasting multiple small paintings onto screen panels took hold in fashionable society. The great dramatist, garden designer, gourmet, and cultural critic Li Yu

(1610–1680) commented disapprovingly on this popular fad as early as 1671. In his short essay called "Screens and Scrolls" ("Ping zhou") we can almost hear him sighing: "Ten years ago, if one were doing screens or scrolls of paintings or calligraphy there were three formats: hanging scrolls, square sheets, and horizontal scrolls. But in the past few years there appeared 'assembled brocades' [*hejin*], using large and small, long and short, and even small fragments; as long as they match, they can be used. They can be quite varied. As soon as this format emerged, everyone hastened to participate. Wherever you looked, you could see it. After a while, you began to feel it [*hejin*] was old and hackneyed and could not compare with vertical scrolls, square sheets or horizontal scrolls, but after a long time of not seeing it, it looks new and fresh again."[12]

These same "assembled brocade" screens made an appearance in the texts of novels of the time as well as in illustrative paintings and woodblock prints. In the great seventeenth-century erotic novel *The Plum in the Golden Vase* (*Jin ping mei*) several room descriptions mention the presence of "brocade screens" (*jinping*) that are probably the decorative room dividers that so irritated Li Yu. Woodblock prints and exquisitely painted illustrations from *The Plum in the Golden Vase*, all from the same period, show screens with multiple images—album leaves, fan paintings, and so on—all adhered (or at least seemingly adhered) to the surface. One meticulously painted album leaf from a series of two hundred, attributed to the court artist Gu Jianlong (1606– ca. 1687) and now in the Nelson-Atkins Museum in Kansas City, Missouri, depicts a scene from chapter 24 (fig. 5). In the antihero's expansive garden space, outfitted with luxurious furnishings for the celebration of the Lantern Festival, a woman is seen flirting with a young man. A large standing screen with a gilt-speckled lacquer frame displays a painting of a complex and ornate hanging lantern with calligraphic

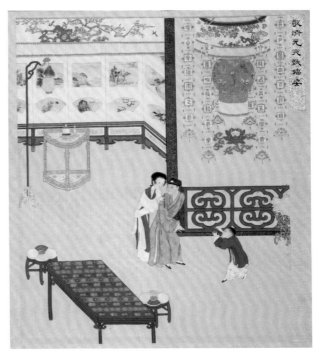

Fig. 5 Unidentified artist, painting from album of illustrations to *Jin ping mei* (*The Plum in the Golden Vase*), 18th century

dangling pendants. A polychrome carved lacquer, semicircular table, decorated with a phoenix, displays beautiful ceramics. Silk brocade begonia-shaped cushions, composed of several contrasting patterned fabrics, sit upon red-lacquered begonia-shaped stools. A multipaneled screen decorated with square and fan-shaped paintings surrounds the space. Each vertical panel of the screen presents a square scholarly landscape painting above and a fan-shaped flower painting on gilt paper below. The dramatic and almost ostentatious juxtaposition of contrasting imagery and patterns on the screen—as well as on the cushions—was the fashion of the times. The well-to-do merchant class portrayed in the novel, eager to show off their wealth and culture, demonstrated a flamboyant taste sharply distinct from the more restrained decorative palate of the Song and

Ming literati. This variety and plenitude of imagery is another step toward a bapo aesthetic.

A nineteenth-century Korean folding screen now in the collection of the Museum of Fine Arts, Boston, exhibits a similar scheme (fig. 6). Ten panels display a total of fifty-one sheets of paintings and calligraphies, imitating celebrated Chinese artists and calligraphers including the Song calligrapher Mi Fu (1051–1107) and the Yuan master Ni Zan (1301–1374). The papers, though each decorated in a distinct style, are in fact all by the artist Sin Heon (1810–1884). The viewer's eyes scan over landscapes, calligraphies, blossoming trees, birds on branches, gold ink on indigo-dyed paper, fan paintings, and half-unfurled scrolls—a lavish display of treasures.[13]

In addition to pasting actual paintings or calligraphies on screens, by the late seventeenth century, Chinese artisans were also applying the style of multiple-image panels to polychrome carved lacquer screens (fig. 7). (Known as *kuancai* in Chinese, they are often confusingly called Coromandel screens in English.)[14] Unlike the hejin or jinping brocade screens appearing in scenes from *The Plum in the Golden Vase*, the lacquer panels presented reproductions of original works transformed into an entirely different medium. Jonathan Chaves has done a thorough study of one *kuancai hejin* screen that he has determined was produced in the early to mid-Kangxi period (1661–1722).[15] The entire twelve-panel expanse of one side of the screen presents, carved into the lacquer, a series of fan paintings and square album-leaf paintings, laid out in a grid pattern surrounded by a decorative frame with bogu images of ancient bronzes, flowers, jades, and desk paraphernalia.

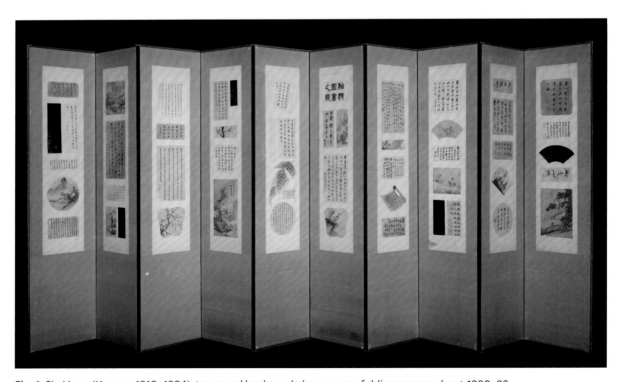

Fig. 6 Sin Heon (Korean, 1810–1884), ten-panel baeknapdo byungpung folding screen, about 1880–83

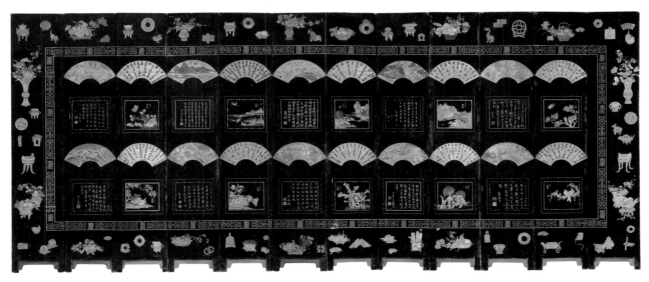

Fig. 7 Ten-panel folding screen, Kangxi period, 1661–1722

The fans and album-leaf paintings—so reminiscent in composition of illustrations for *The Plum in the Golden Vase*—display paintings and calligraphies by artists from the Song through the Ming dynasties. Chaves concludes that the screen artisans copied the imagery from woodblock-printed volumes, increasingly available in the seventeenth century, reproducing well-known paintings and calligraphic rubbings.[16]

During the Kangxi and later periods artisans at the Jingdezhen, Jiangxi Province, imperial porcelain factories also created works reproducing multiple paintings and calligraphy on the surfaces of large vases (fig. 8). Like many of the images brushed onto porcelain as underglaze blue or overglaze polychrome at the time, these dramatic scenes, landscapes, and bird and flower pictures were most likely also inspired by woodblock-print illustrations.

Such groupings also appeared on palace walls. Under the rule of the Yongzheng emperor (r. 1722–35), a court artist created a set of twelve paintings depicting twelve women, at one time thought to be the emperor's courtesans. One panel in the *Twelve Beauties* series, still in the Palace Museum in Beijing, portrays a leisurely dressed elegant woman sitting at a table, a book in her hand (fig. 9). She appears to have paused from her reading to think for a moment. A group of artworks is arranged vertically on the wall behind her. It includes a landscape hand scroll and, below it, calligraphy signed by the renowned Song dynasty artist, poet, and calligrapher Mi Fu, inscribed on a banana leaf. The table and the flower vase on it almost completely obscure a third work—a landscape painting.

Unlike the screens belonging to Li Yu's contemporaries, the objects decorating the palace walls are re-creations rather than originals. How do we know? Their lack of authenticity is evident from the inscribed leaf attributed to Mi Fu. A six-hundred-year-old leaf would not have lasted long hanging on a wall! An eighteenth-century emperor would have surely preserved such a rare and precious calligraphy in his storerooms. Moreover, and amusingly, the poem—

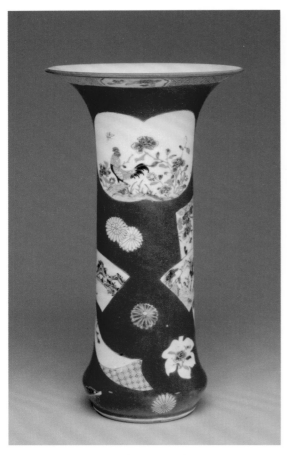

Fig. 8 Beaker vase with decoration depicting paintings, mid-18th century

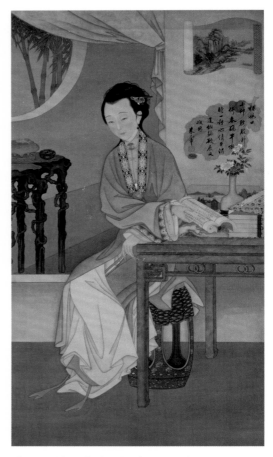

Fig. 9 Unidentified artist, from *Twelve Beauties*, 1723–35

though signed by Mi Fu—was composed six hundred years *after* Mi Fu died—and by the Yongzheng emperor himself![17] One suspects that the artist of this *Beauty* hoped to charm the emperor by including his imperial poem within the painting.[18]

These re-creations of famous works of art, depicted as if they were pasted on walls (or screens), continued to appear in the palace into the eighteenth century. This "showy" display of cultural icons may have grown out of the eagerness of China's aspirational classes—wealthy merchants as well as their non-Chinese Qing rulers—to demonstrate their

ownership and appreciation of classical Chinese culture.

There are, however, clear differences between these multiple-image/single-surface works of art and bapo paintings. These earlier works all display whole objects rather than worn or tattered works, and they usually display the objects in regular, orderly arrangements rather than the haphazard compositions of bapo. However, these screens, paintings, and porcelains—with their collections of culturally significant objects—did provide a visual foundation on which bapo would grow.

Verisimilitude

A bapo painting is far more than a painted depiction of paper objects. The naturalism of these paintings is often so well executed that viewers are tempted to rub their hands over the surface to confirm that the papers are not pasted onto the background surface. For artists, the pursuit of illusionism and, for audiences, the delight in viewing it are a natural result of the human eye-hand-brain relationship—a key impetus to human culture since earliest man began drawing in the sand. The illusionistic verisimilitude in bapo paintings was no doubt one of the features that both challenged the artists and captivated their customers.

Though admittedly seductive and amusing, this particular aspect of bapo may also have been one reason behind its obscurity. The Chinese literati have, since the eleventh century, dismissed verisimilitude and emphasized self-expression and the abstract shapes of brushstrokes. Verisimilitude, the great Song dynasty art critic Su Shi (1037–1101) proclaimed, was for those with the mentality of children.[19] The pursuit of superficial likenesses was considered a mere skill, a display of technique, not an expression of the brush holder's inner integrity. The act of perfectly reproducing a calligraphy rubbing in a bapo painting did not constitute, in the traditional critics' eyes, the deep communication possible through original calligraphic brushstrokes.

Despite the dominant post-Song intellectual attitude that successful verisimilitude could never be an artistic triumph worthy of any note, naturalism—which had reached its zenith during the northern Song dynasty—did continue to exist in a variety of forms through the centuries. And bapo fits neatly into the history of Chinese naturalism as, one might say, a medium carrying on that tradition through time.

Starting in the seventeenth century, painting in China received a nudge from Europe that awoke a latent appetite for verisimilitude in imperial circles—and then beyond. This nudge came from Jesuit missionaries. The Jesuit priest Matteo Ricci (1552–1610) first arrived in China in 1583 carrying European books with illustrations that influenced a few Chinese artists. One hundred years later, during the late seventeenth and early eighteenth centuries, the newly established Qing imperial household opened its doors to more Jesuits—introducing many European scientific technologies and artistic techniques to China for the first time. Fascinated by the innovations brought by these visitors, the Kangxi emperor accepted a number of them into his court as scientific advisers. A series of Jesuit artists were invited into the imperial atelier. European verisimilitude captured the eyes and minds of many in the capital.

By 1729, the court official Nian Xiyao (1678–1738), intrigued by the mathematics and perspective he had learned from the Jesuit missionaries in Beijing, collaborated on a translation with the Jesuit Giuseppe Castiglione of *Perspective for Painters and Architects* (*Perspectiva pictorum et architectorum*) by Andrea Pozzo (1642–1709) from Latin into Chinese. Among the many illustrations in that book was a drawing of a sheet of paper tacked to a wall which may have had an eventual effect on bapo (fig. 10).[20] Other efforts by Nian demonstrated the growing interest in verisimilitude in China. He had been director of the imperial kilns in Jingdezhen, where, most likely under his guidance, the kilns began producing fine trompe-l'oeil ceramics for the court, porcelain vessels imitating ancient bronzes and carved cinnabar lacquer, wood, and stone (fig. 11).

Illusionistic perspective paintings created by Jesuit artists—who had honed their skills on church walls and ceilings in Europe—delighted the Qianlong emperor.[21] The emperor's favorite among these European artists was Giuseppe Castiglione (1688–1766). With his disciples and a few other Europeans, Castiglione, who had been trained by Renaissance masters in Italy, produced vast illusionistic murals and even ceilings in the private spaces of the Chinese

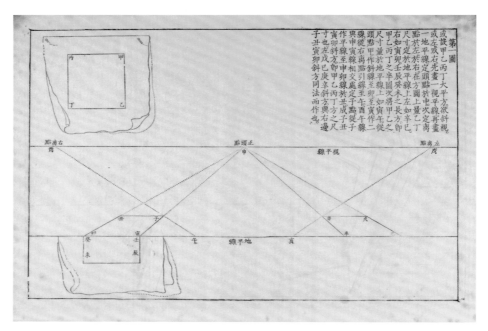

Fig. 10 Nian Xiyao (died in 1739), illustration from *Shixue jingyun* (The Essence of the Science of Vision), 1735

imperial palaces. The Qianlong-period imperial household records contain numerous requests from the emperor for perspective paintings (*tongjing-hua*).[22] The emperor also insisted that Castiglione train Chinese court atelier artists in this inspiring new European style. Many of the surviving works are by these Chinese disciples.

A number of these works still cover the walls in the private quarters of the Forbidden City—such as the Qianlong Garden. A mural covering the entire back wall in the Bower of Jade Purity (Yu Cui Xuan), for instance, depicts women and children relaxing and cavorting in a residential room of the palace (fig. 12). The distinct European-style perspective contributes to a powerful sense of the room extending into a deeper space. The wallpaper on the walls and ceiling of the painted room match the wallpaper of the actual room exactly—furthering the illusion of depth.

Many of these murals share a distinctive feature—with paintings and calligraphies hanging or pasted on the wall within the depicted spaces. That is, paintings within paintings. A number of paintings decorate the walls and screens that define the space in the Jade Purity murals. A painting of three men—representing Confucianism, Daoism, and Buddhism—is pasted on the back wall of the room. On either side, also pasted on the wall, hang calligraphic couplets. The wall decoration of the three vertically arranged images in the Yongzheng painting of the young woman were painted trompe-l'oeil imitations of such pasted works (see fig. 9). The eighteenth century, with its new interest in verisimilitude, brought Chinese artists yet another step closer to bapo. The spread of realism in painting from the court to a wider population has been attributed to Chinese artists who served at the imperial academy—where they studied with Castiglione or other

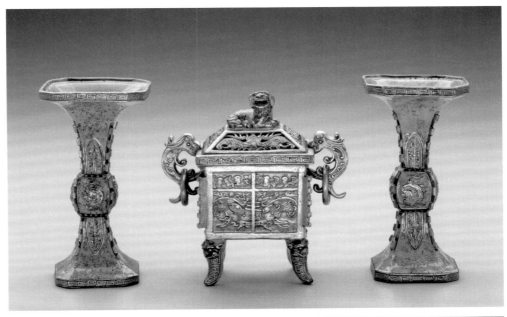

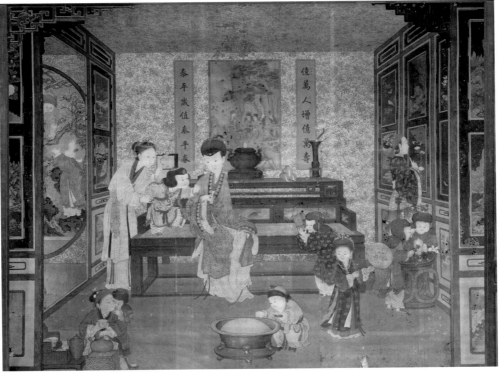

Fig. 11 Garniture set of two vases and a censer, imitating cloisonné, 18th century
Fig. 12 Yao Wenhan and others, interior scene, about 1776

foreigners—and then returned home. Many of these artists came from the Jiangnan region in south-central China, renowned for its fine artists and artisans.

One of China's most famous novels, *Dream of the Red Chamber* (*Honglou meng*), describes the household and luxurious interiors of an expansive and well-to-do family (and its servants) in the Jiangnan region. The winding plot is thick with varied and colorful characters and their ventures. In chapter 41, an elderly grandmother becomes befuddled by the household's new-fangled and fashionable decor, such as European glass mirrors and illusionistic murals: "Forthwith, she crossed the doorway, but her eyes were soon attracted by a young girl, who advanced to greet her with a smile playing upon her lips. 'The young ladies,' goody Liu speedily remarked laughing, 'have cast me adrift; they made me knock about, until I found my way in here.' But seeing, after addressing her, that the girl said nothing by way of reply, goody Liu approached her and seized her by the hand, when, with a crash, she fell against the wooden partition wall and bumped her head so that it felt quite sore. Upon close examination, she discovered that it was a picture."[23]

More affordable naturalistic imagery also began to materialize from woodblock-print workshops in Jiangnan's cultural center, the city of Suzhou. The wider distribution of these detailed, mass-produced renderings of spaces and objects aroused a renewed interest in the illusionistic aesthetic—at least among less scholarly inclined audiences. And that resurfacing excitement about verisimilitude may have also nudged along the emergence of bapo. Early touches of illusionism in popular imagery can be seen in a finely produced eighteenth-century New Year's bogu woodblock print from Suzhou (fig. 13).[24] Bogu still life compositions, filled with propitious symbols, had become common for decorating homes at New Year's. One work, for example, depicts a typical antique bronze vessel filled with flowers and a tray of coins to intimate prosperity.

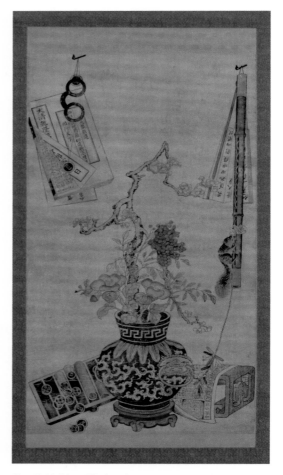

Fig. 13 Unidentified artist, New Year's print, 1744

The new European-inspired illusionism can be seen in the upper section of the print. There are two hooks, both drawn in perspective and from which hang various objects, including a printed and bound book, spectacles, a flute, and a fan. Part of the book's title is visible, reading *The Great Qing Qianlong* (*Da Qing Qianlong*), referring to the Qianlong reign (1736–96) of the Qing dynasty (1644–1911). A folded corner obscures the rest of the title. Upon closer inspection, it's possible to identify some of the hidden characters, as they have been depicted lightly in reverse as if to be viewed through the thin paper.

The book is the annual calendar printed and distributed by the imperial authorities for the year 1745. The calendar, with its translucency and its perspective in the plane of the print, is depicted as if it were pasted directly onto the surface of the print. Here is a touch of illusionism within an otherwise routine artwork.

These bogu-inspired prints—with their auspicious objects and messages—were commonly sold on the street for decoration at New Year's time. The designer of this print included the usual auspicious messages—but cleverly added the innovative gimmick of the calendar to announce the New Year. The visual joke required the viewer to work a little harder to understand the book's title and meaning. It would have certainly amused viewers and attracted buyers. And it demonstrates the development of verisimilitude in the broader commercial reaches of Chinese culture. A second print with a similar composition—including the hooks and the calendar with its folded front page—but different details was published in the same year. The demand for this new illusionism must have been significant.

Interestingly, the same print includes perhaps the earliest depiction of a scrap of "broken" paper. A mouse can be seen crawling up the flute on the right side of the page. In his mouth is a small piece of paper. The observant viewer—who understands the Chinese characters on the paper—will discover that the mouse has been chewing on the previous year's calendar. The appearance of the paper fragment and the book in the same image demonstrates that the artists and viewers of the time were developing a new visual sensibility—one that would contribute to the introduction of bapo.

By the early years of the nineteenth century, the key visual strategies that would contribute to the development of bapo were in place in the Chinese art and decorative worlds: depictions of antiquities, including ancient bronzes; a scholarly interest in the value of written characters; interest in rubbings taken from stone carvings and metal etchings; and the arrangement and illusionistic depiction of multiple paintings and calligraphies on a single surface. With these elements well established in visual culture, the stage was set for the entrance of bapo.

Religion, philosophy, superstition, and magic

Traditional Chinese beliefs and philosophical systems also played important roles in the development of bapo. Aspects of Confucianism, Daoism, and Buddhism—all three of them important influences on Chinese society—contributed to the conceptual foundations of the art.

Confucian ideology, for example, promoted a culture that venerated textual learning—and was ruled by scholar bureaucrats. These ideas influenced not just the elite, but all of Chinese society. The imperial examination system—first instituted during the Han dynasty—made it possible for a peasant to rise to become a high official through diligent study of the classics. Merchants, with their pursuit of monetary gains, were at the bottom of the Confucian hierarchy. Individuals with aspirations to rise through the social ranks would therefore be more likely to display collected images of classic texts than symbols of wealth.

Daoism teaches that things break; that is reality. Nature sprouts and grows, and then it deteriorates. Early Chinese philosophers glorified this "brokenness." Laozi, the first teacher of the Dao, notes in the *Daodejing* that "great perfection appears defective . . . great fullness seems vacant." Zhuangzi, one of the greatest Daoist philosophers (from the late fourth century BCE), depicted heroes who succeeded in life *because* of their physical disabilities.[25] He found great significance in objects no longer in perfect condition and even wrote, "That which is rotten turns magical."[26] Zhuangzi may have been commenting on natural processes, such as the fermentation of liquor and its intoxicating effects, or fermented bean curd,

or he may have had a deeper philosophical, spiritual, or even magical significance in mind. This interest in the concept of broken-ness eventually found its way into the visual arts. Song and Ming art connoisseurs, for example, dismissive of what they considered superficial prettiness or perfection, profoundly appreciated an aesthetic of brokenness and incompleteness. Connoisseurs delighted in the crackles that appeared in the glazes of Guan, Ge, and Ru ceramic wares as a result of their firing processes.[27] And they cherished even the remnants of great works of calligraphy or painting.

Buddhism—in its earliest stages in India—also incorporated deteriorated goods into higher services. The Sakyamuni Buddha instructed his disciples to wear robes made of cast-off rags. Known in Sanskrit as *pamsukula kasaya*, meaning "a robe [made from] rags off a dust heap," such a mantle would exhibit their humbleness and their disinterest in worldly goods. The Buddha suggested a template of rectangular rag patches that has been in continual use among Buddhists in China and Japan up to today. In time these robes, known in Chinese as *jiasha* (from the Sanskrit *kasaya*) or *bainayi* (one hundred stitched clothes), were often constructed from beautiful silks and brocades, rather than, as in Buddha's time, discarded cloth scraps from the garbage or from dead bodies. Daoist monks adopted the jiasha custom in China (fig. 14). By the Qing dynasty, mothers were making bainayi to ensure good fortune for their newly born children. For a time during the mid-Qing dynasty patchwork robes even became quite fashionable among young women.[28]

Today, peasants in northern China still make patchwork coats, kneeling cushions, quilts, and door curtains for their homes and local religious institutions. These are a poignant example of "broken" imagery. Originally intended to reflect humbleness and poverty—like the objects in bapo paintings—they have subsequently evolved into decorative and auspicious designs. The connection is more than incidental. Liuzhou uses the term *bainayi*—a word he would have been familiar with as a monk—in an inscription on a scroll of multiple rubbings (see figure 1). And multi-image screens from Korea (see figure 6) came to be called "one hundred stitch screens." (These were known as *baeknapdo byungpung* in Korean—the name was more than likely derived from Chinese terminology.) Thus we see multiple customs linking scraps and remnants with religious traditions.

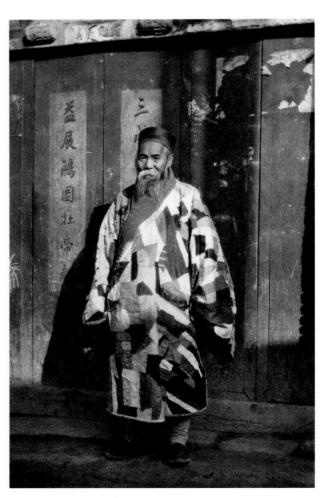

Fig. 14 Unidentified photographer, Daoist monk, northern China, about 1930

Zizhihui and veneration of inscribed papers

By the nineteenth century, fragments of texts had also become important—in fact, almost sacred—among the less-educated sections of society. For members of an unusual sect, the respect for classical learning and calligraphy developed into veneration for any and all written characters. The Confucian classics, after all, were created with characters, and any character could be an element of one of these texts. As a result, the belief took hold that any written character was sacred.

To allow written characters to be strewn as garbage in the gutters, or to be left where they might be stepped upon by filthy, unknowing feet, these devotees believed, was too inglorious an end. During the nineteenth and early twentieth centuries, members of Inscribed Paper Associations (zizhihui) hired men to roam the streets, carrying large baskets on their backs, in search of tattered scraps of papers. Labels pasted on their baskets read "Take pity on the characters!"[29] The inscribed papers would then be burned collectively in special ovens at temples devoted to Wenchang, the god of literature. Those who participated in this collection, it was believed, would reap longevity and good fortune.[30] Many households saved scraps of inscribed papers in separate baskets or containers, which were labeled with the characters "zi zhi," to pass on to members of the zizhihui when they passed by.[31]

"Turned-over basket of inscribed papers," dafan zizhilou, became another name for bapo at least as early as the 1930s.[32] Though bapo did not derive directly from the zizhihui customs, there is a clear relationship between the two. Visually, bapo paintings do indeed resemble a bag or basket of papers spilled open. The randomness of the papers, their degree of disintegration, the inclusion of commonplace papers such as envelopes and advertisements, and their haphazard arrangements all suggest a connection. And—conceptually—works of bapo art, like the

inscribed paper collectors, can suggest deep meaning in any and all written characters.

Several bapo artists call attention to this relationship by including references to the zizhihui in their works. For example, one unsigned, undated painting depicts, among other specimens of calligraphy and paintings, a label with the four characters "jing xi zi zhi," the motto of the zizhihui. Another bapo fan painting, done in the summer of 1940 by Li Cunlin, depicts a fortune slip, a receipt from a pawn shop in the French Legation, a playing card (the king of hearts), a one-yuan bill from the Bank of China, a rubbing, and several other bits of inscribed papers. Li titled it The Basket of Characters Is Overturned (Zi lou da fan).

The broken century

While elements of visual representation, intellectual and philosophical systems, and popular culture provided the foundation for the innovation of bapo, current events also exerted a powerful influence on its development. Serious political and social upheaval—with threats from both at home and abroad—increased artists' focus on the remains of their traditional culture. As the eighteenth century turned the corner into the nineteenth, as the extravagant reign of the Qianlong emperor ended and he handed over the reins of power to his son, the Jiaqing emperor (r. 1796–1820), a sumptuous century yielded to what would become a tragically "broken" century.

The Qianlong emperor, with his lavish spending, had left his son a much-diminished treasury. In brief, these reduced circumstances led to greater corruption among the bureaucracy, higher taxation of farmers, and the abandonment of government careers by many of the country's most capable scholars. Increased taxation led to uprisings and internal strife, and the weakened government forces were unable to defend the country's borders from foreign intruders. The major events of destruction and devastation that

best represent nineteenth-century Chinese history are the First Opium War (1839–42), between Chinese and British forces; the domestic uprising of the Taiping Kingdom (1850–64); and the Second Opium War, in 1860, which culminated in the occupation and destruction of the imperial palaces and gardens at Yuanmingyuan. By the end of the nineteenth century, China might best have been described as "trampled."

The turn of the twentieth century did not improve the situation. It began with the Boxer Rebellion in 1900—leading to a year-long occupation of the Forbidden City by European, American, and Japanese forces—followed by the total collapse of the Qing imperial rule in 1911, the 1930s invasion of China by Japan (including the horrific massacres at Nanjing in 1937), and the civil war between the Nationalists and the Communists that stretched until the 1949 victory of the Communists—leading up to the turmoil of the Cultural Revolution. Along with the staggering toll of death, political upheaval, property damage, and human suffering, these events contributed to the wholesale destruction of many revered elements of classical Chinese culture—a carnage openly mourned in bapo paintings.

The Taiping Rebellion, for example, led to the violent destruction of Buddhist and Confucian temples as well as massive bonfires of classical texts. In 1853, the leader of the rebellion, Hong Xiuquan, declared that "the books of Confucius and Mencius should be put into flames, and the temple of Confucius be turned into a slaughterhouse."[33] In an essay published under the Taiping in 1853, one of Hong's adherents, Huang Zaixing, declared, "All works by Confucius, Mencius, and the philosophers of the hundred schools should be committed to the flames."[34]

Firsthand observers reported on the ensuing destruction: "In the various cities along the river [Yangzi] there are a number of book collectors, including Ye Yunsi of Hanyang, Yuan Wenda of Yangzhou, Qing Dunfu, and Cheng Mutang. Their houses were filled with tens of thousands of scrolls, like exhibits of jade and pearls. But when the Taiping army went through the cities they committed them to flames, using them to smoke away mosquitoes or to make tea; sometimes they even used these books to wrap up their horses' hoofs, or as toilet paper. What a misfortune to literature, a misfortune even greater than that which it met in the Qin fire."[35] For the literati at the time, who were concentrated in the Taiping-controlled Jiangnan region of Suzhou, Yangzhou, and Hangzhou, the loss of these almost sacred books must have been an emotional calamity. The legendary Qin dynasty bonfires destroying Confucian texts two millennia earlier became their immediate comparison. (Li Chengren would reference the same Qin conflagration in his bapo painting almost a century later [see cat. 26].)

The two imperial commanders who eventually suppressed the Taiping Rebellion—Zeng Guofan (1811–1872) and Zuo Zongtang (1812–1885)—were hailed as heroes by Chinese society. Both of these men's calling cards appear in later bapo paintings, as if the artists are calling out for heroes to once again save their culture from the violence and havoc that continued to rock China.

Any of these calamitous experiences—with visions of the great classic texts scorched and squandered, turned into "a pile of brocade ashes"—would have been enough to inspire artists to depict the sorry, crumbling state of their once glorious culture. But the Taiping Rebellion, with its immediate and overwhelming impact—not to mention burnt books—may have been the singular catastrophe that sparked bapo.

MESSAGES
Mourning the past
Bapo paintings overflow with visual representations of the revered hallmarks of China's cultural past. Masterpieces of calligraphy, the most esteemed art form; classical Confucian texts on ethics and social

harmony; poetry; and rubbings of ancient stone inscriptions litter the surface of bapo paintings. Why these remnants from bygone years? In China, the past has always been the location of the ideal society. Even Confucius, the sage whose teachings have directed Chinese thought for 2500 years, glorified what he saw as an earlier ideal past. He proclaimed that he was not presenting new approaches, but only transmitting the wisdom of those ancient times.

Mourning the destruction and loss of the ancient lifestyles, culture, and values—so palpably and visibly expressed in bapo painting—had long been a primary theme among the Chinese literati. "Yearning for antiquity" (*huaigu*) became a motif in Chinese poetry—and art—as early as the Han dynasty (206 BCE–220 CE). Huaigu conveyed both a reverence for the past and a grieving for its destruction, often ruminating on the physical ruins of devastated places.[36] Flourishing during the Tang dynasty (618–907), huaigu continued as an integral and fundamental component of Chinese literati culture, the most esteemed social class in China. The "death and destruction" (*sangluan*) poetry form, focusing on war and its devastation, arose at the end of the Song dynasty when Mongols from the north overran China and established the Yuan dynasty (1271–1368). "Broken-hearted [am I] at the sites of the Qin and Han dynasties. Thousands of palaces and watchtowers have all become dust," wrote the Yuan poet Zhang Yanghao.[37] "The Sichuan birds and Zhejiang flowers are damaged but still exist, [however, I can barely] stand to look at our ruined city, and its crumbling walls," wrote the Song poet Deng Yan after foreign armies plundered his city.[38] Artists of bapo paintings were surely well aware of these classic Chinese genres—and were creating works that would be their visual equivalents.

Many bapo paintings, in fact, contain examples of huaigu and sangluan poetry among their assemblages. The bapo artist Zhu Wei included a page from a Tang dynasty poetry book in one of his paintings. The page featured a classic huaigu poem lamenting the destruction of Nanjing during the Sui dynasty—where little remained but the "tides pounding the hollow city."[39]

As mentioned earlier, a common term for bapo paintings in the southern Jiangnan region of China, an area encompassing cities such as Hangzhou and Suzhou at the lower end of the Yangzi (Yangtze) River—an area celebrated for its cultural sophistication—was *jinhuidui*, "a pile of brocade ashes." The late Song–early Yuan artist Qian Xuan (1235–1305) was the first to use this phrase as the title for a painting.[40] At the age of forty-one Qian Xuan, trained to be a scholar official, refused to serve the Mongol-ruled Yuan court that had overrun the Jiangnan region in 1276. Instead of being a functionary for the foreign dynasty, he devoted the rest of his life to painting. Many of his finely limned landscapes and figure paintings express a yearning for earlier times and Chinese rule through their intentionally archaic styles.

Qian most likely adapted the words *jinhuidui* for his title from a reference in the well-known Tang dynasty poem *The Ballad of the Lady Qin* (*Qin fu yin*), by Wei Zhuang (836–910). This early lament describes, from a palace woman's point of view, the charred ruins of brocade and embroideries in the imperial storage after a violent military conquest of the palace. "When the Inner Treasury was gutted, it became just ashes of brocade and embroidery; one trod along the Street of Heaven over the pulverized bones of state officials."[41]

Another descriptive term for bapo paintings, "broken bamboo slips and damaged sheets of paper" (or *duanjian canpian),* appears as the title for numerous bapo works. It is also a direct reference to the destruction and loss of Chinese classical culture. In the time of Confucius and earlier, texts were written vertically on a series of bamboo slips that would be tied together and rolled up. During the Qin dynasty

(221–206 BCE), legend holds, the despotic Qin emperor, the first to unify China and considered the first emperor of China, was intent on suppressing any form of government other than his Legalism. He insisted that all Confucian texts be destroyed. These texts would have been written on bamboo slips, and the expression "broken bamboo slips" refers back to their tragic destruction. A variant of the expression was used as early as the sixth century, and the term continued to reappear for generations as an indication of a passion for all scholarly matters of the past, no matter how fragmented. A line in the *History of the Song* (*Song shi*) describes the historian, poet, and calligrapher Ouyang Xiu's love of ancient learning. "As long as it was a remnant from the Zhou or Han, *broken bamboo writing slips or damaged sheets of paper*, he gathered together and collected them all." Verses by the Song poet Lu You (1125–1209), commentaries on Laozi by the Ming philosopher Li Zhi (1527–1602), and even scenes from the twentieth-century progressive playwright Cao Yu (1910–1996) all made use of this evocative phrase.

Notably, the Song scholar of ancient bronzes Lu Dalin (1046–1092), sometimes referred to as the father of Chinese archaeology, used the words in his preface to his *Illustrated Research on Antiquities* (*Kaogu tu*), saying, "Although there are vestiges of compilations and *broken bamboo slips*, only two or three remain, and the times and traditions have changed; the ancient writers are gone and the books are damaged. We cannot imagine the mental states of the ancient emperors anymore." The phrase *duanjian canpian*, with its allusion to the near obliteration of Confucian culture by the cruel Qin emperor, was also used as a veiled reference for many later difficult political situations faced by the Chinese.

Over the ages, Chinese intellectuals have looked back to an idealized past and mourned the loss of past standards. Bapo paintings, created during equally turbulent times, expressed the same themes with their depictions of the crumbling, deteriorated remnants of China's great cultural icons.

Auspicious imagery

"I have chosen from among the thousands of symbolic expressions. I wish you all of their good fortune, and all the best blessings." This kind of sentiment for good wishes, inscribed by a bapo artist on a painting for a friend or client, has been a staple of Chinese culture for thousands of years. Auspicious and apotropaic (protective) visual images first appeared in China's ancient culture 3500 years ago—and have remained integral to Chinese visual culture at all levels of society since. Images of "door gods" have been hung on front doors at New Year's season since at least the Han dynasty to ward off evil spirits. Paintings of peaches were believed to inspire longevity. Embroideries of mandarin ducks reflected wishes for a blissful marriage. Chinese viewers of decorative arts read these symbols as easily as—or for many even more easily than—written texts. The potent symbols had various origins, some inspired by the cultural elite, others derived from popular culture, but over time, many of them reached all strata of society.

Written characters also took on auspicious and apotropaic functions. In addition to magical objects like Daoist amulets depicting fabulously complex characters, specific common characters—such as *fu* for good fortune or *shou* for longevity—became primary elements of everyday visual culture. This usage of written characters led naturally to the auspicious and apotropaic aspects of bapo paintings, most of which focus on the written word.

Rebuses, an entire subsection of China's visual symbols, developed out of homonyms. The bat became a symbol for good fortune because the word for "bat," *fu*, sounds like the character representing "good fortune," also pronounced *fu*. The "good fortune" *fu* is often seen pasted upside down on doors to indicate the arrival of good fortune—because the

word for "upside down," *dao*, sounds the same as the word for "arrival." The word *sui*, meaning "age" or "year," sounds like the word *sui*, or "broken." As a result, brokenness became a common symbol for longevity in some provinces of China. And in some regions of southern China, the New Year is celebrated by breaking a ceramic pot and yelling, "Sui sui ping'an," sounding like "Broken, broken, there will be peace and calm," or "For many years, there will be peace and calm."

The word *po*, also meaning "broken," took on auspicious meanings through a number of expressions, including *bupo buli*, literally, "no broken, no stand," implying that you cannot stand without first being broken. A bapo painting, with its "broken" elements, could, therefore, be seen as a wish for success. The word *bapo* translated literally means "eight brokens." Why eight? Eight is an auspicious number in Chinese. The penchant for eight in China may originally have arisen from the eightfold path and the eight auspicious symbols of Buddhism.[42] As Buddhism spread through the general population, so did an affinity for the numeral eight—its meaning also gradually evolving. The presence of the number eight in the term *bapo* suggests that the paintings were considered to have propitious functions.

The use of bapo paintings to offer auspicious wishes is also apparent from the popularity of the expression *baisui tu* ("Picture of One Hundred Brokens" or "Picture of One Hundred Years") as the title of numerous bapo paintings. It was first used in 1831 by the monk-artist Liuzhou (see figure 1) to communicate the auspicious message "May you live to be one hundred years old." The scholarly artist Sun Mingqiu inscribed his round fan paintings with the words *baisui tu* in 1893 (cats. 7 and 8). Zhu Wei entitled his set of six hanging scrolls *Baisui quan tu* in 1908 (cat. 10). And in 1936, Hua Jifu was using the same title for his colorful square painting overflowing with scraps of inscribed and painted papers.

Some have claimed that in addition to auspicious benefits attached to the imagery of bapo, bapo paintings themselves may have had apotropaic properties. For example, in a discussion from 1992 Zhang Cisheng of Tianjin, author of a symbolism dictionary, explained that bapo paintings were meant to ward off evil spirits and disaster.[43] The *po* of *bapo*, he said, is a homonym with the word *po*, as in *pochu*, meaning "to eradicate" and implying the eradication of evil spirits. Li Zhitan, a researcher at the Chinese History Museum (Zhongguo Lishi Bowuguan) in Beijing and a specialist in the history of woodblock-printed illustrations, remembered that in his youth bapo paintings hanging in a home were intended to protect the building from fire.[44] A popular Chinese belief holds that a small disaster discourages larger disasters. The burnt images in the bapo painting, according to this logic, would thwart further dangerous fires.

SURVIVAL AND REVIVAL

The first bapo works that we can date accurately come from the fourth quarter of the nineteenth century—Sun Mingqiu's scrolls and fans, Ma Shaoxuan's snuff bottles (cats. 17 and 18) and a scroll painted by the Buddhist intellect and calligrapher Li Shutong (1880–1942) when he was teenager. The genre peaked during the "broken" nineteenth century but was still practiced and popular through the early part of the twentieth century.

During the mid-twentieth century—an era characterized by war, invasion, and political and social tumult in China—the art form entered a dormant phase that led to its almost complete disappearance. And when the political situation finally began to stabilize after the end of World War II and the subsequent establishment of the People's Republic of China, other styles of art, more in line with the dominant political system, began to take precedence. Unpopular among the sophisticated elite from its

beginning, bapo had rarely been recorded in art histories and even casual essays. By the 1980s, the world had almost completely forgotten about it—even in China, few museum curators, art historians, or connoisseurs had heard of or seen examples of the art form.[45]

At first, the 1950s had held some promise for bapo. The artist Zheng Zuochen created bapo works until at least 1953, and was accepted in the Shanghai Artists' Association.[46] Zheng's bapo work continued along his previous, successful style—without any reference or response to the contemporary changes in China (cat. 25).

Another artist turned to bapo in the later 1950s specifically to register his reaction to the changing world. Zhao Fa'an (born 1886), whom we otherwise know little about, employed the bapo style to celebrate the "Hundred Flowers" political campaign. This 1950s campaign encouraged people to voice their diverse thoughts and concerns about the progress of the Communist government. In a wide horizontal work, at first glance a typical bapo painting, Zhao presents various historic papers, calligraphies, rubbings, book pages, and covers, all as if pasted on the surface, alongside books and artists' and scholars' tools depicted in three dimensions.[47] He includes brushes in a brush pot, an ink stick, an ink slab for grinding ink, fabric-covered thread-bound books, and for good measure an ink-washing bowl inscribed with the characters for good fortune, prosperity, and longevity. His enigmatic inscription leaves the viewer wondering if he was optimistic about the future, or was quietly, like his predecessors, already mourning some future loss of the past:

> Scribbles all over the place; fakes competing with
> authentic works,
> Paintings depict forms but their meanings are deep.
> One Hundred Flowers bloom in our new society.
> Bapo is also an art.

> Epigraphy of the past leaves no traces.
> The current imitations are not satisfying.
> Fa'an is not an expert.
> This stupid gourd has already passed fifty springs.
> The liberation of the people will raise the level of culture.
> Old books and ancient rubbings will also be turned over.
> Hoping that there is no misunderstanding,
> I am just using my writing to find friends who
> appreciate my meaning.

Zhao's meaning seems to have been intentionally vague. Any optimism voiced in his inscription was not to be realized. Directly following the Hundred Flowers campaign, an Anti-Rightist campaign cracked down on those who had been critical of the party. Eight years after the Anti-Rightist campaign came the start of the Great Proletarian Cultural Revolution (1966–76). Like the Taiping Rebellion (which late twentieth-century political leaders considered a heroic predecessor), the ideology of the Cultural Revolution criticized classical conventions and traditional thought and culture. Artists were to create only art that would serve political purposes. The Anti–Four Olds Campaign, started in 1966, sought to rid society of Old Customs, Old Culture, Old Habits, and Old Ideas.

Bapo painting—with its sentiments of mourning for the past and reverence for ancient culture—would have been completely unacceptable. Families who owned antique books or objects got rid of them—by burning, donating, or dumping them in latrines or rivers—lest they be caught and criticized for possessing remnants of the past. Less cautious collectors watched as mountains of their long-cherished books, paintings, and calligraphies went up in flames set by zealous young people. The fate of traditional Chinese culture, and with it the fate of bapo, could again be described by the expression *jinhuidui*, "piles of brocade ashes."

In 1976, with the death of Mao and the subsequent arrest of the Gang of Four, who were held responsible

for the eleven years of havoc, the forces of the Cultural Revolution diminished. Deng Xiaoping (1904–1997) came to power in 1979, and was soon encouraging economic reforms, individual prosperity, and less stringent controls on cultural and artistic pursuits. For some artists, the cumulative effects of the decades of uproar had been too traumatic. According to his son, bapo artist Chen Erzhi (1896-1971) was too discouraged after the 1949 revolution, when he was arrested as a spy, to take up his brush again.[48] But in the hands of a few others, bapo experienced a revival in the years that followed the 1979 liberalization.

One artist who returned to painting bapo after the Cultural Revolution was Yang Renying (literary name Kegeng, 1937–1992), born into a family of "village scholars" in the small town of Sulu, in Hebei County.[49] His intellectual background left him vulnerable after the 1949 liberation, and his village ostracized him. Mostly left alone—when not being criticized—he took to studying the volumes left to him by previous generations. Since childhood, he had been enraptured by Tang dynasty poems. In addition to classical literature, Yang studied traditional Chinese music and art. In 1958, at the age of twenty-one, he began studying painting with his fellow townsman and fellow social outcast Li Shufen, a painter of bapo. Yang started painting bogu still lifes and bapo, but his endeavors came to a halt during the Cultural Revolution. Red Guards criticized him publicly and burned or otherwise destroyed his inherited books and paintings. But several years after the death of Mao and the arrest of the Gang of Four, Yang dipped his brush in ink again. During the 1980s, he resumed painting works in the bapo style.

In a 1992 interview, he reflected on his style of painting and his personal motivations for choosing bapo as his subject. When asked why he enjoyed working in this genre, Yang answered that he was passionate about old things. "I love the ancient. If I see an antique, I cannot leave it" (*Wo ai gu. Wo jian gudong, wo zou bu dong*). Unlike other painters of bapo, Yang said, he did not like to include new objects in his paintings. "I could paint new stamps, or new money, but they are not interesting to me. Old stamps are okay. I don't like bright colors. I prefer ancient, faded colors."

Like his teacher, Yang included old objects that he desired to preserve, at least in some manner, in his bapo paintings. He mentioned an old painting that he had recently found in Beijing. It was only about one hundred years old, was done by an unknown artist, and had no market value, but, he said, he felt it was very finely done and planned to include it in a bapo painting. "It is because I love these things and because I want to preserve them." He included a Fan Zeng painting in one composition because, he explained, even though he was unable to own a work by the well-known contemporary ink painter, he could at least possess it in his painting. He had copied works by Fan Zeng, Wang Xuetao, and Zheng Banqiao from calendars, he said, pointing to the reproductions he had replicated within one composition. Other works he had copied from books.

Yang said he felt differently about his bapo paintings than about his other works. He never sold them, he said—only gave them away. For Yang, bapo paintings were an expression of cultured sentiments. The man whose family library and painting collection had been destroyed was trying to preserve knowledge. The paintings were so significant to him that they could not be exchanged for money.

In 1987, Yang began to pass his artistic knowledge on to a younger man in his village. Yang trained artist Sun Zhijiang (b. 1967) in painting as well as in the techniques of bapo. While most of the paintings Sun now exhibits depict sorghum, corn, grapes, and other products of the land, he occasionally creates bapo compositions, and always proudly recounts his years of training with Yang Renying.[50]

The Beijing artist Song Yiqing (1918–2007) also returned to painting bapo after the Cultural Revolution. Anxious for the technique to be preserved and carried on after he passed away, Song urged a younger man, Geng Yuzhou (b. 1945), to take up bapo painting.[51] After five years of training, with the master watching over his shoulder, Geng felt confident about going off on his own. In turn, he passed the art form on to his own son, Geng Xuezhi (cats. 32 and 33).

Another artist, Niu Chuanli (style name Xiao-chuan, 1921–2005), was determined, after the chaos of the Cultural Revolution had dissipated, to revive the bapo tradition. The painting form had captivated Niu in the early part of the century, long before the 1949 revolution. According to an article written by his son, the young Niu Chuanli had been transfixed by a freshly mounted bapo painting he had serendipitously discovered on the street, drying outside a mounting shop in the small town of Xinghua, Jiangsu Province, just north of Suzhou. The work had been created by the artist Yuan Runhe (see cats. 11 and 12). The boy returned over and over again to stare at the collected and arranged images and then ran home to attempt his own version. Coming from a long line of scholar officials in both the Ming and Qing imperial government, he had already begun to learn calligraphy, the classics, and traditional brush painting from an uncle— his father having died when he was eight—and continued to study with other teachers as he grew older. One of his painting teachers had studied in Shanghai, where he had worked with the Paris-trained Chinese artist Xu Beihong (1895–1953).[52] Despite the Japanese invasions of China and the Republican-Communist conflicts, Niu Chuanli followed his artistic interests, eventually arriving, in his twenties, at the National Art Academy in Chongqing, Sichuan Province, where the school had moved to avoid the turmoil of the war.[53] By this time, most of the classes at the academy were training students in European painting styles. Perspective, shading, and proportions all became part of Niu's

skills. But Niu also continued studying Chinese painting techniques. All of these skills, he applied to what he called "the ten brokens" (or shipo) painting style that he had learned from his "mentor," Yuan Runhe. Why the "ten brokens"? The term is clearly derivative of the "eight brokens" of bapo, but it carries an additional significance. The character shi can mean both the number "ten" and "to pick up," referring to the gathering of "broken" inscribed papers on the street.

With World War II over and his studies completed, Niu was sent to teach at a technology institute in the southern city of Tainan, on the island of Taiwan. But in 1949 the Communists defeated the Nationalists, and the Nationalists relocated their base to Taiwan. Niu moved back to the mainland, where he became an art teacher in a primary school in Nanjing. In his spare time, he painted bapo paintings. The winds of politics eventually caught up with him. In 1958 he was sent, along with many other intellectuals, to the countryside. First, he was off to a labor camp outside Nanjing, and then to a fishing village near his home region of Xinghua. During the Cultural Revolution Niu was labeled a traitor (pantu). Like many others at the time, he put down his brush. In 1978, the political winds shifted again and Niu was rehabilitated. In 1980, at the age of fifty-nine, he gathered his energies and began to paint bapo again.[54]

His works, while painted in a Chinese painting style, reveal his education in European painting techniques (fig. 15). The three-dimensionality of the curled-up edges of papers is emphasized with shading and perspective. Primarily, however, the viewer sees shreds of the past: a page of rubbings of Shang dynasty oracle bones and tortoise shells displaying examples of China's earliest characters, first discovered by scholars in 1899; a fan with a poem by the great Tang dynasty poet Du Fu (712–770) written in seal script; a page from the woodblock-print book Illustrated Collection of Ancient Weapons (Gudai bingqi tu ji); a rubbing of characters from a Tang dynasty stele; a

mounted scroll of calligraphy by the mid-Qing artist Zheng Banqiao (1693–1765), who hailed from the same town as Niu; a title page from the eighteenth-century imperial Kangxi dictionary (*Dianban Kangxi zidian*); and a title slip from a book of calligraphy models, *Inscriptions on Bells, Tripods and Bronze Vessels from the Jigu Studio* (*Jigu zhai zhongding yiqi kuanzhi fatie*), collected by the esteemed eighteenth-century scholar, collector, and epigrapher Ruan Yuan.

A number of the objects represented in Niu's paintings are nineteenth-century copies of older objects, such as the 1927 lithographically printed version of the Kangxi dictionary that was first published in woodblock-print form in 1710. Here he is making copies of copies—but this was clearly his intent. Niu's awareness of bapo as a form of play is obvious. The outline of his seal, imprinting the two characters *shi* and *po*, is ragged, as if the stone seal itself had been broken. Beyond the playfulness, beyond the desire to continue an almost lost tradition, a current viewer of these paintings might also sense sad memories of having witnessed once cherished objects destroyed during the decades of turmoil. Fortunately, Niu lived until 2005, to the age of eighty-four. He was not only able to revive the bapo tradition, but also, like Yang Renying, to pass it along to the next generation. His son still paints bapo.[55]

Not only have a few artists managed to preserve the bapo tradition, but the state-owned publishing house and bookshop New China Bookstore (Xinhua Shudian) mass-produced a bapo painting as a New Year's decoration in 1983. New Year's prints—originally made from woodblocks—are an age-old tradition in China, used both to decorate the home and to usher in good fortune. In the early twentieth century, merchants sold bright lithographic prints at New Year's time. By the 1950s the New China Bookstore was producing inexpensive posters reflecting subtle political and social aspirations. Happy farmers, giant vegetables, soldiers helping out elderly peasants,

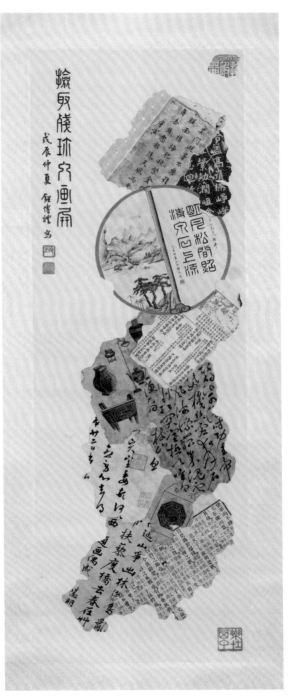

Fig. 15 Niu Chuanli (1921–2005), *Picking Up and Gathering Damaged Treasures*, 1988

chubby babies surrounded by the peaches of longevity, all found their way onto the walls of homes throughout the country.

Political themes were less subtle during the Cultural Revolution when posters exhorted people to follow Mao's teachings and celebrated the ever-persevering masses. In the early 1980s, new imagery—alongside some traditional motifs—began to appear. Among the selections available behind the counter on the third floor of the New China Bookstore on Wangfujing, Beijing's main retail thoroughfare, in the winter of 1983 were a pair of horizontal prints depicting calligraphic rubbings, slightly burnt at the edges; several ceramic vessels, two of which are broken; and stacks of 10-, 5-, and 1-yuan bills. Though the objects are depicted three-dimensionally in space, rather than flat as if pasted on a surface, the work is unmistakably inspired by bapo (fig. 16). As with many earlier bapo paintings, the artist—possibly a professional working for the publishing company—is an uncelebrated, unknown personage. The works are signed with the name Zhang Xuecong, but as yet nothing is known about this artist.[56]

In many aspects the print follows the typical pre-1949 bapo pattern, combining a reverence for deteriorating traditional culture with wishes for good fortune. The classical documents that spread across the expanse of each print are rubbings of famous texts pasted into accordion-formatted books. The left-hand print holds rubbings of texts on ethics. The right-hand print contains *Ming xian ji*, a collection of Confucian texts for children's elementary education, first compiled during the Song dynasty and commonly used for teaching ethics and calligraphy. The folded pages—with their distinctly burnt edges—stretch forever into the distant background, as if representing the endless extent of Chinese classical wisdom.

The artist also added, not unexpectedly in a bapo New Year's image, purely auspicious elements. In addition to the common visual pun of "broken" (*sui*) objects implying "wishes for many years" (also *sui*), Zhang added other aspirational references. On one vase the characters, written in the ancient seal script, read, "Build up the family fortune" (*fa jia zhi fu*), an expression used in post-1949 literature that had become a political motto. For those unwilling or unable to decipher the ancient script, he includes the more easily understood stacks of money. Ten-yuan bills were the largest paper currency unit available in 1983, and the money represented in the image probably amounts to about a year's wages for the average urban worker at the time. Chinese people of all nationalities—Han, Mongolian, Hui, and others—stare out from the face of the ten-yuan bill placed on top of the pile here. The artist is implying "prosperity for all," portraying, like the fat babies with buckets of gold shown in premodern New Year's prints, aspirations for personal fortunes.

The reverence for the scholarly traditions of calligraphy and Confucian texts—and recognition of the damaged state of those traditions—is obvious in the print. The artist here was perhaps quietly acknowledging the damage inflicted on China's age-old scholarly culture. One sentence in the displayed calligraphic text reiterates the artist's appreciation of the recent hard times. It reads, "A person enduring poverty has shortened ambition." But unlike earlier bapo works that bemoaned cultural losses, this state-approved print announces an after-the-storm optimism with blossoming flowers and affluence for all. The message is: "Yes, our traditions have taken a beating, but let us now treasure them again and return to rich and happy lives."

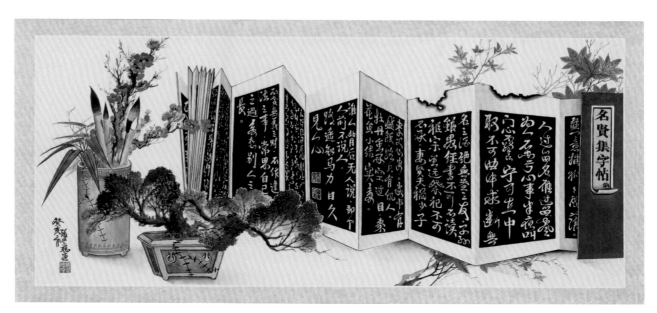

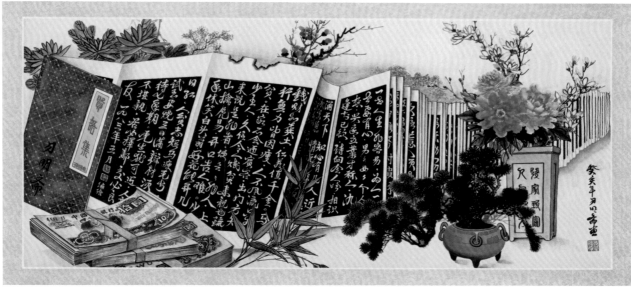

Fig. 16 Zhang Xuecong, pair of New Year's posters, 1983

Deconstructing a Bapo Painting

The paper objects replicated in this bapo painting reflect aspects of Chinese cultural values and practices—imitation of masterpieces, reverence for antiquities, veneration of calligraphy and epigraphy, mourning for the past, and love of poetry—as well as wishes for longevity and good fortune, and commentary on political turmoil.

1	Fan painting with an inscription by Xu Sou (Liu Yecun, teacher of Liu Lingheng) noting that the work is in imitation of the great master Wang Hui (1632–1717) and was made in the summer of 1911

2	Rubbing of the cover of an ancient Western Zhou dynasty bronze *hu* vessel known as the *Shu Ji Liang Fu hu*, with a dedicatory inscription referring to the aspiration for many grandsons

3	Rubbing in cinnabar ink of a Han dynasty belt hook with characters indicating hopes for official promotion

4	Calligraphy rubbing of the phrase "upon the dark blue river on a still night," from a famous poem by Huang Tingjian (1045–1105) to his friend the artist and calligrapher Mi Fu (1051–1107)

5	An envelope addressed to the Hall of Glory and Longevity

6	Rubbing of characters on a Han dynasty roof tile end

7	A cinnabar imprint of a large seal of four characters, *wan shou kang ning*, "ten thousand [years] of longevity with health and peace"

8	Rubbing of calligraphy on the 137 BCE victory memorial stele *Ji Gong Bei*; Liu marks his rendition of the rubbing with the red seal of the collector Xiang Yuanbian (1525–1590), though the stone itself was discovered more than a hundred years after Xiang's death

9	Title page from *Qing wen qi meng*, a textbook of the Manchu language, necessary for Chinese aspiring to succeed in government during the Qing dynasty ruled by the foreign Manchus

10	Inscription by the artist, Liu Lingheng, respectfully dedicating the painting to his elder "Jiechen" and dating the painting to the summer of 1911, just months before the uprising that led to the end of the Qing dynasty and imperial rule

Liu Lingheng (1872–1949), *Lotus Summer of the Xinhai Year*, 1911 (cat. 3)

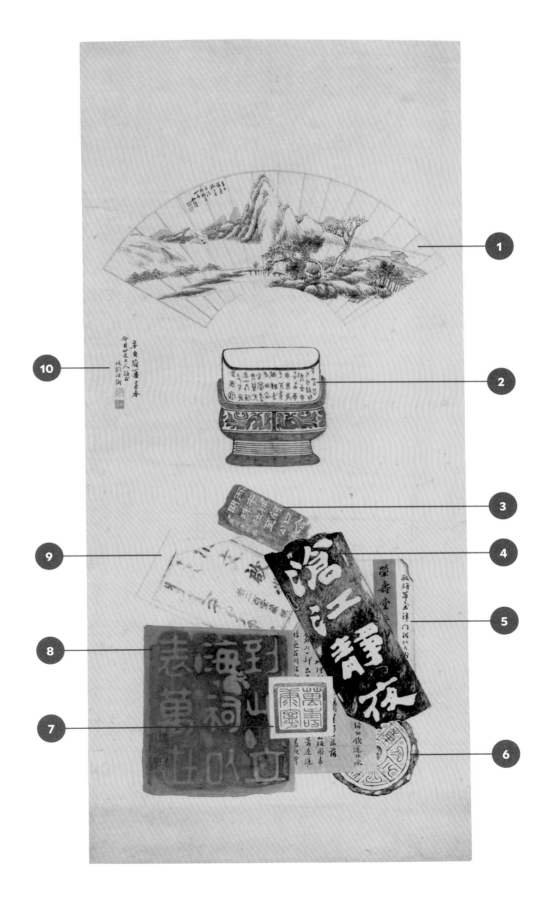

Catalogue of
Bapo Artworks

1

Wu Chunkui (dates unknown)
Vertical scroll with fan, rubbing, and landscape, late 19th–early 20th century

Ink and color on paper, 123 x 64.3 cm (48½ x 25¼ in.)
Anonymous gift in memory of William W. Mellins, 2017.15

2

Wu Chunkui (dates unknown)
Horizontal scroll with fan, rubbing, bird and flower, and landscape, late 19th–early 20th century

Ink and color on paper, 63.5 x 118.9 cm (25 x 46¾ in.)
Anonymous gift in memory of William W. Mellins, 2017.16

Two works by the artist named Wu Chunkui are known to exist. Together they reveal a few hints about this otherwise unrecorded artist—and about the development of compositions of multiple images—from an orderly, stable presentation to a chaotic and jumbled display.[1]

The first hanging scroll adheres to the traditional composition style of regularly positioned objects seen in seventeenth- and eighteenth-century screens. Every object is upright. With the centrally placed painted fan at the scroll's top, and the square album painting at the bottom, there is a balanced symmetry to the entire arrangement. In the second work—in a horizontal format—Wu also uses a balanced composition, but adds one randomly folded calligraphic rubbing to break the symmetry. Moreover, he rewards even the casual observer with a visual punch line—the central fan-shaped painting is a bapo painting with haphazardly positioned papers. This painting within the painting is where the artist has affixed his seals. Wu has literally demonstrated the leap from order to disorder.

The compositions of these works are noticeably similar to New Year's posters produced for lower- and middle-income members of society in the nineteenth century. But instead of depictions of filial piety tales or popular operas, Wu's work was intended to appeal to a more sophisticated audience—one with at least scholarly aspirations—by presenting rubbings of ancient bronzes, rubbings of calligraphic masterworks, and paintings by well-known artists.

The first work includes two paintings, two rubbings of calligraphies, two three-dimensional rubbings of bronzes, a rubbing of a seal, rubbings of Shang and Zhou dynasty coins, and a rubbing of the Northern Zhou dynasty coin called the *wu xing da bu*. In reality, this coin is just over an inch in diameter, but Wu's representation is as large as the ancient bronze beside it. Intellectuals of the eighteenth and nineteenth centuries valued these ancient coins for their elegant, archaic characters. For Wu and his clients, they carried two connotations—sophistication coupled with prosperity.

A close review of these two paintings suggests that Wu was a commercial artist who needed to cater to audiences to earn a living—rather than striving for his own personal expression. There is evidence for Wu's commercialism throughout. One hallmark of the scholarly artist is an inscription on the painting where he or she expresses in writing a

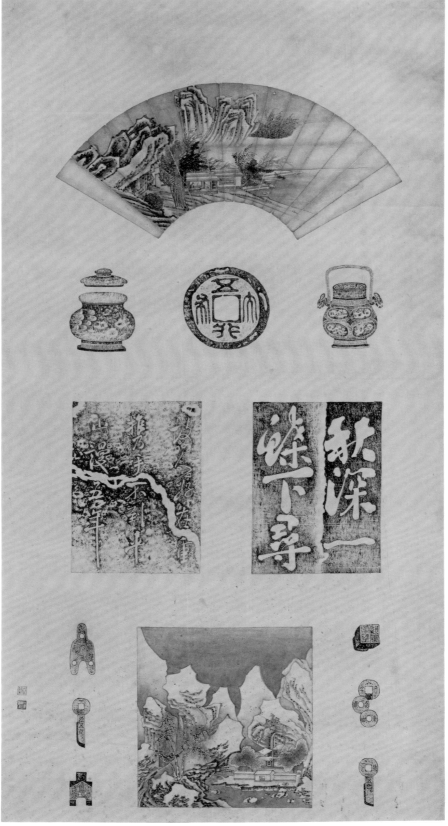

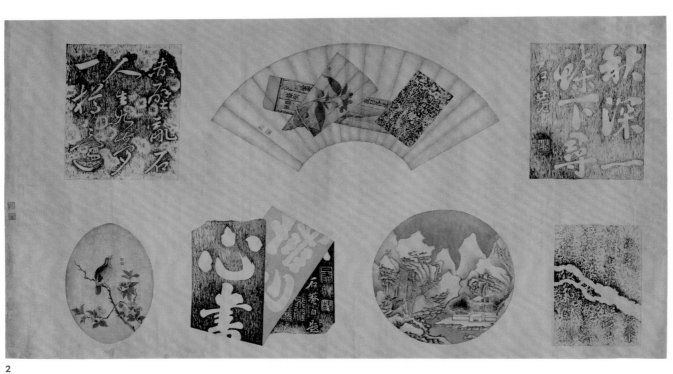

2

hint of a message, or at least a signature and a date. In Wu's work, this kind of calligraphic inscription is noticeably absent. On the hanging scroll, Wu has even refrained from placing signatures on the paintings and calligraphies he has reproduced. Was he ashamed of his lack of calligraphy skill?

Wu's reliance on the same imagery in both works also suggests a commercial background. Wu repeats the rubbing by the respected Qing calligrapher Liu Yong (1719–1805) and a landscape painting by the great Qing painter Wang Hui (1632–1717). In the vertical scroll, Wu does not give the names of the artists he is copying. In the horizontal scroll, he has decided to include them, perhaps to assist less knowledgeable clients who would recognize the masters' names, but not necessarily their styles.

The rubbings of calligraphy by Liu Yong that Wu reproduces were also readily available in the marketplaces of late nineteenth-century China. Liu, the minister of war and minister of ritual propriety, was considered the finest calligrapher of the Qing dynasty. His exuberant and powerful brushstrokes were reproduced as rubbings for distribution as models for calligraphy students.

The Wang Hui landscape painting that Wu duplicates in both works, once with a square frame and once with a round frame, was most likely his improvisation on an image in one of the many mass-reproduced woodblock or lithographically printed painting manuals in circulation during the late nineteenth century. Likewise, his model for the painting of the bird on the flowering branch—with

the seals of the great bird and flower painter Yun Shouping (1633–1690), a close friend of Wang Hui—was probably in a mass-reproduced book, rather than an original work.[3]

Though most of the objects Wu reproduces are complete, he does introduce some "brokenness" even when it did not exist in the original. The rubbing on the left side of the vertical scroll reproduces a calligraphic work by the Song artist Mi Fu (1051–1107). The original work is now in the Palace Museum in Beijing—and was a cherished object in the collection of the Qianlong emperor. In 1747, the emperor had his 340 favorite calligraphic works carved into 495 blocks of stone and reproduced as a series of rubbings known as the Model Calligraphies of the San Xi Tang. This collection included the poem *Pale Ink Autumn Mountain* (*Dan mo qiu shan*) as inscribed by Mi. Wu would have either seen a copy of the Qianlong edition or, more likely, a later reprinting of those rubbings. His replication of Mi's characters is quite close to the original, though to create an effect of greater age, he has inserted a jagged line across the characters representing cracks that do not exist in the original stone.[2]

The objects Wu has assembled are ones that an aspiring, but not necessarily deeply educated audience, would easily recognize. They would, moreover, recognize the items as icons of the scholarly lifestyle. Wu's final punch line—the fan depicting a bapo painting—reaches out to one other segment of society: people interested in a new, innovative, and surprising approach to aesthetics.

3
Liu Lingheng (1870–1949)
Lotus Summer of the Xinhai Year, 1911

Ink on paper, 127 x 57.6 cm (50 x 22¾ in.)
Anonymous gift in memory of William W. Mellins, 2017.30

The art of Liu Lingheng (also known by his style name Yuenan, literary name Da Chi Seng, "the big stupid monk," and Master of the Drunken Flower Lodge) went unrecorded in Chinese art history. But the writers of the county gazetteer in his home county of Wudi, in Shandong Province, were impressed enough by his artistic accomplishments—and a rumor that the Empress Dowager Cixi (1835–1908) had acquired one of his works—that they included his biography in their 1925 edition.[4]

The biography offers a sketch of the typical painter to whom bapo appealed as a subject. Liu grew up in an impoverished family in the small farming village of Liujia Xingwangcun (in Chezhen township, Wudi County, Shandong Province), about two hundred miles south of Beijing.[5] As a young man, he was fond of studying and excelled at painting. In time, he studied with the artist, calligrapher, and epigraphy specialist Liu Yecun (1855–1929).[6] Soon he was selling paintings and screens of birds and flowers. The maturing artist moved west to Hebei Province, where he was a tobacco store manager, and eventually to Tianjin. He continued painting, and became known for his bapo works, which he referred to as *buque*, "patched defects." He exhibited his works, and reportedly sold them to members of the official class who collected them as auspicious talismans.[7] At the age of sixty, Liu retired back to his rural roots and became a primary school art teacher in Wudi County— where he continued to paint and sell his works.

Both of Liu Lingheng's extant bapo paintings— this one, and an undated work (not shown)—follow a similar composition. An open fan painting anchors the top, providing a rare strength and stability to the work. Only a slight rip on one fan, and deep fold lines on the other, hint of any decay or irregularity. This symmetry at the top contrasts markedly with the disorderly elements at the bottom. Below each fan, the ancient and contemporary objects arranged haphazardly include rubbings of bronzes, tiles, coins, and calligraphies; book title pages in Chinese and Manchurian; and letters and envelopes. Like Wu Chunkui, Liu's style belies an awareness of both the regularly composed forms of the past and the new bapo style.

With a fully opened fan at the top of the painting, the artist presents a quiet, personal tribute. This literati-style monochrome ink landscape carries its own inscription, noting that it was painted in 1911 in imitation of the artist Wang Hui. Wang Hui was also a dedicated student fluent in copying the ancient masters. The signature on this fan painting is Liu Yecun, Liu Lingheng's teacher. The fan was in reality, of course, painted by Liu Lingheng, imitating his teacher imitating the seventeenth-century master Wang Hui.

Below the fan the artist has depicted an emblem of nineteenth-century scholarly culture, a rubbing of the cover of an important bronze vessel from the Western Zhou dynasty (1046–771 BCE), as well as a

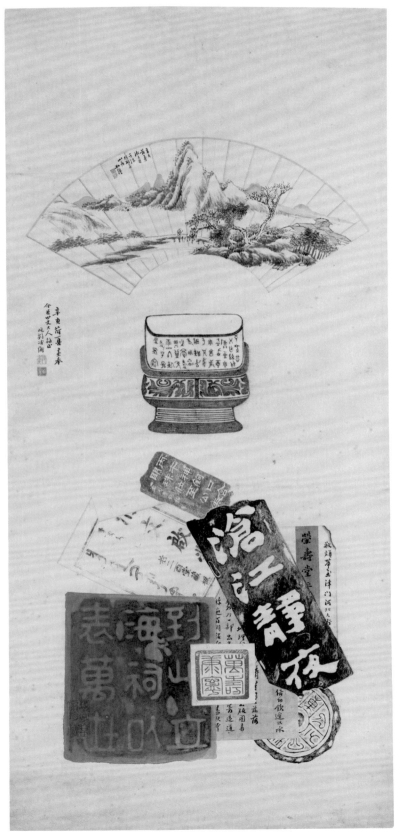

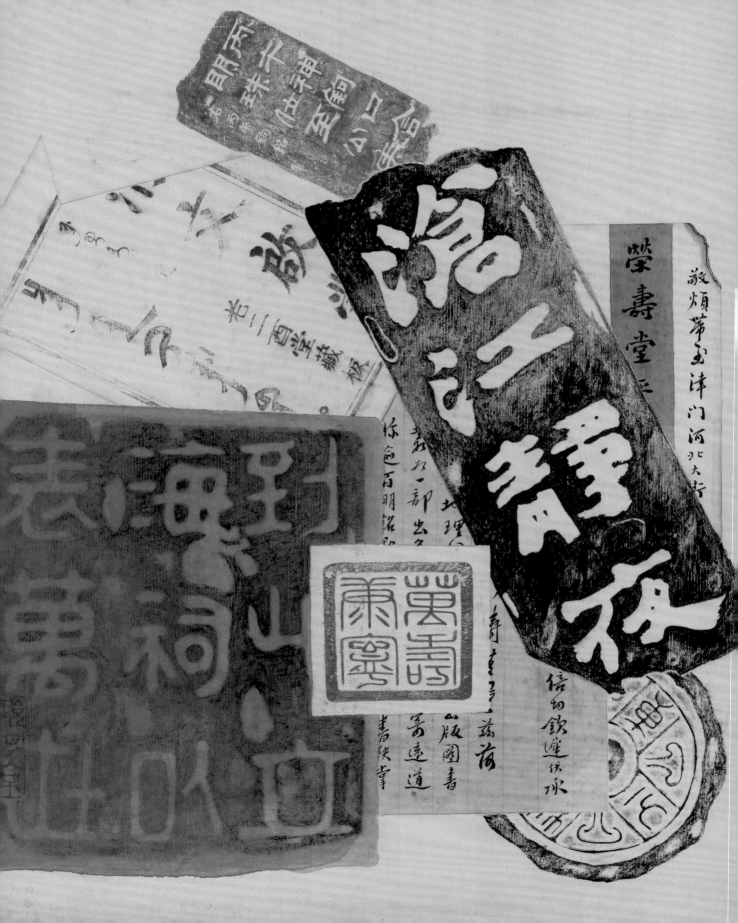

rubbing of the vessel's extensive inscription. Known as the Shu Ji Liang Fu *hu*, the object had at one point been in the Beijing collection of Prince Gong (1833–1898), son of the Daoguang emperor.[8] Liu includes the entire seal-script text written on the exterior of the hu cover's flange—hidden when the cover was fitted onto the hu. Liu places the object in the respectful central location of the painting and, perhaps unknowingly, depicts the cover upside down, with the flange projecting upward. This orientation made it necessary to invert the text to make it legible for the reader.

The existence of this bronze had already been recorded in many texts, though there are no known published visual records of it from before 1911. Many nineteenth- and early twentieth-century collectors had made rubbings of the Shu Ji Liang Fu hu cover and its inscription, and Liu may have seen one of them in his travels.[9] These rubbings also depict the hu cover upside down and the characters reoriented for legibility. Liu, perhaps more involved in the scholarly community than Wu Chunkui, may have known someone who possessed a rubbing of the bronze.

Moving down into the less orderly section of the scroll, Liu's painting may at first appear to be a typical bapo painting—providing the viewer with a range of scholarly, auspicious, and contemporary ephemera. Liu includes a number of scholarly collectibles and puzzles for his viewers. There is a rubbing of four characters from a poem written by the great Song calligrapher Huang Tingjian for his friend, the other great Song calligrapher and artist, Mi Fu. The well-educated viewer of Liu's painting would recognize

that the calligraphy in the rubbing was in the style of the eighteenth-century eccentric artist Zheng Xie (also known as Zheng Banqiao, 1693–1765). There is also a rubbing of a Han dynasty roof tile and a large imprint of a seal. This last object carries an auspicious message for the recipient. The four characters on the seal are *wan shou wu jiang*, meaning "long life forever."

Liu's work is also a rich reflection of the time period in which it was created. One of the dominating objects in the composition is the title page, in Chinese and Manchu, of a Manchu-language instruction book for Chinese speakers, *Qing Language Primer* (*Qing wen qi meng*), first printed in the Yongzheng era (1723–35).[10] The book would have been an important resource for Han Chinese trying to advance in the official life of the Qing dynasty—ruled by the foreign Manchus. Liu's inclusion of the book in his composition demonstrates the extent to which the Manchu had infiltrated his cultural world. It was also perhaps a comment on the tense current events swirling as he was painting the work.

Liu dates his painting to the summer of the momentous year of 1911, just two or three months before the October 10 overthrow of the Qing dynasty. The radical change of rule is known in China as the *xinhai geming* (*xinhai* revolution) after the same two-character cyclical denotation for the year with which Liu signs his painting. This portentous year requires an extra layer of interpretation for this painting. Was the radical change in composition—from the orderly to the chaotic—intended as his comment on the times?

4

Unidentified artist
Broken Bamboo Slips and Damaged Sheets, after 1877

Ink and color, and gold, on paper; three scrolls, each: 127 x 33.3 cm (50 x 13⅛ in.)
Anonymous gift in memory of William W. Mellins, 2013.577, 2013.578, 2017.10

These three scrolls—most likely from an original set of four—are each labeled with the title *Duanjian canpian*, "Broken bamboo slips and damaged sheets [of paper]." The expression refers to the destruction and loss of Chinese classical culture—and is used as the title of many bapo works. The phrase has its roots in an ancient act of cultural destruction. Confucian texts would have been written on slips of bamboo. When the despotic Qin emperor decided to rid China of any Confucian influences in the third century BCE, he ordered the destruction of all Confucian works— hence, "broken bamboo slips."

These three paintings, however, demonstrate the transformation that bapo underwent in the hands of artists oriented toward a less educated clientele, who delighted in surfaces, trompe-l'oeil effects, and colorful compositions. Their works were not the literati art that strived for deep insights, but a popular art designed to entertain and provide pleasure for customers who delighted in visual luxury.

Decorative Chinese painting styles are dominated by color and sparkles, as well as fine contour lines of uniform width. Professional and commercial artists often employed this *gongbi* style of Chinese painting to depict birds and flowers or figures—with bright, opaque mineral colors. Scholarly artists, beginning in the Song dynasty, rebelled against this seductive colorful realism. The restrained, modest, literati style—reflecting Confucian ideology—demanded a focus on calligraphic strokes with only pale, retiring colors that allowed a focus on the brushstrokes.

These three paintings highlight a conflict inherent in the bapo style. The artist intends to evoke a "yearning for the past" for a sophisticated literati audience, but presents that message in a decorative, non-literati visual style. Sparkling dashes of gold leaf and strong, opaque colors—including solid reds and yellows—distinguish this artist's work from the more ethereal, scholarly style of Chinese painting. The paintings demonstrate how literati themes—though not necessarily their visual approach—had become integrated and respected symbols within popular decorative culture.

The three paintings all follow the same compositional pattern: a long, thin framework displaying a book cover in the upper left corner, as well as a number of objects running down the length of the scroll, sometimes overlapping, but never crowding one another. To the bottom right of each book cover is a sheet of printed stationery; below that, a brocade-mounted painting or album leaf; then an upside-down page of a printed text; then a damaged rubbing of regular script calligraphy; below that a page of handwritten poetry or prose on colored printed stationery; then a long, narrow, and bent book title slip; and in the bottom left-hand corner the title page of a book. The bottom right-hand corner of each scroll displays a painting.

A number of additions have been made to this basic format—there's an advertisement for a stationery store added onto a painting—and the titles, colors, and textures of the books presented differ

greatly, but there is an intentional consistency in the composition of the paintings. The calligraphy rubbings all seem to be pages from one book. The brocade album leaves (one of which is blank) all seem to be pages from one album. And the letters on the gold-flecked printed stationery seem to be written by the same hand.

Almost all of these objects are depicted in crumbling or fragmentary condition. However, many of them are luxurious examples of their types—luxury balanced with literati tastes. At the top left-hand corner of the right-most painting is a brocade book cover with a red paper label reading, "Xue Tao Poetry Paper," in gold. The educated viewer would have recognized the reference to the celebrated Tang dynasty woman poet Xue Tao (768–831), who had invented a red-colored paper for writing her poems.[11] Just below is a mounted album painting of a charming woman with a fan standing in a garden, perhaps intended to be a portrait of Xue Tao. The work is mounted together with a blank page of gold-flecked paper awaiting a poetic inscription.

Other items scattered across the painting carry references to poetry. There is, handwritten on woodblock-printed, illustrated stationery, an essay on topics and rhyme schemes for civil service exams. A printed page, seen from its back, is from another book on rhymes for poetry. There is also a printed advertisement for an elegant stationery shop selling a variety of sumptuous goods including coral, amber, and fine papers, along with the title page of an 1847 reprint of *A Collection of Studies on Fu-Style Poetry* (*Fu xue ji zhi ji*), a book on how to write *fu*-style poems. Though focused on displaying sumptuous objects and representing them with luxurious materials such as the gold leaf flecks, the artist has also infused his work with a sense of refined and scholarly culture.

In part of each of the three compositions, the artist includes a less extravagant monochromatic ink rubbing of calligraphy—the kind collected by sophisticated connoisseurs. The rubbing on the center scroll is of one of the most important literati icons— *The Preface to the Collection of Orchid Pavilion Poems* (*Lantingji xu*) by Wang Xizhi (303–361). The *Orchid Pavilion Preface* was immediately identifiable by any culturally educated Chinese. The masterpiece was created on the third day of the third month of the year 353 (the ninth year of the Yonghe reign period) when a group of scholar friends gathered at the Orchid Pavilion by a stream in a bamboo forest outside the town of Shaoxing. As part of celebrating the Spring Purification Festival, servants floated cups of wine down the stream. As the cups floated by, the scholars imbibed and dashed off poems. At the end of the day, the senior among them, Wang Xizhi, took up his brush and inscribed a stirring prose essay as a preface to the poetry written by his friends. The relaxed and expressive brushstrokes in Wang's calligraphy, perhaps written while still partially intoxicated, were deemed extraordinary. Almost two hundred and fifty years later, the Tang dynasty emperor Taizong (598–649), an enthusiast of Wang's calligraphy, acquired the *Orchid Pavilion Preface*. To preserve the work for posterity, he had the calligraphy carved into stone. So passionate was this emperor about the calligraphy, legend holds, that he had the original entombed with him at his death. Rubbings of the carved stones, and the subsequent copies of copies of copies, have had to suffice for later generations. All calligraphy students learn to copy these copies of copies.

Professional bapo artists strained to include objects that would imply scholarly tastes without being so obscure that their less-than-scholarly clients would not recognize them. The *Orchid Pavilion Preface* filled that need perfectly. Understandably, it appears over and over in bapo paintings. The artists Xi Rui and Sun Mingqiu both included references to this renowned calligraphic work (see cats. 13, 8).

Though the fourth (missing) scroll may have contained more information, the three existing scrolls do not include an artist's inscription or a date. It is still possible to try to identify when the work was created. A book of poems dated to the *dingchou* year of the Guangxu reign, or 1877, is at the bottom left-hand corner of the right-hand scroll. This is the latest determinable date for any object found in the painting. The painting in the lower right corner of the same scroll is dated, but the fold at the corner hides the first and much of the second character of the cyclical date. The second character seems, from the two exposed brushstrokes, to be a *chen* character. The first cyclical date after 1877 to end with a *chen* character is the *gengchen* year, 1880. It's likely, though impossible to confirm, that the paintings were done in that year. The age of the paper, the mounting, and the painting style also fit this date.[12]

The identification of these paintings' creator is more difficult. The only hints of a name are signatures with literary names on fragments of paintings in the lower corners of two of the scrolls. One is signed Monk of the Whole Rock (Shi Wan Dao Ren); the other is signed Yearning for the Hut (Huai'an). Neither name can be connected to a known artist of the late nineteenth century. The absence of inscriptions, signatures, or even seals on the paintings, as on the Wu Chunkui works (cats. 1 and 2), suggests that the work was done by a more commercial artist, and not a trained connoisseur, collector, or literary figure such as the artist Zhu Wei.

The artist revealed his lack of scholarship in at least one instance. The bright red book cover in the center painting is the *Complete Register of Qing Officials* (*Da Qing jinshen quan shu*), a book listing all of the ranking officials in the country. The book as depicted is dated to the *bingshen* year of the Tongzhi reign, a year that did not exist.

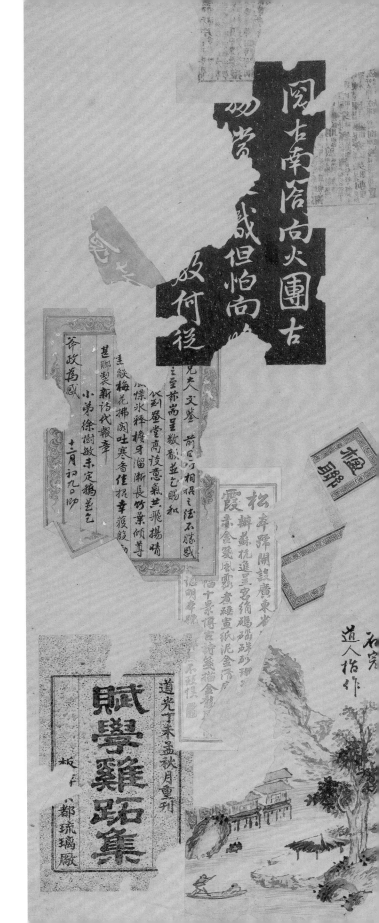

5

Sun Mingqiu (1823–after 1903)
Set of four hanging scrolls, late 19th century

Ink and color on paper, each: 121.9 x 29.8 cm (48 x 11¾ in.)
Museum purchase with funds by exchange from the
Denman Waldo Ross Collection, Special Chinese and
Japanese Fund, Bequest of Mrs. Mary Ripley Goodwin, Gift
of Mrs. Charles Goddard Weld, John Gardner Coolidge
Collection, Gift of Mrs. John Gardner Coolidge for the John
Gardner Coolidge Collection, Gift of Mr. and Mrs. William
Lawrence Keane for the Mr. and Mrs. William Lawrence
Keane Collection, Bequest of Phila S. James, and Gift of the
Carolyn C. Rowland Trust, 2017.3995.1-4

6

Sun Mingqiu (1823–after 1903)
Set of four hanging scrolls, late 19th century

Ink and color on paper; one scroll trimmed to
90 x 27.1 cm (35⅜ x 10⅝ in.); others, each:
about 127.8 x 31.3 cm (50⅜ x 12⅜ in.)
Museum für Asiatische Kunst, Berlin
Image: bpk Bildagentur/Art Resource

7

Sun Mingqiu (1823–after 1903)
***Picture of One Hundred Years (Baisui tu)*, 1892**

Ink and color on silk, 49.5 x 40 cm (19½ x 15¾ in.)
Anonymous gift in memory of William W. Mellins, 2014.1964

8

Sun Mingqiu (1823–after 1903)
***Picture of One Hundred Years (Baisui tu)*, 1892**

Ink and color on silk, 49.5 x 40 cm (19½ x 15¾ in.)
Anonymous gift in memory of William W. Mellins, 2014.1963

In 1823, the year Sun Mingqiu (style name Zizhen) was born, the monk-epigrapher-artist Liuzhou was still alive. It would be another eight years before that visual innovator created one of the landmark works in the development of bapo, his masterpiece of rubbings, *Baisui tu*, or *Picture of One Hundred Years* (see fig. 1). The British occupation of Hong Kong would not happen for another eighteen years, and the British concession in Shanghai was still two decades off. And it would be almost ninety years before the end of dynastic China. Sun was born while China was still solidly entrenched in a traditional culture.

He was probably born in a small town south of Beijing and Tianjin.[13] Reading between the lines of the many inscriptions on his paintings, one can determine that in his youth Sun studied for, but did not pass, the civil examinations that would have guaranteed him an official post in the imperial government. The failure would have propelled the bright young man, brimming with talent and knowledge of the classics, to find another means of earning a living. Painting may have been a pursuit that could bring in an income, and creating bapo paintings would have engaged his intellectual interests. The decision to follow, or yield to, this path would lead to his earning a reputation as the most celebrated bapo artist.[14]

The majority of the first fifty years of Sun's life are unrecorded, awaiting future researchers. But enough works by Sun survive that we can trace a distinct evolution in his innovative work and thought. A hand scroll from 1876 reveals that he had begun exploring bapo while in his fifties.[15] Floating across the space of the scroll are scraps of calligraphy rubbings, book title slips, a round fan painting of birds, and a page torn from an epigraphy book depicting ancient coins—a subtle wish for prosperity for the painting's recipient. In 1884, he produced another horizontal scroll depicting rubbings of antiquities, a painting of a painting of a young

woman, images of the cover of a book of collected poems by the Yuan poet Yang Zhonghong, and burnt and folded printed book pages.[16]

During the 1880s, Sun made at least two large-scale works. This first set of four vertical scrolls, undated, but most likely from the 1880s, represents his second style, before he begins creating more intellectually complex works. The fan paintings at the top of each of this set of scrolls include Sun's finely rendered versions of works signed by two well-known artists of the Ming and Qing periods—Tang Yin (1470–1524) and Wang Hui (1632–1717), one by the female artist Ma Quan (late seventeenth–early eighteenth century), and one slightly damaged but repaired work by another, unnamed female artist.

Under these relatively intact objects, Sun places his torn, burnt, and folded fragments off-kilter in vertical columns. The central objects in the third from the top position of each scroll are rubbings taken from calligraphy carved into stone, or, to be more precise, are *painted* representations of such rubbings. To produce this effect, Sun would have had to fill in dark areas with ink so that they would convey the roughness and chipped parts of the stone, leaving the sharp edges that outlined the engraved characters white. The representation of a rubbing by painting with a brush is called *yingta*, meaning a "rubbing" (*ta*) made with the "tip" (*ying*) of the brush. Sun may have invented this technique—as of yet, no earlier yingta have been found.[17]

The next-to-last row features writings by more recent calligraphers. A letter from Liu Yong, considered the finest calligrapher of the Qing dynasty, and a poem brushed by the eccentric artist and calligrapher Zheng Xie (1693–1765) demonstrate Sun's ability to mimic the distinctive handwriting of the masters. He also demonstrates handsome, balanced regular script on a lined, gold-flecked stationery sheet. The edge of the paper is curled back to reveal the stationery maker's stamp. A ripped and burnt page

from a book depicting decorative images on ink sticks adds a touch of auspicious wishes. One of the sticks displays an image of a bowl of pears. The reverse side features an expression that plays on the similar pronunciation of the words for pear, "li," and profit, "li."

The bottom row displays a variety of objects—a painted *bodhi* tree leaf illustrating a Buddhist story; a title page and table of contents from an eighteenth-century collection of supernatural stories—*Strange Tales from a Chinese Studio* (*Liaozhai zhiyi*) by Pu Songling (1640–1715); a brocade-wrapped cover of a book of calligraphy by the Ming artist Wen Zheng-ming (1470–1559); and a page from a book of seals belonging to Ruan Yuan (1764–1849), the highly respected Confucian scholar and official. This last object was not selected randomly by Sun. Ruan was deeply passionate about the history of writing and epigraphy and was a close associate of the monk-artist Liuzhou. The presence of this seal book not only demonstrates Sun's talent in representing yet another visual medium, but also indicates a relationship between Sun and epigraphy.

A second set of four vertical scrolls—also undated but also clearly from the same period—is held at the Museum of Asian Art in Berlin. At first glance, this set follows a similar approach—with a complete, upright, usually undamaged fan at the top of each vertical strip. Sun's superb ability to reproduce numerous calligraphic styles and scripts, rubbings, textures of silk and brocades, woodblock-printed matter, and even gold-flecked papers is evident. He adds another flourish in this second set, successfully imitating a photograph—depicting a Japanese woman, no less—with brush and ink.

In the early 1890s, while already in his seventies, Sun was either working in or at least spending his days at an art supply and fine printing shop in the heart of Beijing's art world.[18] Liulichang is a small street in the southern section of Beijing. During the

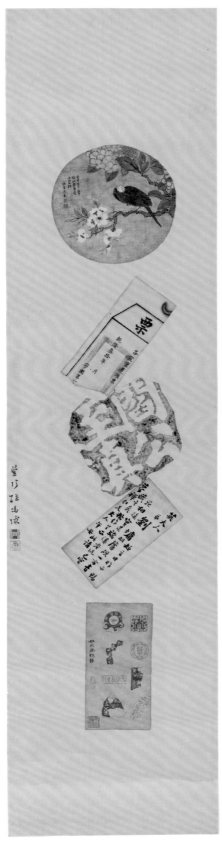

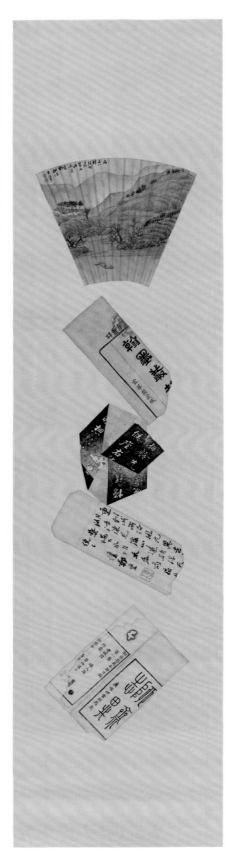

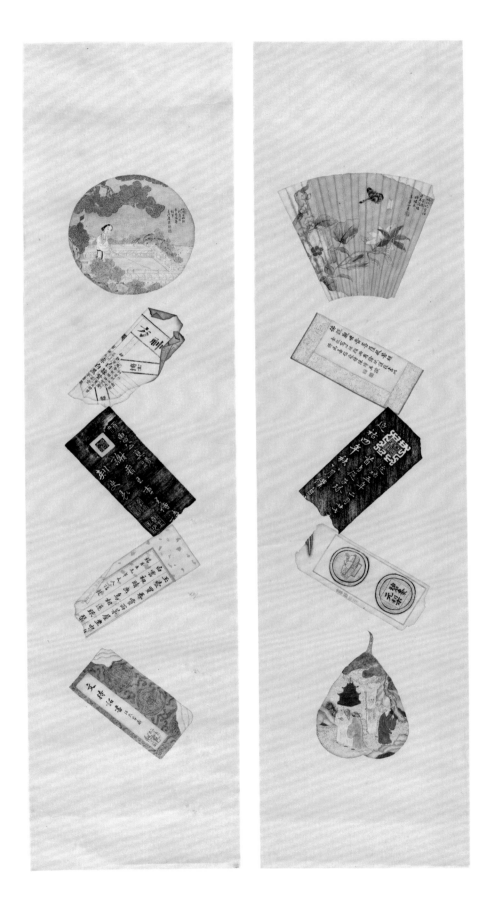

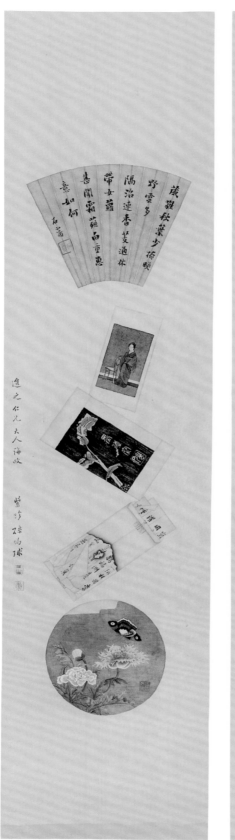
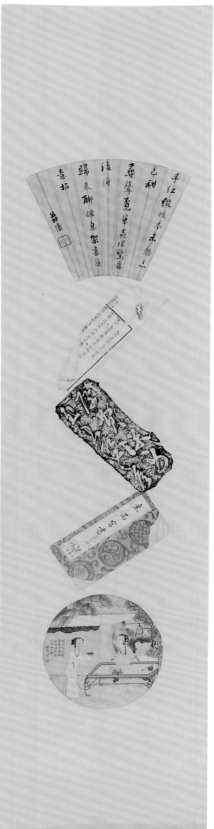

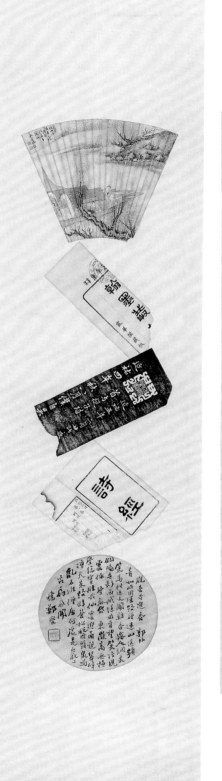
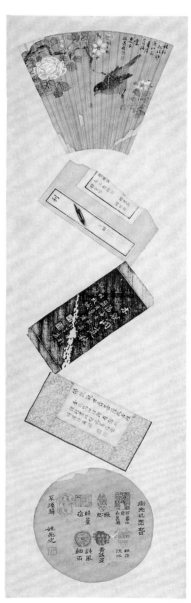

Yuan dynasty, kilns in this area manufactured the glazed roof tiles for the Forbidden City. By the Qing dynasty the neighborhood had been transformed. The kilns had moved and artists and calligraphers flocked to the district—which retained its old name, meaning "Glazed Tile Factory"—to purchase art supplies. Collectors and connoisseurs came to window-shop and acquire antiques, rare books, paintings, and calligraphies.

Sun's employment—or at least presence—on Liulichang would have offered him endless opportunities to experience works of art—both originals and reproductions. Older woodblock-printed books—as well as the new versions created by the recently imported technology of lithography—would have been available there. Discussions between the collectors, connoisseurs, and scholars wandering through Liulichang would have inspired Sun as well—helping him develop a new conceptually complex approach to composition. These influences were the raw materials for the next stage in his development as a leading bapo artist.

The images and texts Sun chose for his later works showed a serious interest in calligraphy, but also a passion for playing with composition. A number of his works followed a standard form—called *tiao*—that used vertical strips to mimic lacquer screen panels and calligraphic couplets. But he also started using images of rubbings to form frames, arranging objects into unexpected shapes, and included personal and art historical comments on the works he depicted.

The years 1892 and 1893 were among his most prolific and innovative. Two of his most dramatic experiments were round fans with the same name but radically different compositions. The composition of his *Picture of One Hundred Years* (*Baisui tu*), for example, created in the sixth month of 1892, mimics a common Chinese decorative feature that arranges four curved lozenges around the outside of

a circle, leaving a central open space. The shape is seen in gardens, window lattices, and patterns for walking paths. Intended to suggest a Chinese coin, with a hole at its center, it expresses a wish for prosperity. Sun has created the outlines of the lozenges from calligraphic "rubbings," which are in fact *yingta*, paintings of rubbings. A close look at these outlines reveals that Sun has generated the appearance of characters engraved in stone or bronze. Most likely he was imitating a line of characters found along the edge of a Han bronze oil lamp base.

In the right and left lozenges of the composition Sun has placed rubbings of calligraphic texts, demonstrating his intimate familiarity with the classic Chinese masterworks. The rubbing on the left is part of a text written by the great Song statesman, historian, poet, and calligrapher Ouyang Xiu (1007–1072). Ouyang Xiu was among China's most important commentators on the art of calligraphy. The text of the rubbing is a sentence from Ouyang's 1064 essay "Ba cha lu," an afterword to the 1049 *Record of Tea* (*Cha lu*), by his contemporary, the prominent calligrapher Cai Xiang (1012–1067). In his afterword, rather than discussing tea, Ouyang reviews the history of calligraphy. The quote selected by Sun, not surprisingly, is a reference to calligraphy: "It is not rare to see the calligraphy of Ouyang Xun [557–641], but small characters like his are hardly ever surpassed." The origin of the rubbing represented on the right side of the fan is currently unknown.

As in many bapo paintings, Sun has mixed his calligraphic interests with imitations of classical paintings and good wishes for the recipient. The round painting on the lower section represents a fan painting by the Ming artist Qiu Ying. Depicting children who are playing outdoors dressed in brightly colored drama costumes, and sporting the inscription "10,000 generations of sons and grandsons" (*zi sun wan dai*), the work is a classic example of the popular

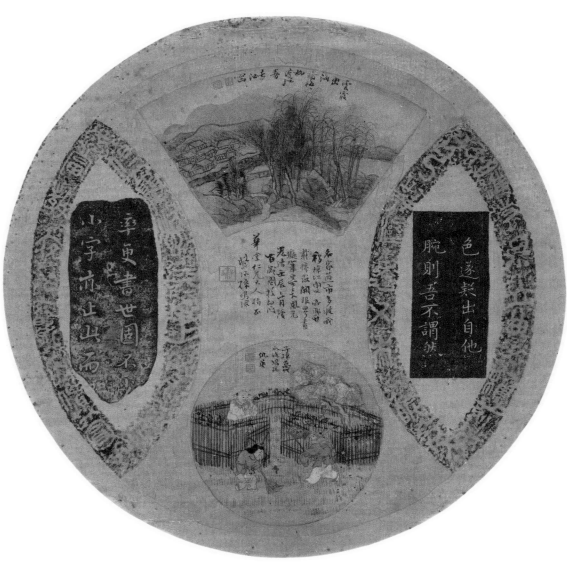

7

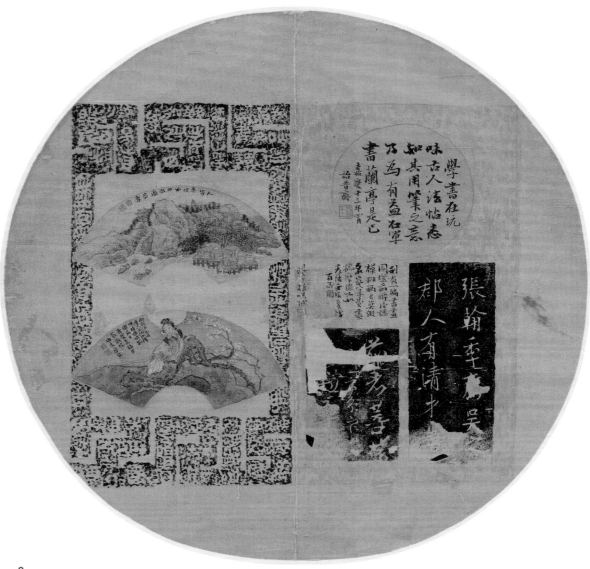

8

hundred-children theme with its implied wish for an abundance of heirs.

Sun might have found this image in one of the many painting manuals (*huapu*) that presented black-and-white line reproductions of famous Chinese paintings. Many of these were being republished lithographically during the late nineteenth and early twentieth centuries. For instance, the 1603 *Manual of Historic Famous Masters Paintings* (*Lidai minggong huapu*) included works by Qiu Ying and many other famous artists from the Six Dynasties through the Song, Yuan, and Ming periods. The Shanghai Hong-wen Shuju publishing house reprinted it lithographically in 1888. These painting manuals were not great scholarly volumes and did not necessarily present the authentic styles or specific paintings by the artists, but they would have served as excellent sourcebooks for bapo painters.

Again, in his pursuit of visual variety, Sun has placed a landscape fan painting on the upper portion of this work, which contrasts with the playfulness of the Qiu Ying. Inscribed "The clouds coming off the ocean," the painting depicts trees and rocks by a waterway in muted colors, with a village, mountains, and a setting sun in the background.

The central text in Sun's distinct composition is his inscription for the entire painting. The painting, he records, was done in Beijing, but he notes that "though there are many famous people in Beijing," going to the Jiangnan region had "opened his eyes." Jiangnan encompasses Zhejiang and Jiangsu Provinces—and such culturally sophisticated cities as Suzhou and Hangzhou—where the monk Liuzhou lived. Is it possible that he saw works in Hangzhou by Liuzhou or others that sparked his imagination, and inspired him to make his new, innovative compositions?

Also created in the summer of 1892, Sun's second *Baisui tu* fan presents a different kind of maze of interrelated objects and texts. Sun lays his objects out in an organized manner with almost no overlapping, with all of the texts and papers running vertically and parallel to each other. The right half of the painting includes two calligraphic works—one circular in shape and one square—along with two rubbings depicted as if all four were mounted together on a pale blue silk damask surround. The left half of the sheet depicts two fan paintings, one above the other as if mounted on a vertical scroll—with an unusual mounting created to look like a rubbing of ancient bronze or stone. On closer inspection, ancient seal-script characters can be discerned in this constructed yingta framing. The entire composition reveals an artist who is experimenting with aesthetics while also presenting a serious discourse about calligraphy and its history.

The yingta depicted on the fan's right side is a miniaturized replica of several characters from the famous rubbing *Zhang Han Model Calligraphy* (*Zhang Han tie*) brushed by the Tang dynasty historian and calligraphy master Ouyang Xun (557–641). The text tells the story of a talented and cultured general, Zhang Han of the Western Jin period (266–316), from the Suzhou region. The original calligraphy, once in the collection of the emperor Song Huizong, is now in the Palace Museum in Beijing, only one of four still extant ink examples of this master's writing. The similarity between the calligraphy in Sun's depiction of the rubbing and the original ink work reveals Sun's remarkable talent. While Ouyang's original calligraphy still exists in ink on paper, Sun elected to represent it as a rubbing of an old stone engraving of the characters. A chip in the stone, as Sun has depicted it, renders the fourth character illegible—implying that much time had passed between the engraving of the stone and the making of the supposed rubbing. On a rubbing done soon after characters had been incised in stone, all the characters would have been clearly discernible. By displaying only a fragment of the text, Sun suggests that even the rubbing is a cherished remnant of the past.

Reading the round-framed calligraphy work at the top right of the composition, the viewer begins to sense Sun's growing interest in the history and historiography of calligraphy. The miniature round fan carries the signature of a prominent cultured prince of late eighteenth- and early nineteenth-century Beijing, Cheng Zhe Qinwang Yongxing (1752–1823). The eleventh son of the Qianlong emperor, the bright and well-educated Prince Cheng was the brother of the Jiaqing emperor. Though he held various high posts in the government under his father, later tension with his brother (by then emperor himself) prompted the prince to leave the political sphere and devote his energy to calligraphy. He preferred writing in the style of the Yuan dynasty artist Zhao Mengfu (1254–1322) and the later style of Ouyang Xun. The calligraphy on Sun's painting is his copy of Prince Cheng's 1808 copy of a text from a commentary on the iconic fourteenth-century *Orchid Pavilion Preface* (*Lantingji xu*) by Zhao Mengfu. Zhao, in 1310, had come across and marveled at an old and superb rubbing of the *Orchid Pavilion Preface*. He wrote thirteen brief commentaries on it in just over a month.[19] The viewer of *Baisui tu* sees Sun's miniaturized late nineteenth-century copy of an early nineteenth-century copy of a fourteenth-century commentary on a fourth-century calligraphy.

The many stones inscribed with Prince Cheng's calligraphy—including his own version of the *Orchid Pavilion Preface*—are evidence of the respect given to his work during his lifetime. Rubbings of these inscribed stones were distributed as calligraphic study models. Such a rubbing may have been Sun's source for Prince Cheng's calligraphy. In keeping with Sun's complex approach, the excerpt he has selected from Prince Cheng's copy of Zhao's calligraphy is about the study of calligraphy. "To learn calligraphy," it says, "one must study the ancients' models; to understand the intentions behind the brushstrokes is even more beneficial." With his quotation of a

quotation of a masterwork, Sun confirms his personal dedication to calligraphy.

The square-framed calligraphy below Prince Cheng's work is Sun's formal inscription for his composition. It is signed by Sun himself, dated the summer of 1892. He titled the painting *A Picture of One Hundred Years* (*Baisui tu*). But Sun also presents a commentary on the practice of copying masterpieces. In his poetic inscription, Sun makes fun of both his own and Prince Cheng's attempts at copying:

> There is a scroll of painting and calligraphy;
> In front of the lamp, I am drunk and cannot recognize it.
> I advise you not to borrow a famous master's brush;
> Even if you make great efforts, your work can never be compared to that of a master.

The original Zhao Mengfu calligraphy that Prince Cheng had copied—and which Sun included above his personal inscription—was partially burnt in a fire in 1809, within a year of Prince Cheng's copying it. Only fragments exist today in the Tokyo National Museum, with, not surprisingly, an inscription added to the work by Prince Cheng.[20] Perhaps Sun knew about the fire and the damage to the treasure, and therefore included it in his *Picture of One Hundred Years*.

The two colorful folding fans depicted on the composition's left side are lighthearted and sharp contrasts to the restrained and erudite commentaries on calligraphy. The upper fan is a landscape painting signed by the artist Pan Gongshou (1741–1794). Why this specific artist? Perhaps because the first half of his given name, *gong*, means "respectfully," and the second half, *shou*, means "longevity." Including these words reinforces Sun's intention that his composition be a picture of one hundred years. The lower fan is a celebration of female beauty and a man's feelings for a woman. The work depicts a young woman with gold hair ornaments, sitting on a rock in a garden. The inscription, signed by the

celebrated Ming artist Tang Yin—also known as Tang Bohu (1470–1524)—includes a poem about the passage of time that Sun himself seems to have composed:

> With the muffled drum sounds, the clock shows
> the time is late;
> It is the time for the moon to brighten outside the
> handrail.
> Could the beauty Chang'e still remember her pre-life?
> Which branch of plum flowers are you transformed from?

Sun places these two birthday fan paintings as if they were mounted on a vertical hanging scroll, with the ingenious and inventive ornamental border constructed from a fretlike, wandering geometrical yingta strip of ancient inscribed characters.

These striking, intellectually vibrant, and radically innovative types of compositions must have made an impression on people with whom Sun came in contact on Liulichang. By 1893, within a year of completing these two round fan paintings, Sun was mingling with important scholars, government officials, and artists in Beijing.

From the dates on his works, we know that Sun was working well into his old age—the known works by him date from 1879 through 1903. In this, he followed a Chinese painting tradition that holds that an artist trains in conservative approaches for decades but may create something original, expressive, or even outlandish in his or her later years. This same route was taken by some of the great artists of the twentieth century—such as Huang Binhong (1865–1955) and Zhang Daqian (1899–1983)—who created their most mature and pathbreaking works in their eighties and nineties.

Sun lived through the great turmoil of the nineteenth century, but his intellectual pursuits—or his internal caution—kept him on a path more focused on traditional aesthetic discourse rather than bemoaning the loss of traditional culture. Sun's refined brushwork and unique visual flair garnered him a reputation that lasted over a century. He was also recognized in an early twentieth-century listing of artists, *Jottings from the Studio of Concealing One's Strength* (*Tao yang zhai bi ji*), and in the *Dictionary of Chinese Artists' Names* (*Zhongguo meishujia renming cidian*). As late as the 1980s, he was still known among elderly Beijing art dealers as the most famous artist of the bapo genre.

Sun's legacy continued beyond his lifetime. His works are in at least three museums outside China.[21] And he instilled at least one of his children with the skills and interests of this art. A recent biographical reference lists one of his sons, Sun Yumei, born in 1853, as an artist and bapo painter. An example of the son's work reveals that he followed quite closely in his father's footsteps.[22]

9

Unidentified artist
Horizontal painting with colored depiction of book pages, paintings, and calligraphy, 1900

Ink and color on paper, 68.6 x 132.1 cm (27 x 52 in.)
Anonymous gift in memory of William W. Mellins, 2017.27

This relatively large composition is dominated by an innocent-looking, partially burnt round fan depicting a goldfish.[23] The inscription on the fan carries a more ominous reference. The calligraphy tells us that the painting was done during the first third of the seventh month of the *gengzi* year—or August 1900. The Battle of Beijing, during which the allied forces of Great Britain, Russia, Japan, the United States, and France broke the siege of the foreign legations in Beijing, began on August 14 of that year. It ended with the empress dowager fleeing and foreigners occupying Beijing and the palace for over a year. The clash between the foreign troops and the patriotic Chinese Boxers resulted in destruction, looting, and carnage in Beijing and surrounding areas. An image of torn, burnt, and scattered papers would have been appropriate to depict the situation in Beijing at the time.

The artist—who does not sign his name—includes a few other reminders of Beijing. Most prominent is the *Jing Bao* in the upper left-hand corner. The *Jing Bao*, or *Capital Report*, was a bulletin that published imperial edicts and staff promotions.[24] The torn issue of *Jing Bao* in this work was no doubt intended to reflect the disintegrating situation of the imperial court and the occupied palace. A Chinese

reader of the painting would also have noticed two ink characters brushed onto red paper—*guo* and *fan*. Together they are the given name of the heroic general Zeng Guofan (1811–1872), heralded for his defeat of the Taiping Rebellion—which had devastated China between 1850 and 1864. Did the artist's inclusion of Zeng Guofan's name express a hope that a new hero would emerge to return stability to the country?

On the right-hand side of the composition is a formal report written in 1873 by an official who had just arrived at his new post in Chaha'er (now in eastern Inner Mongolia). He notes that the previous leader in Chaha'er had put down Muslim rebellions.

The artist scatters these subtle political messages among more common components of bapo paintings—such as rubbings of a Han stele, the ever-present calligraphy of Wang Xizhi, a number of other calligraphic references, and contemporary visual ephemera. There is a receipt from the Henghe financial institution, based in Beijing, and a page of writing in Manchu, the language of the Qing rulers, who were nearing the end of their reign. This ability to contain—and convey—multiple levels of meaning within a single visual artwork was one of the great appeals of the bapo form.

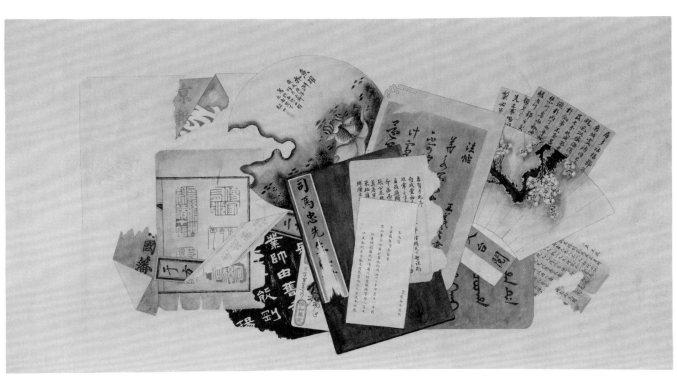

9

Zhu Wei (1836–after 1908)
Vertical scrolls with rubbings and printed book pages, 1908

Ink and color on paper; set of six hanging scrolls, each: about 166 x 43.5 cm (65⅜ x 17⅛ in.)
Anonymous gift in memory of William W. Mellins, 2017.6.1-6

The artist Zhu Wei (style names Yilou and Yisou) hailed from the village of Huogang outside Huzhou in Zhejiang Province, halfway between the two great cultural centers of Suzhou and Hangzhou.[25] He came from an educated level of Chinese society, was passionate about China's scholarly traditions, was skilled and knowledgeable in artistic and scholarly manners, and surely, at the turn of the century, was nostalgic for a time when the literati lifestyle was still flourishing. Throughout his adult life, he tells the viewer in an inscription on this work, he collected what he could of China's great cultural past. A man of a prominent literati ancestry—and a proud descendant, at that—Zhu Wei often marked his paintings with a seal reminding any who might take note that he was a twenty-fifth generation descendant of the illustrious Song dynasty Neo-Confucian scholar Zhu Xi (1130–1200).[26] Despite this remarkable pedigree and what he demonstrates was a solid classical education, Zhu does not seem to have passed the civil exams.[27] Passing the exam would have guaranteed him a position as an official in the government, the most respected and desirable occupation in Chinese society. Like many others who failed, he pursued work that could both make use of his acquired classical knowledge and offer some income. In 1877, the well-educated forty-plus-year-old Zhu took on the responsibility of editing an updated Huzhou Zhu clan genealogy.[28]

He was probably also selling paintings to bring in income. The earliest known paintings still extant by Zhu Wei are finely limned landscapes.[29] Monkeys inhabit all of his mountain scenes. These simians are a traditional Chinese rebus promising promotion to become a government official. Were the monkeys perhaps an echo of Zhu's desire to pass the civil examinations?

What Zhu painted in the intervening years or how he busied himself is as yet unknown. But by the time he reached his seventies—in the early years of the twentieth century—he was creating bapo paintings. These paintings reveal a skill that could only have come from years of painting and a thorough knowledge of centuries of classical literature, calligraphy, and art.

At least two other bapo works by Zhu Wei predate the six-scroll set.[30] Both are folding fans. The fans were created in 1905 when he was sixty-nine years old and in 1907 when he was seventy-one.[31] He began the mammoth project of this hanging scroll set in 1908, at the age of seventy-two, as a birthday present for a friend or associate.

The six scrolls reveal a controlled and restrained, but lively, line, which is at once personally expressive and at the same time naturalistically effective. The elements include elegant drapings of deteriorating calligraphies, rubbings, book pages, and prints flowing over the paintings' surface, with each painting displaying its own unique rhythm.

Revealing his literati sensibilities, Zhu uses black ink to outline all of the forms in his painting and as the primary "color" on the paper's surface, with a few red cinnabar characters or rubbings, and occasional subdued washes or colored details. Calligraphy, in all its various guises, is the principal focus of the images depicted. There are traditional rubbings and works of calligraphy, supplemented with what seem to be contemporary calligraphic objects, such as luxuriously decorated multicolored stationery and envelopes with handwritten addresses and letters; calligraphy practice sheets and printed books with a few fine well-placed illustrations. The general effect of these calligraphy-focused paintings is the depiction of an elegant literary lifestyle.

The viewer of these paintings encounters a vast range of objects, almost all with some connection to calligraphy. And all of which the scholarly Zhu Wei—he reports in an inscription—collected himself. "For fifty years, I have toiled to select the best of these broken pieces." There is a rubbing of characters carved in a rare relief style from a Northern Wei (386–534) stele recording the dedication of statues at the Longmen Buddhist grottoes site in Luoyang in the year 468.[32] This stele's sturdy and vigorous calligraphy quickly became a model for calligraphers to study and emulate. Educated viewers looking at Zhu's painting would have immediately recognized the powerful square brush style of the characters that distinguishes this work. Zhu's educated viewers would also have appreciated his inclusion of a page from a dictionary of tadpole (kedou) script characters used during the Zhou dynasty, with "translations" into regular script. A rubbing of calligraphy by the renowned Deng Shiru (1743–1805) from the eighth year of the Jiaqing reign (1803) would have offered an extra intellectual puzzle for the educated and curious viewer. Zhu includes only the signature section of the Deng Shiru calligraphy, done in running script. The larger original work to which this

signature was attached was Deng's seal (zhuan) script rendition of a text written by Zhu Xi, Zhu Wei's ancestor.[33] The hidden self-reference—for the knowing few—certainly had to have been intentional. There is also a rubbing of calligraphy by the less well known Ming calligrapher Huang Ruting (1558–1626). The rarity and obscurity of this last work suggests that Zhu *had* collected the originals of these objects—as he claims in his inscription—and was not merely looking at reproductions in a book. Zhu reveals his deep scholarly sensibilities with the pointed inclusion of a specific page from a woodblock-printed edition of *Three Hundred Tang Poems* (*Tang shi san bai shou*). The book is the best-known and most frequently reprinted poetry book in China—and often appears in bapo paintings. Zhu chose to depict a page with a classic huaigu—"yearning for the past"—genre poem—*Stone City* (*Shitou Cheng*) by Liu Yuxi (772–842):

> The site with surrounding hills still remains;
> The tides pound the hollow city and return
> disconsolately.
> To the east of Qinhuai River, the same moon of
> old times.
> In the depth of night, stillness rises over the ramparts.[34]

The subject matter and atmosphere of such huaigu poems resonated with bapo paintings.

Zhu also includes numerous references to the great Song dynasty poet, scholar, artist, art theorist, and father of literati thinking Su Shi. Su was the first and ultimate literary scholar, who was emulated by all later followers of the literati tradition. Here, near the top of one scroll, is a ripped and folded page from the preface of a rare edition of Su's poetry, *Commentaries on Dongpo Poems* (*Zhu Dongpo shi*).[35] There is also a page from the book *Thematically Arranged Manuscripts from the Western Pond* (*Xi pi lei gao*) with comments on Su Shi's poems written by the famous

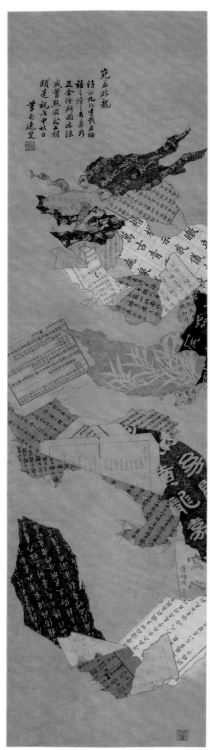

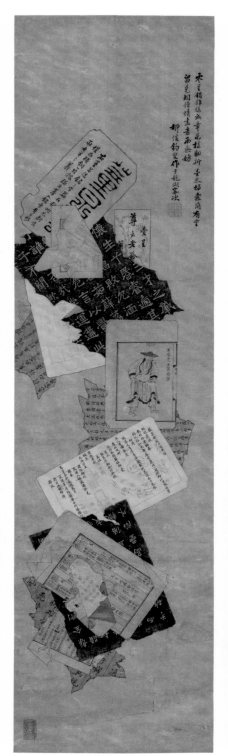

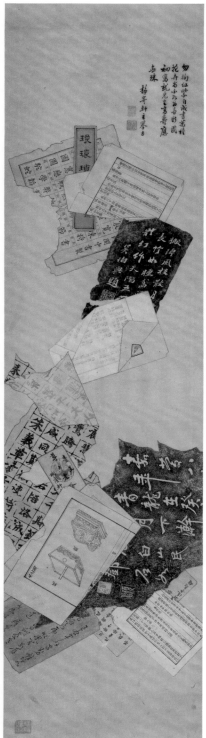

10

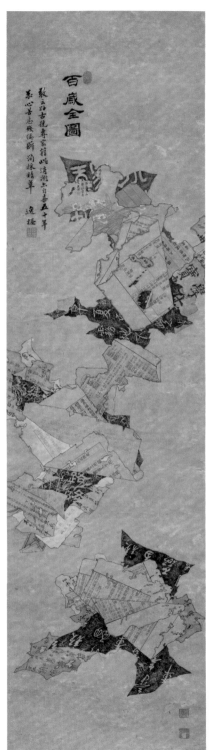

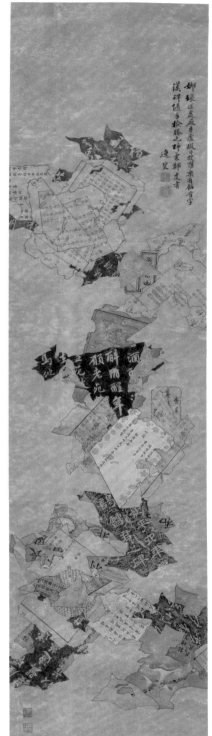

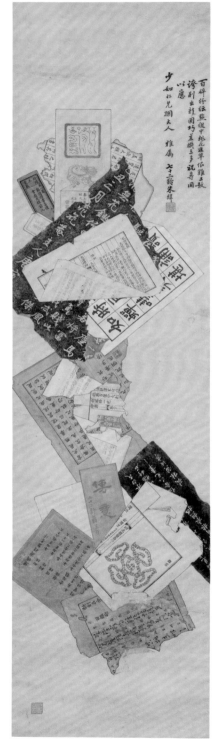

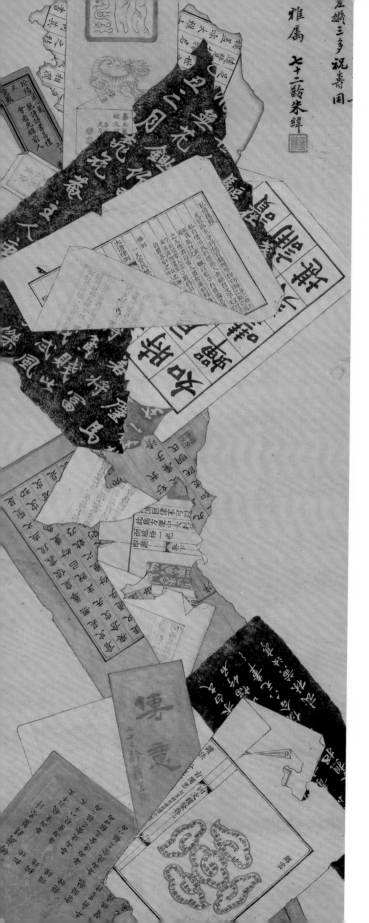

Kangxi-period collector Song Luo; and a page from a chronology of Su Shi's life—with a woodblock-print illustration of the great scholar in a straw rain hat and clogs.

For an intellectual fond of wordplay, the artist also depicts pages from the book *Types of Revolving Poetry* (*Huiwen leiju*), displaying a Chinese form of concrete poetry. Traditionally considered to have been invented by the fourth-century poetess Su Hui, who was pining for her distant husband, *huiwen* were composed and published through the centuries. Several published huiwen collections came on the market in the nineteenth century, and they appear in a number of bapo paintings by different artists. The literary play with characters in these poems is reminiscent of bapo paintings—and it's not surprising that bapo artists were attracted to them.

Veering from the scholarly and poetic into a more private and intimate realm, Zhu also displays a personal letter. The missive concerns a celebratory banquet and is no doubt a subtle reference to the festivities the painting's recipient deserves for his birthday. To further enhance the message of the letter, Zhu has chosen to depict it as if written on fine multicolored, woodblock-printed stationery, decorated with seal (*zhuan*) script characters from ancient epigraphic inscriptions—and drawings of ancient Shang and Han coins. This seemingly scholarly presentation provides another wish for the recipient, for prosperity.

Zhu additionally depicts an envelope with a decorative motif that copies a rubbing of a Han roof tile depicting a goose (*yan*) accompanied by the two characters *yan*—meaning "to extend," and with the same sound as the word for "goose"—and *nian*, meaning "year," suggesting a wish for longevity. There is also a fortune slip from a temple, with the markings *shang shang*, meaning "top, top," indicating the best of fortunes, with a notation stating that familiarity with the classics will bring honor to the

recipient's ancestors; and an envelope sent by a seventy-two-year-old man (perhaps Zhu Wei himself, who was seventy-two at the time), inscribed with two characters, *chuan* and *yi*, meaning to "transmit meaning," written in red ink. Red is the symbol of happiness, and red characters on an envelope indicate good wishes or important news. Here the characters were probably a reference to the birthday wishes being conveyed to the painting's intended recipient.

Zhu Wei does not exclude contemporary life from his calligraphic musings. He depicts a Qing legal work with texts about monetary loans. There is also a price list of various types of liquid ink. Chinese ink had traditionally been sold in solid sticks that the calligrapher or artist ground on a stone with water to create liquid ink. This far more convenient liquid ink came on the market in the mid-nineteenth century. Here Zhu Wei combines his scholarly leanings with the expediency of modern life.

Through the inscriptions and seals Zhu placed on the paintings, he communicated even more of his thoughts, perceptions, and sense of self. The inscriptions on the scrolls inform the reader—and the recipient—that the paintings were produced as birthday wishes, but also expressed time-honored literati reverence for scraps of calligraphy. Together they portrayed an avid enthusiast for calligraphy, amused by wordplay, willing to accommodate his workmanship to wishing good fortune, and delighting in the freedom to experiment with a new visual and—poetic—art form.

The title of Zhu's series is *The Complete Picture of One Hundred Years* (*Baisui quantu*). Though almost eight decades had passed since Liuzhou created his rubbing masterpiece *Baisui tu* (see fig. 1) there is a possibility that Zhu Wei had seen the work and been inspired by both the title and the concept. A native of Huzhou, Zhu lived only thirty miles from Hangzhou, where Liuzhou had created his work—and where it remained in a collector's hands.[36] In case Zhu's

viewers did not immediately recognize the title's pun on the word *sui*, Zhu assists them with an inscription on another part of the set. He begins this second inscription with characters also pronounced "bai sui tu," but uses the *sui* character that means "fragments," instead of the *sui* meaning "years." The inscription continues to offer good wishes:

> One hundred broken fragments decorate the atmosphere;
> Like neither painting flowers nor grasses, it is difficult to perfect.
> All one can do is take pride in painting cleverly and meticulously,
> And hope to equal the three wishes for good fortune [*fu*, *lu*, and *shou*] in presenting these birthday greetings at the request of my brother-in-law.

Another inscription repeats the good wishes: "My poetry strives to wish that you achieve all you desire; whether you read or chant them, they will bring you longevity."

Zhu Wei also exposes his sheer delight in creating the compositions of ancient calligraphic fragments. The sincerity of that joy can be seen in the meticulousness of the painting as well as the inscriptions:

> Intricate objects in deep spaces brighten my little thatched cottage;
> In my leisure time, I collect these little things to amuse myself.
> Jin calligraphy, Han steles, I pick up the best little pieces.
> They are even finer than the calligraphy of Zheng Qian who wrote on persimmon leaves.
>
> Dare I claim that I am a specialist in antiquity?
> I only do this to pass the time and please myself.[37]

11

Yuan Runhe (1870–1954)
Picture of Obtained Flaws, 1926

Ink and color on paper, 30.5 x 56 cm (12 x 22 in.)
Anonymous gift in memory of William W. Mellins, 2014.1967

12

Yuan Runhe (1870–1954)
Vertical scroll with round fan painting, envelope, letter, book cover, and rubbing, 1926

Ink and color on paper, 77 x 36 cm (30¼ x 14⅛ in.)
Anonymous gift in memory of William W. Mellins, 2014.1966

A strong foundation in Chinese traditional arts and culture did not prevent the artist Yuan Runhe (courtesy name Defu) from recognizing the integration of modern international lifestyles into daily life. Trained in Chinese classical studies well enough to have passed the provincial military exams during the Guangxu era (1875–1908), Yuan Runhe also had, his paintings reveal, a solid understanding of Chinese art history.[38] The downfall of the Qing dynasty in 1911 most likely led to Yuan's lack of participation in government—and the subsequent development of his painting. Records note that in addition to bapo, he also painted birds and flowers. A small hanging scroll of birds on a flowering branch and a distinctive figure and animal painting survive, providing evidence that he worked in the flamboyant Shanghai style of painting.[39] His bapo paintings, however, expose his desire to go beyond more conservative artistic conventions, to embrace the contemporary, with surprise and even humor.

Yuan's interest in the life around him rather than mourning the past is evident in his clever and conceptually tight creation of a fan. Painted in 1926 for a Mr. Dong Yusheng, it is titled *Picture of Obtained Flaws* (*De que tu*). It depicts personal letters, a broken fan painting, envelopes, and a book title slip. With this work, Yuan has moved beyond the purer focus on calligraphy and calligraphic history seen in many bapo works. He constructs a fun, if somewhat mysterious, narrative—definitively taking place in his own time.

To understand this narrative, the viewer would have to inspect the five objects depicted in the fan. On the left is a token bapo nod to epigraphy, a title slip for *A Pure Compilation of Epigraphy* (*Jin shi cui pian*). To its right side are a number of nonhistorical items: First, an envelope addressed to Dong Yusheng, "from Zhang Yushan," and a notation that it contains one fan painting and one fan bone. Next, there is part of a torn letter, obstructed by the envelope, which reads, "Mr. Yusheng, my dear brother [a term of address to a male friend who is younger], thank you for giving me [...] I don't know how to return [...] I am living in a place so remote that even though there are local specialty products, they are not up to the standard that I would want to offer you. But desiring to do me a favor, a friend of mine, our famous local painter, painted this 'ten broken' fan. It is rather nice to look at. He also engraved the fan bones, which are of good quality. I love it but I give it up for you. This

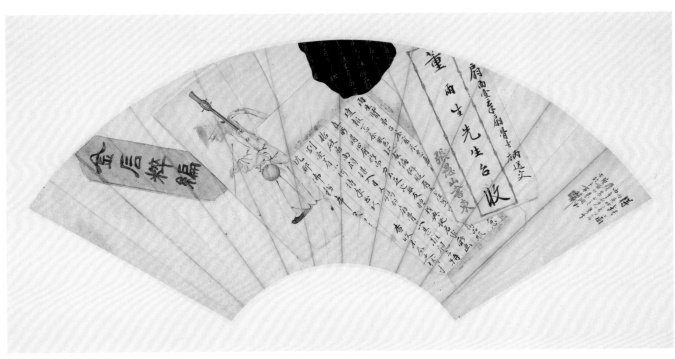

11

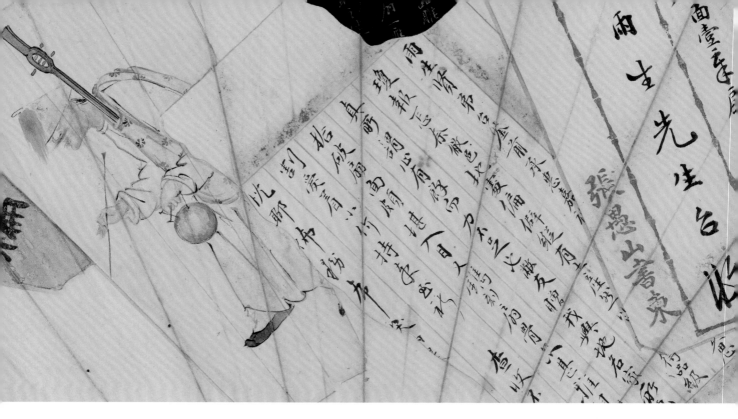

young man will bring it to you. Please examine it as it represents a little heartfelt gesture from me to you. [. . .] Hoping [. . .]." There is also the torn vestige of a fan painting that depicts a blind beggar musician carrying a stringed instrument, a gong, and a stick. And there is a fragment of indigo-dyed paper inscribed with gold calligraphy, a medium usually employed for Buddhist sutras, but here the text consists of multiple instances of the character for "fan."

The depiction of these objects raises questions for the reader-viewer. The letter is torn; the fan painting of the blind beggar musician is tattered. What happened to the envelope and its contents? Did the young man carrying the letter drop it on his way? Did he encounter some unexpected disaster? Is the fan painting of the musician the *shipo* (or "ten broken") fan referred to in the letter? Or is it the entire fan painting set before us by Yuan?

The letter becomes a secondary inscription to the painting itself.

Our questions continue: What did the generous Mr. Dong do that inspired the sender to offer this gift? Yuan seems to reflect on the situation and includes an explanation. The story is expressed through two objects: the book title slip inscribed on gold leaf paper and the fan painting of the blind man. *A Pure Compilation of Epigraphy* was published in 1805 and edited by Wang Chang (1725–1806).[40] It records more than 1,500 pieces of ink rubbing from inscribed metal, stone, and clay objects from the Xia, Shang, Zhou, and Song dynasties. Many of the objects included in the volume are fragmentary—and Yuan's message can be interpreted to mean "even though all that remains are fragments, they are still precious."

This thought is echoed in the image of the blind beggar musician. The term *que*, "lacking," in the painting's title could also refer to this man, who is lacking

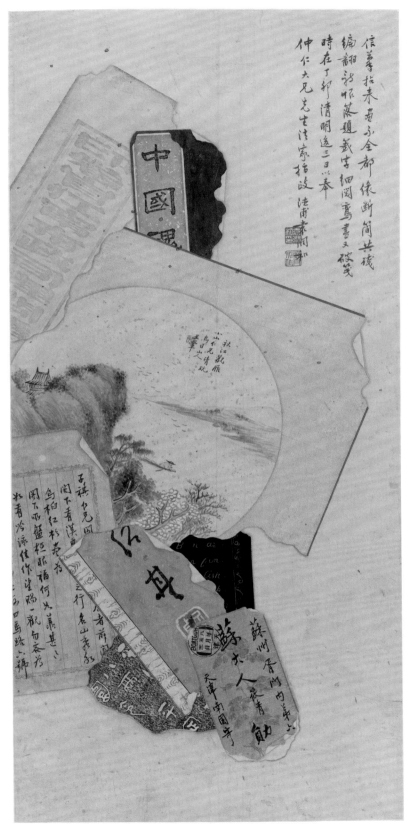

sight. This portrayal of a blind musician is the second instance in a bapo painting. A likeness of a blind musician, within an oval frame, is among the calligraphies, rubbings, and paintings in the bapo fan painted by Xi Rui in 1895 (cat. 13). The repetition of this image signals an intentional symbolism worth deciphering. Why are there paintings of blind musicians within bapo paintings?

Both bapo and blindness are associated with comprehending visual reality. One element of bapo painting is deception—a trompe l'oeil—a trick on the eye. In China, it was commonly believed that the blind man "sees more clearly." Bapo expresses an appreciation for the beauty and significance of seemingly decrepit objects. The inscription on the painting within the Xi Rui fan painting includes the saying *yen an xin ming*, "though the eyes are darkened, the heart is clear." The blind man, who we believe cannot "see," actually grasps the truth more immediately than those of us with visual abilities.

Looking at a bapo painting, the viewer first assumes he or she is looking at a pile of rubbish, and only on closer inspection realizes that these are remnants of cultural jewels. The message therefore is that the object, or person, with damage or impairments may be purer, or closer to the truth, than that which is whole. The Chinese expression *que xian mei*, "the beauty of the defective," is echoed in the title of this painting, *De que tu*, as well as in the painting of the blind musician.[41]

One further question the reader—as the viewer has now become a reader—may ask is, "Who was Dong Yusheng?" A number of works from this time in private hands include inscribed dedications to a Mr. Yusheng.[42] Many are by prominent Chinese artists, among them Zhang Daqian, Wu Hufan, Chen Shizeng, and Qi Baishi. Though Dong's identity is not known conclusively, he clearly was an enthusiast of the contemporary art of his time, a man with cultivated taste. He may be the same Dong Yusheng recorded

as an important collector of woodblock prints in Beijing.[43] It is possible that Yuan was requested by a client, most likely Zhang Yushan, to paint a work for Zhang's friend Dong Yusheng. Yuan was then cleverly able to work the history of the presentation into the context and content of his painting. Surely, Yuan and Zhang, and eventually Dong, all had a good laugh over the artist's wordplay, surprises, and ingenuity.

Yuan refers to his works as *shipo*, "ten brokens," rather than bapo, "eight brokens." Yuan's choice of the number ten, instead of the more auspicious eight, demonstrates a preference for intellectual wordplay rather than merely conjuring up good fortune. His *shipo* term is a visual-verbal pun, as the character he employs for "ten" has two meanings. The Chinese writing system has two sets of characters for the numerals one through ten. There are the simple numerals for everyday use, and a set of more complex, many-stroked characters used in legal documents so that prices cannot easily be forged. Instead of the simple version for ten, Yuan uses the complex form, which coincidentally has a secondary meaning of "to pick up." Thus, Yuan's epithet for bapo means both "ten brokens" and "picking up brokens."

Yuan's bapo paintings demonstrate a charming sense of design narrative. In his hands, the bapo motif was no longer just a medium to express melancholy or a way to wish for longevity or good fortune. Instead, Yuan, mixing ancient and contemporary objects, amused himself by creating visual puzzles to be solved by his viewers. For example, within the dynamically balanced composition of this hanging scroll, Yuan presents several easily recognizable classical artworks, including the round fan painting of fishermen signed by the eminent Qing artist Wang Hui (whose work, so familiar to most Chinese, is reproduced in many bapo paintings [see cat. 3]), the gold-flecked title slip of a book on the Wei dynasty, a ripped-off corner of calligraphy by He Shaoji, a rubbing of ancient calligraphy—and an official

government-issued document. A letter asks about recent travels and whether the recipient wrote poems about the sites visited. In his inscription in the top right-hand corner, Yuan includes the nostalgic expression *duanjian canpian*, referring back to the destruction of classical texts by the Qin emperor in 213 BCE, but he does not restrain himself from reflecting on the contemporary lifestyles surrounding him in 1927.

A dark indigo paper scrap tucked behind the other objects reveals a foreign language written in Roman lettering. The letters seem to be randomly selected by Yuan and do not appear to be in a specific language. Despite his possible lack of knowledge of foreign languages, Yuan tries again to show off his ability to render Roman letters on a decorative envelope addressed to a Mr. Su in Suzhou. The envelope has a cancellation stamp from Tianjin dated the twenty-first day of the fifth month of the eighth year, 1919, with the additional word *boatguh*. Cancellation stamps on Chinese envelopes at this time included Chinese dates—along with city names written in Roman letters—listing the postal towns through which the envelope had passed. The "boat-guh" letters, perhaps intended to mean "gunboat," don't make sense. Like the nonsense lettering on the indigo paper, this "boatguh" text seems to be only a pretense—Roman letters for the sake of appearing foreign and modern.

Yuan continued to work on his mastery of foreign scripts. Dominating a painting he did in about 1948 is a fragment of a painting depicting a finely sketched grasshopper on a grass strand that bends over small blossoming flowers.[44] The painting-within-a-painting was mounted on a pale blue, patterned damask fabric that Yuan has lovingly drawn thread by thread. The figure is surrounded by rubbings of various script types, book covers, handwritten pages, a title slip for a Qing dynasty Hunan provincial government document, and a book title slip poignantly dated 1911—the year the Qing government was overthrown. To this pile of somewhat traditional Chinese cultural items, Yuan has added an envelope written in Roman script letters, addressed to a "[?]hao Xa Chien" at "[?] College" from a "C. L. Chai" at "40 Rue de Bource, Paris, France." The spelling mistake—"de Bource" instead of perhaps "du Bourse"—is still an improvement over the earlier nonsense writing. (Another painting by Yuan includes the same envelope with the recipient's address more clearly exposed. The location was Nanyang College in Shanghai, which after 1938 became known as Jiaotong University.) The desire to include foreign elements, even though the artist was far from an expert, again divulges the fashion for imported culture at the time and the potential of bapo—with its radically different aesthetic—to encompass the new.

13
Xi Rui (dates unknown)
Mounted fan with miniature works, 1895

Ink and color on silk, 31.8 x 58.4 cm (12½ x 23 in.)
Anonymous gift in memory of William W. Mellins, 2017.26

The orderly composition of this 1895 birthday fan by an unidentified artist calling himself Xi Rui is reminiscent of the multi-image screens and wall paintings of the seventeenth and eighteenth centuries. All of the objects are oriented vertically, without bending, tilting, or overlapping. Moreover, they are primarily whole and undamaged in appearance.

Though the work is reminiscent of the earlier compositional type from which bapo developed, the artist of the fan was also clearly aware of the bapo theme and its conventions. Most poignant is the oval-shaped painting of the blind beggar musician. In the inscription on that painting, the artist has written, "From midnight to noon and from sunrise to sunset, he follows along the street tapping his stick. Though the eyes are darkened, the heart is clear." The message resonates with one of the key concepts of bapo—the superiority of the damaged. This motif of a blind beggar musician appears in yet another bapo fan created three decades later (cat. 11).

Among the nine works that Xi Rui re-creates for his recipient of, as his inscription indicates, fiftieth birthday wishes are two works referencing China's most famous work of calligraphy, *Preface to the*

Collection of Orchid Pavilion Poems. Xi Rui does not simply present a rubbing of the original calligraphy. Instead, he depicts a rubbing of a preface written by the fifth-century official and poet Wang Rong (468–494) for poems written on the occasion of a later Spring Purification Festival poetry gathering in the year 491.[45] Xi Rui selected the easily recognizable words "the third day of the third month" to refer to the great original masterpiece. He reminds his hopefully educated-enough viewer again of the *Orchid Pavilion Preface* with a second rubbing of characters that reads: "The 28 lines are as everlasting as heaven and earth." Those "28 lines" refer, as well-educated viewers would also know, to the original twenty-eight lines of Wang Xizhi's text.

The *Orchid Pavilion Preface* was an icon of the respected scholar in Chinese society for hundreds of years. The persistent presence of this calligraphic masterpiece in bapo paintings is not only testament to its lasting influence on Chinese culture, but also an indication that among the middle-class patrons of bapo the aspiration to show off their scholarly knowledge was far more important than displaying wealth.

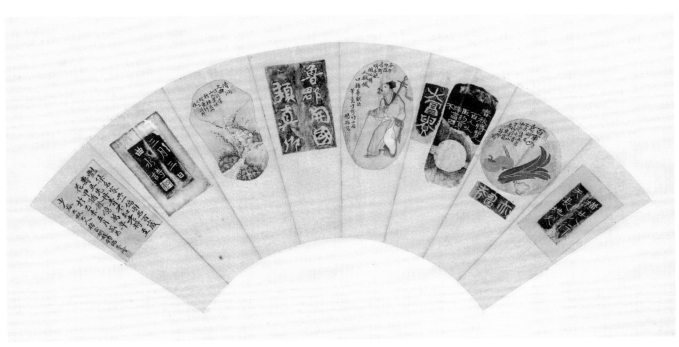

13

Chen Bingchang (1896–1971)
Willing to Reside in a Shabby Alley, 1945

Ink and color on silk, 64.6 x 61.1 cm (25⅜ x 24 in.)
Anonymous gift in memory of William W. Mellins, 2017.19

Chen Bingchang was born with only a thumb and one finger on his right hand. Never one to avoid the issue of his appearance, his self-selected literary names were Erzhi, meaning "two fingers," and Yingwu, meaning "should be five." Chen came from a well-to-do and cultured family. His father was a poet and calligrapher, and Chen developed a passion for writing and painting.[46] Determined to pursue his artistic ambitions, he trained his left hand to execute fine and controlled brushstrokes. He seemed to personify bapo—damaged but superior.

After graduating from a normal college, he returned to his hometown to continue studying painting, calligraphy, and seal carving with respected local artists. He excelled at bird and flower paintings as well as *bogu*—depicting ancient bronzes, coins, and other antiquities. But bapo painting became his specialty. Considered a lettered man in his community, he eventually became a leader in his town.

The small fan, probably created at the height of his talents, demonstrates the focus, skill, and sensitivity he devoted to his work. It is dedicated to Ju Zheng (literary name Meichuan, 1876–1951), a prominent official in the Republican government—in celebration of his seventieth birthday. By 1945, Ju had experienced a significant political career. He passed the imperial provincial exams in 1900, before the Qing dynasty had fallen. Then, to further his studies, he went to Japan, where he joined the Chinese United League (Tongmenghui), a group started by Sun Zhongshan (Sun Yat-sen). Later, Ju was involved in organizing the Wuchang Uprising, which would lead to the fall of the Qing government. After the 1911 revolution, he was an important member of the Republic of China government, and eventually rose to be president of the judiciary.

The painting depicts a page from a book of seals, book title slips, and a rubbing of regular script—and carries an inscription placed by the artist across the top left side of the fan. Chen does not refer to Ju's civic contributions, but instead plays with his surname, inserting the character *ju*, meaning "to reside," repeatedly throughout the painting. A book title slip—blue with gold flecks—includes the name Ju zhu xuan (in regular script)—referring to "The Bower of Residing among Bamboo," the studio name of the Yuan dynasty poet Cheng Tinggui. Another title slip (this time in grass script) is for the 1868 book *The Records of Works* (*Ju ye lu*), edited by Hu Juren. A sheet from a printed collection of seals is open to a page that shows two four-character seals. One is inscribed "jin qing xian hou"—referring to the evolution of the surname Ju and the genealogical origins of Ju Zheng's family.[47] On the left side of the fan, a scrap of a rubbing partly displays the characters *ju zheng* and a part of a seal. The seal reads, "Mei chuan ju shi," or "The Scholar Residing by the Mei River"—an alternate literary name for Ju Zheng (Ju Zheng who

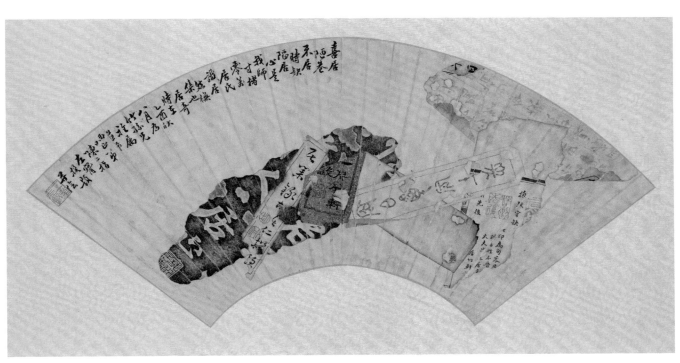

14

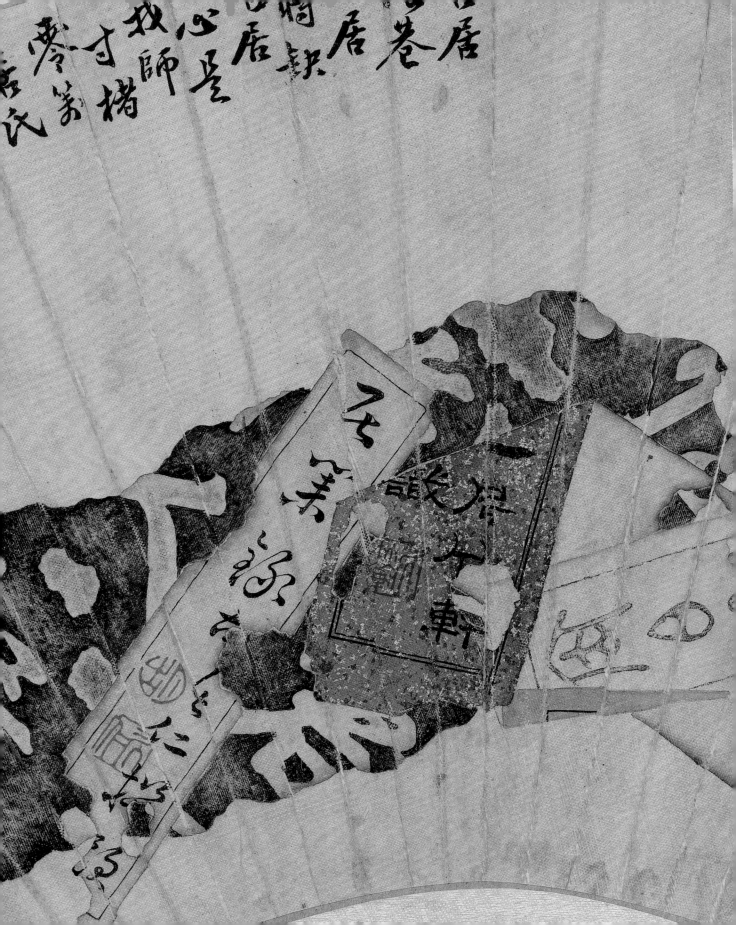

came from the Mei River region). Chen also employed the character *ju* repeatedly in his poetic inscription.

In addition to the incessant puns on Ju Zheng's name, Chen squeezes in a subtle reference to bapo painting. Like other bapo inscriptions, it reflects on the artist's preference for humble surroundings and connections with masters of the past through scraps of their works. A seal in the seal book reads, "bao can shou que." The characters literally mean to "protect the damaged and keep watch over the deficient," an expression that implies the cherishing of broken and worn-out things. Used as early as the Han dynasty, the saying came to indicate an old-fashioned, conservative attitude. Here, Chen uses it ironically as a reference to bapo painting—and its principle of saving cherished bits of the past.[48]

The clever word- and character play aside, this fan stands out for its exquisitely crafted brushwork. Each object is delineated without any obvious ink outlines, in a style known as *mogu*, or "boneless." Chen achieves a delicate effect by pooling colors at the edges of the papers instead of defining them with ink brushstrokes. The result is an intimate work with a uniquely soft texture and effect.

Though we are fortunate to know the recipient of this work, the fan leaves us with an important unanswered question. The inscription dates the painting to the eighth month of the *yiyou* year, which would have been about mid- to late September 1945. How did Chen, who was living in his home village (outside Taizhou) at the time, encounter this powerful official just a month after the end of World War II? The Japanese had surrendered in August 1945 (the official ceremony was September 9 in Nanjing) and by mid-September were withdrawing from China and Taiwan. It would make sense for Ju to travel back from the temporary capital of Chongqing in western China to the newly liberated capital of Nanjing. For the moment, we can only speculate that Chen Bingchang also visited the capital—less than a hundred miles from his hometown—where he met someone who needed an appropriate birthday gift for an official. Just as the Taiping Rebellion may have first instigated the bapo theme, perhaps the ruins of the historic capital city inspired a gift depicting treasured scraps.

Chen's cultivated background and perhaps his local leadership earned him a jail sentence after the 1949 revolution. In the years that followed, he primarily kept to himself, writing poetry about his home village and a book on the local dialect. Unfortunately, according to an online biography, his surviving family members no longer own any of his work, and though his specialty was bapo painting, no other bapo paintings of his have surfaced.[49]

15

Wu Zhuohua (1873–1941)
Scrolls made for the Hua Yuan Da Bao company, late 19th–early 20th century

Ink and color on paper, each: 147 x 39.7 cm (57⅞ x 15⅝ in.)
Herbert F. Johnson Museum of Art, Cornell University
Acquired through the Membership Purchase Fund, 84.077.001a,b

According to the inscription, these two decorative scrolls, displaying colorful paintings alongside more staid calligraphic works, were created for the company Hua Yuan Da Bao. A commercial artist, Wu made a living from his art, selling primarily bird and flower paintings influenced by the vivacious and colorful Shanghai style, and by running a school of painting and poetry in his home region of Guangdong Province.[50]

Though taken as a whole the painting does not communicate grief for the loss of ancient traditions, the artist does include a few allusions to this critical component of bapo painting. For instance, partially hidden behind book title pages and a shop receipt for silk is a calligraphic rubbing of a well-known poem filled with mourning for past glories.

The artistically inclined Li Yu (937–978) had become emperor of the Southern Tang state in 961, but lost his dominion to the expanding Song dynasty in 975. In the last years of his life, living in captivity, he wrote poetry reflecting his deep grief over the loss of his kingdom. Wu's bapo includes his most celebrated poem—one easily identified by most educated viewers. Just by seeing several of the characters,

many viewers would have been able to recite the poem's most famous lines: "I cannot bear to remember the bright moon of the old country. . . . How much sorrow can one man bear? As much as the water in a river flowing east during the spring."[51]

Other classical and literati elements are scattered throughout the primarily decorative work. There is the title page from an 1885 reprint of the *Four Books* (*Si shu zheng wen*), the classic Confucian texts studied by every Chinese scholar—dispensing the moral values, behaviors, and beliefs of a Chinese gentleman. Another page remnant floating on the painting's surface is from the *Three Character Classic* (*San zi jing*). First composed in the thirteenth century, the *Three Character Classic*, with its easy-to-memorize three-character verses, became the fundamental textbook for a Chinese child's education. By committing the lines to memory and then reading the written text, the child would learn basic Chinese characters as well as absorb critical Confucian values. Another sheet of paper in the assemblage carries words from a manual of family precepts, a type of text written by family elders to guide their descendants on proper behavior. To further instill a scholarly atmosphere to

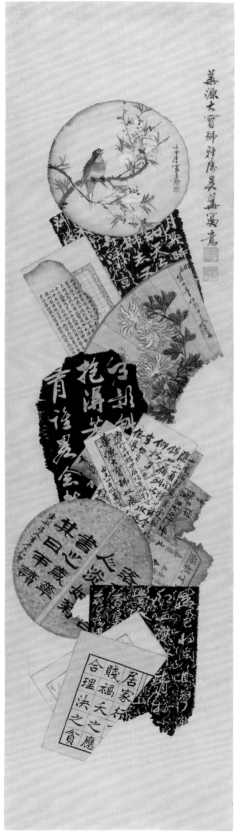

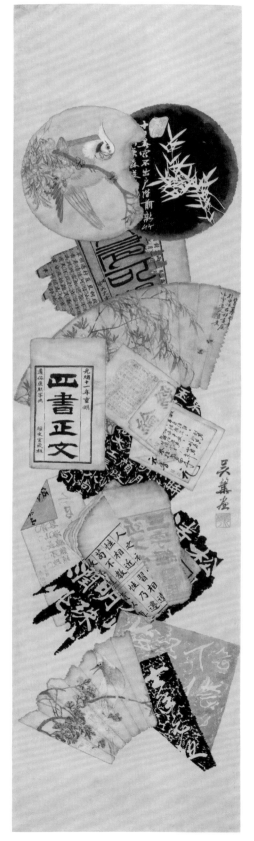

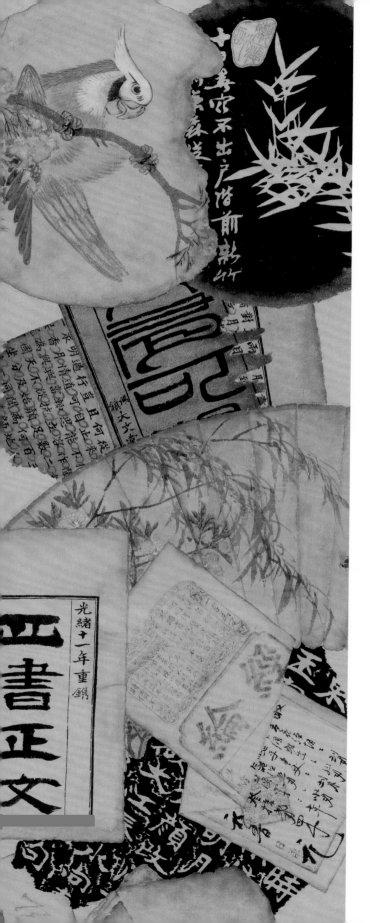

the painting, the artist added a rubbing of a poem by the poet, critic, connoisseur, artist, and official Su Shi—an iconic figure and the progenitor of the literati ideal.[52] The inclusion of these poems and texts in this decorative work reveals how scholarly sentiments and aesthetics had become a highly regarded part of popular culture. It also demonstrates the key role education played in Chinese society.

The artist, conscious that the work needed more than serious texts to appeal to his commercial clients, also distributed decorative paintings of birds and flowers around the composition. The signatures the artist adds to these paintings are those of the most recognizable of Chinese artists—such as Yun Shouping (1633–1690), one of the six masters of the Qing dynasty, renowned for his flower paintings.

For the viewer with the patience to take a closer look at the painting, the artist also offered a touch of humor. There are the familiar ephemera of contemporary daily life, such as a rice-selling license, an envelope, and its enclosed letter. The envelope is addressed to Hua Yuan Da Bao—the company to which the painting was inscribed. The letter and a notation on the envelope indicate that the package includes a gift of four vertical "assorted brocade" (shijin) scrolls. The artist seems to be alluding to the same paintings at which the viewer was looking. The return address is indeed a Mr. Wu of Xiangshan, Wu Zhuohua's hometown. The note on the envelope confirms that the set originally consisted of four paintings, not just these two. This would explain the absence of the usual inscriptions on the works that survive.

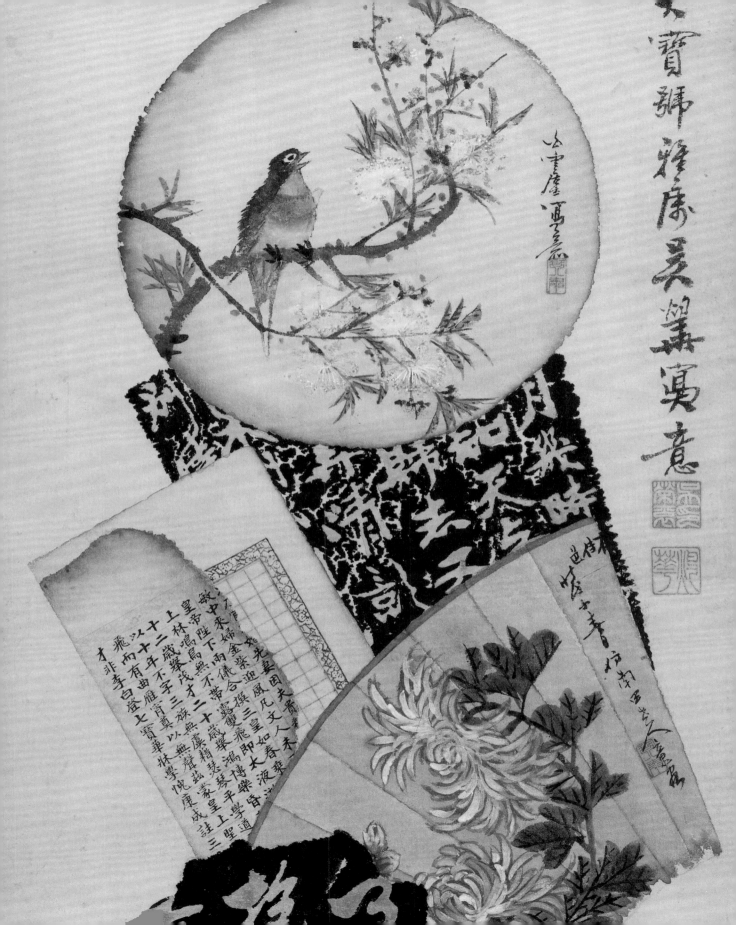

16
Wang Xueyan (dates unknown)
Printed fan, 1893

Color lithograph printing, 33 x 48 cm (13 x 18⅞ in.)
Anonymous gift in memory of William W. Mellins, 2017.37

A mass-produced printed fan displaying a bapo painting provides evidence that by the late nineteenth century bapo had become a part of popular culture. A printed inscription on the fan states that the Delong Painting Shop printed it in 1893. This company, established in the eighteenth century, had branches around the country, including Hebei, Shaanxi, Shanxi, Tianjin, and Shandong. Delong got its start producing woodblock prints as auspicious New Year's decorations. By the end of the nineteenth century they were importing German printing machines as well as foreign dyes and foreign paper.

Their bapo fan depicts a standard mixture of objects: two printed book pages, one a calligraphy text, the other a table of contents—perhaps a list of chapters from a novel, as well as a rubbing of running (*xing*) script, and a fan with a painting of a crane. Though intending to include objects that represented a culturally sophisticated lifestyle, the artist has not taken the care to depict recognizable texts or works.

More important was the inclusion of auspicious imagery. The greatly damaged remnant of a fan depicts a crane, symbolizing longevity. Part of the fan is folded over and reveals two seal (*zhuan*) script characters on the reverse side, one of which reads "immortal." In addition to showing off new printing techniques, the fan followed the bapo and New Year's print convention of conveying good wishes to the recipient.

The appearance of bapo on decorative arts helps place the form in the context of the Chinese arts of its time. Two tattered versions of this one-hundred-plus-year-old fan have been found, confirming that this work was mass-produced and disseminated. If mass-produced versions of this imagery were being distributed in 1893, bapo must have developed in the painting world at an even earlier date. Bapo's presence on decorative objects also confirms the extent to which the motif had become part of the visual culture of the time.

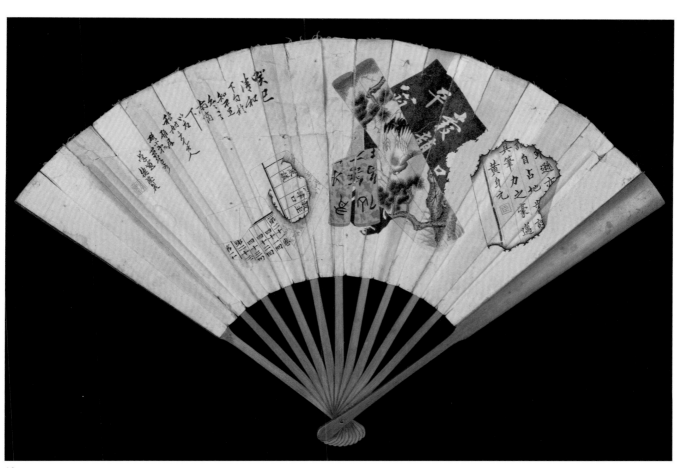

17
Ma Shaoxuan (1867–1939)
Snuff bottle, 1904

Glass; interior painted with ink and colors, 7.5 x 4.5 cm (3 x 1¾ in.)
Private collection of Joseph Baruch Silver, Jerusalem

18
Ma Shaoxuan (1867–1939)
Snuff bottle, 1898

Rock crystal, green and white jade; interior painted with ink and colors, 6.8 x 4.5 cm (2⅝ x 1¾ in.)
Eugene Fuller Memorial Collection, Seattle Art Museum, 33.937

The earliest images of bapo to appear in Europe and America may have arrived not as paintings, but as miniaturized images painted on the inside of three-inch-high snuff bottles. Tobacco first came to China—after being brought to Europe from the Americas—by Spanish and Portuguese traders during the late sixteenth century. In those early days, tobacco was smoked but also taken in the form of snuff, often kept in small boxes. In China, artisans created small containers so that the tobacco could be kept on the user's person. Early Chinese containers were made of metal, but as snuff became more popular, artisans began to make exquisite containers for those who could afford them. In time, the decorative bottles became so desirable that collectors purchased them as miniature objets d'art rather than as useful containers. The Qianlong emperor, for example, collected and commissioned snuff bottles created from myriad precious materials and techniques: jade, ivory, porcelain, cloisonné, and enameled copper.

One of the innovative decorative arts that developed in the nineteenth century was the inside-painted snuff bottle. The crafting of these demanded fine hand skills developed over many years of training. Like the painters of reverse glass paintings made in Guangzhou, the artist of the inside-painted bottle had to first paint the foreground imagery and slowly add the background layers. The inside-painting artist also needed to assiduously control a very tiny stiff ink-and-color applicator—made of bamboo, metal, or hairs—within the very tight confines of the small mouth of the glass bottle. These snuff bottles impressed collectors and admirers not only with their beauty but also with the technical feats they represented.

At the beginning of the twentieth century, the undisputed master of inside-painted snuff bottle painting was Ma Shaoxuan (1867–1939).[53] The artist was born as Ma Guangjia into a comfortable and sophisticated family of the Hui Muslim minority group in the Muslim neighborhood of Beijing known as Niu Jie (Ox Street). The Islamic and Han Chinese culture had mixed for centuries in Beijing. Many antique dealers in the capital city were Hui. Ma's father was a doctor specializing in traditional Chinese medicine and, as an intellectual, was learned in both the Chinese classics and Islamic traditions. Following the Chinese scholarly path, he was passionate about Chinese painting and calligraphy and began training his son at a young age in calligraphy, poetry, painting, and the Confucian classics.

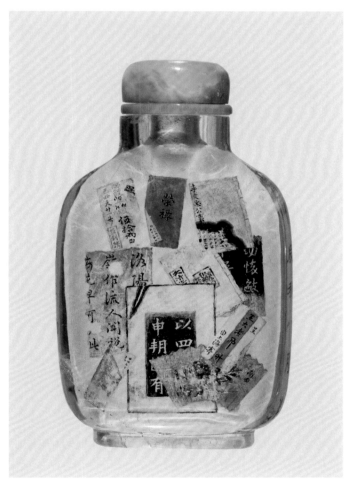

17

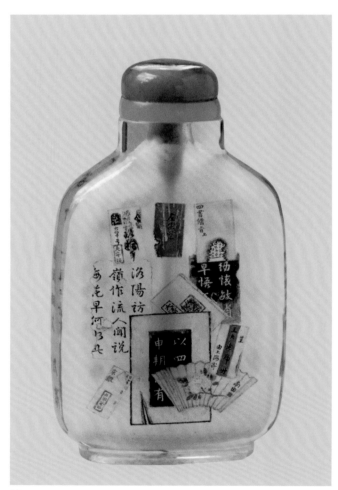

18

In 1885, at age eighteen, the junior Ma took the civil examination that would have ensured him a post in Qing officialdom. Sadly, like many others, he did not pass. At that point he changed his focus to painting and calligraphy. By chance, a family relative who was an antique dealer happened by the Ma home with an inside-painted glass snuff bottle. Ma was enchanted by the precision and beauty of these miniature paintings and decided to pursue the art form. He and his two brothers purchased materials and experimented. After much practice, Ma began to generate passable work reproducing the likeness of brushstrokes with varying thicknesses and expression on absorbent paper. With a talented hand and determination, Ma polished his skills until he rose to become the leading inside-painted snuff bottle painter.

Ma depicted a variety of different themes in his bottles. There were the Two Qiao Sisters (a tale of two Han dynasty sisters that married two brothers) and the five essential human relationships (according to Confucius)—represented by five species of birds, opera characters, portraits, landscapes, and stories of filial piety. On other bottles, he reproduced likenesses of famous world figures—such as Kaiser Wilhelm II and the last Chinese emperor, Aisin Gioro Puyi—from photographs. He was also an excellent calligrapher, and copied important historic calligraphic compositions, or inscribed his own poetry. In a biography, Ma Shaoxuan's grandson emphasizes the artist's deep devotion to, study of, and passion for calligraphy. His faithful copying of the great masters' works and his perfecting of a personal style that integrated the styles of the Tang scholar Ouyang Xun (557–641) and the fourth-century "sage of calligraphy," Wang Xizhi (303–361), revealed his devotion to Chinese scholarly values in his art.

Ma employed two types of bapo compositions in his art. Some bottles display papers in an orderly manner, all upright and whole, akin to the early Qing lacquer screens. Other bottles exhibit a fully mature bapo style with deteriorating objects arranged in a haphazard configuration.

In a bottle Ma created in 1904, he demonstrates his ability to produce a wide variety of calligraphic scripts in many different styles. And then he begins to add elements with more contemporary relevance. Front and center, as a bold white-on-black rubbing, he features a mounted and silk-bordered remnant of a rubbing of regular script (kaishu) characters from the famed stele at the Jiucheng Palace. This stele, known as the Record of the Discovery of Sweet Wine Spring at the Jiucheng Palace (Jiuchenggong liquan ming), memorialized the discovery by the emperor Tang Taizong (598–649) of a spring gushing with fresh water that quenched his thirst on a hot and dry day. So moved was the emperor that he ordered the imperial calligrapher Ouyang Xun to inscribe a text for a stele. The regularity and strength of Ouyang's brushstrokes made it an ideal model for beginning students. Ma had no doubt studied the stele and its distinctive calligraphy. He may even have possessed a rubbing, or, more likely, a less expensive printed version of a rubbing, which would have been readily available by the late nineteenth century.

Another rubbing, on the right, demonstrates Ma's reverence for China's most respected calligrapher, Wang Xizhi. Ma slyly includes Wang Xizhi's calligraphy in his work by depicting a rubbing of a Tang-era stele recording the preface to the Buddhist sacred texts brought back to China by the monk Xuanzang (602–664). The preface text—praising Xuanzang's achievement—was composed by the Tang emperor Taizong. The characters carved into the stele were—according to legend—selected, one by one, from the collected calligraphy of Wang Xizhi. The stele was installed in the Great Goose Pagoda in Xi'an and, like the Ouyang Xun stele mentioned above, generated many rubbings as well as printed versions of the rubbings.

On a white sheet of paper on the left of the composition, Ma has included, in brushed calligraphy, an excerpt from the well-known poem *Preface to Prince Teng's Pavilion* (*Teng wang ge*), written by the Tang poet Wang Bo (650–676). The pavilion, in Nanchang, Jiangxi Province, was first built in 653, and gained its fame primarily because of the poem. Over the centuries, the building was destroyed and rebuilt twenty-nine times. In his poem, Wang Bo refers to the eventual disintegration of important historical sites, a concept that resonates with the deteriorating objects portrayed in bapo paintings. And perhaps Ma is also referring to the disintegration of Chinese traditions in his time. Another sheet of paper contains lines from the poem "Failing to Meet Yuan," by the Tang poet Meng Haoran (680–740): "I went to Luoyang to visit a talented scholar, but he was in Jiangling in exile. I heard that the plum blossoms flower earlier there. But how can it compare to the spring here?" Like Ma, this august and oft-quoted poet did not pass the civil examination.

In the lower right section of the composition, Ma adds an example from the visual arts—a folding fan with a painting of flowers or fish, signed Nantian, the style name of the Qing artist Yun Shouping (1633–1690). Yun, a promising scholar from a sophisticated family in the Jiangnan region of China, could not afford to study for the civil examinations because of his family's financial circumstances. Instead, talented with his brush, he began selling landscape paintings at an early age and eventually made his name as an artist. Yun was so well known that reproductions of his work appear over and over again in bapo paintings. Ma could be sure that his clients would instantly recognize the name and work of Yun Shouping, an artist who was both accessible and sophisticated. Ma's inclusion of Yun's work would have given his clients a sense that they were sophisticated members of society. Yun may have had one other significant meaning for Ma—like Ma, Yun had been an aspiring scholar, but had become an artist instead.

Ma also connects his work to turn-of-the-century daily life by including an envelope and a bank receipt, and introduces contemporary political circumstances with several documents related to the Qing imperial court. He includes a cover of the *Jing Bao*, often called the *Peking Gazette* in English, a bulletin reporting the goings-on at the court. He also depicts another book cover, its title beginning with "The Great Qing . . ." (the full title is obscured), which appears to have been published by the court, and which may be a list of official promotions or decrees.

At least eight snuff bottles by Ma with similar compositions exist.[54] We can imagine that his clients' appreciation encouraged him to make more, each with slight variations. Most of them include one or two items that demonstrate Ma's serious concern with contemporary politics. One of the poignant items appears in the first bottle (cat. 17), and another can be seen in the composition of the second bottle (cat. 18).

In the upper section of the second bottle is a red calling card for Zuo Zongtang (1812–1885), one of nineteenth-century China's most prominent generals. Like Ma, Zuo came from an educated background, but did not pass the civil examination. He tried, and failed, seven times. In 1851, Zuo joined the military general Zeng Guofan and Qing forces in their efforts to put down the Taiping Rebellion. His victories led to promotions, and in time Zuo rose to become a member of the Grand Council. For Ma, the name Zuo Zongtang would have carried two layers of meaning—personal and political: the success of a man who had not passed the exams, and his triumph over the forces attempting to destroy Confucian culture. (A bapo painting from the same era has a similar red calling card, this one with the name of Zuo's superior Zeng Guofan; see cat. 9.)

In this bottle, and most of the others, Ma includes a burnt book cover from a commentary on

the *Four Confucian Classics* (*Sishu beizhi*) next to the calling card. Confucius was considered the great sage of Chinese society—and his works were and still are revered. However, his teachings came under attack at several points during the 2500 years of Chinese history. For example, the Qin emperor (250–210 BCE, r. 220–210 BCE) was an authoritarian ruler who famously destroyed any philosophical texts that he did not condone. During the nineteenth century, the Taiping Kingdom's rebellion was another anti-Confucian movement. That destructive civil war led to the deaths of millions of Chinese and the destruction of many volumes of Confucian and Buddhist texts. Ma's inclusion of the book is both a statement on the significance of these ancient texts in Chinese culture and a commentary on their destruction.

In the first bottle shown here, Ma had replaced the Zuo Zongtang calling card with the auspicious characters *rong* and *lu*—meaning "glory" and "prosperity"—brushed onto a red rectangle. But he had not dispensed with politics. He replaced the Confucian texts with the cover of a just-published book—*The Official Chronicle of Li Wenzhong* (*Li Wenzhong gong shi lue*)—by the scholar, philosopher, and reformist Liang Qichao (1873–1929). Published in 1902, the book is a biography of the controversial official, general, and diplomat Li Hongzhang (1823–1901). Like Zuo, Li had been involved with the suppression of the Taiping Kingdom and with the negotiations after the Boxer Rebellion in 1901.

Known for his military achievements, his enlightened international diplomacy, and his encouragement of modernization in China, Li encountered challenges and even criticisms during his long service to the government. Just before his death, he was the primary negotiator in the 1901 discussions with foreign governments that ended the Eight Nation Alliance forces' occupation of the Forbidden City after their suppression of the violent and destructive Boxer Rebellion in Beijing. Ma's powerful placement of the book in his miniature rendering—its front cover partially burnt away—is a reminder of the tumultuous and ruinous events in late Qing China. His tiny snuff bottles became a vehicle as powerful as any other form of bapo for reflections on the political and social turmoil of the time.

19

Unidentified artist
Meeting Immortal Friends, late 19th–early 20th century

Silk thread embroidery on silk, 69.6 x 30.1 cm (27⅜ x 11⅞ in.)
Anonymous gift in memory of William W. Mellins, 2017.12

The reproduction of paintings and calligraphies as silk embroideries and tapestries began at least as early as the Song dynasty, and reached a glorious zenith in the court of the Qianlong emperor. The court, for instance, commissioned artisans to replicate calligraphy by the Ming master Dong Qichang—who was copying great Song-period artists—using the extravagant, labor-intensive *kesi* (literally "cut silk") technique. Because of the relatively low status of bapo—and the high expense of fine silk textile work—instances of bapo textiles would be expected to be rare. In fact, there are no known kesi bapo works. However, several embroidered imitations of bapo have come to light. These works demonstrate, like bapo itself, the human interest in transferring artworks from one medium to another, an act that elevates the original by perpetuating and spreading its presence in the world.

In the late nineteenth or early twentieth century, an as-yet-unidentified artisan depicted a rubbing of a famous Han-period stone inscription in embroidery. The original inscription, known as "Meeting Immortal Friends," was discovered in 1005—during the Song period—in a cave in Sichuan.[55] It displays twelve characters reading, "A meeting with immortal friends on the eighteenth day of the 4th month of the first year of the Han An period [the year 142]." The text refers to either an encounter between the writer and celestial beings, or between the writer and other members of his Daoist sect. Most likely, the calligraphy, not the meaning of the words, attracted the artisan. Many researchers believe that the original calligrapher was the highly respected scholar Cai Yong (132–192), though his dates do not align.[56] The twelve characters demonstrate a great sense of balance and a strong control over an expressive brush—and probably could not have been executed by the then ten-year-old Cai.

This textile offers much more than a mere reproduction of the calligraphy. The embroiderer has reproduced aspects of the rubbing as well—going to great lengths to depict the ragged edges of the aging paper and the cracks in the original stone. The embroiderer has, like other bapo artists, demonstrated his or her skill by both creating an excellent replica of the calligraphy and adding authenticity by emphasizing its age.

A set of four embroideries by the same artisan, depicting four "rubbings" and marked with the same embroidered seal, is in a private collection.[57] The rubbings represent three second-century steles, including the "Meeting Immortal Friends" inscription, and one Northern Wei–era (386–534) stele. All except the "Meeting Immortal Friends" stele are from Shandong Province. Most likely the embroiderer was working from rubbings rather than the stones themselves. The precise workmanship and the strong similarity between the two versions of the "Meeting

19

Immortal Friends" embroidery suggest that the embroiderer may have been a professional, rather than a young woman preparing a dowry. The work may have been commissioned by a collector of epigraphy, just as the Qianlong emperor commissioned the kesi of his cherished calligraphy.

This artisan was not the sole creator of bapo-like embroideries. In 1904, a female embroiderer surnamed Wei (1842–1914), from Changsha, Hunan Province, created a series of eight fine silk embroideries, intended as pillow end decorations.[58] Each square depicts various epigraphical collectibles—rubbings of roof-tile ends, bits of rubbings of inscribed stones, coins, and ancient bronzes. As in most bapo paintings, every object is an opportunity for calligraphic display.

Another unidentified embroiderer created four vertical strips displaying likenesses of rubbings and calligraphies in all manner of scripts. As was typical of mounted rubbings in the eighteenth and nineteenth centuries, each object is accompanied by a regular (kaishu) script transcription of the ancient script. There are Han bricks and roof-tile ends, Wei dynasty stele calligraphies, an oracle bone inscription, a bird-worm (niaochong) script seal, and an inscription from an ancient bell. Many of the texts and rubbings depicted on this colorful set encompass auspicious meanings. There is, for instance, a Han dynasty roof tile of a wild goose in flight with the two characters yan and nian, meaning "extending the years" or "everlasting." The word for wild goose is also pronounced "yan," so the image is a rebus for longevity. An embroidered "inscription" on this silk handiwork relates that the objects come from a home where "epigraphy cheers the heart," suggesting that it was a commission for a collector. An embroidered seal with the name of Huang Zhixiang denotes the maker, but no record can be found of this artisan.[59]

20
Plate with bapo design, about 1880

Jingdezhen, China
Polychrome glaze on porcelain, diameter 30.5 cm (12 in.)
Peabody Essex Museum, Gift of Carl Crossman, 1983, E73199
Photograph: Kathy Tarantola, © 2017 Peabody Essex Museum, Salem, Massachusetts

A porcelain plate from the second half of the nine-teenth century, rimmed by bird and floral designs and with a bright polychrome and gilt bapo design at its center, shows the sumptuousness that decorative bapo could achieve, despite the genre's scholastic origins and pretensions.[60] Unlike many of the more sophisticated bapo artists who enjoyed creating literary or artistic allusions and puzzles, the painter of this plate was choosing colorful and easily recog-nizable items that would immediately delight clients.

The open book on the top of the pile contains writings by the great Confucian philosopher Mencius (or Mengzi, 372–289 BCE), a name known and respected by all Chinese. Below the book is a monochrome painting of a dragon in the clouds, meant to imitate a masterpiece by the Song dynasty dragon painter Chen Rong. The image combines a less ostentatious and more sophisticated monochrome painting style with an impressive depiction of a dragon, a symbol of imperial power in China. The artist's preference for easily identifiable objects and lack of concern for authenticity is apparent from the red book title slip for *Pictures of Plowing and Weaving* (*Geng zhi tu*). The title slip's supplementary text wrongly implies that the book was published as part of the *Mustard Seed Garden Painting Manual* (*Jieziyuan huapu*).

Both *Pictures of Plowing and Weaving* and the *Mustard Seed Garden Painting Manual* were well-known masterpieces of Chinese printing. *Pictures of Plowing and Weaving* was a 1696 imperial reprint of a set of paintings from the Song dynasty depicting the processes of rice cultivation and sericulture (raising silkworms and producing silk). By the late nineteenth century, the exquisite prints had been reproduced numerous times in books, as well as in embroidery and porcelain. The *Mustard Seed Garden Painting Manual* was a 1679 woodblock-printed instruction manual for artists demonstrating a range of brushstrokes and compositions and reproducing, in often streamlined woodblock style, works by the great masters of Chinese painting. Like *Pictures of Plowing and Weaving*, this painting manual had been printed and reprinted many times over (in fact, it is still in print), and would have been known to a broad range of society.

The plate, which wasn't made for a sophisticated or even a particularly knowledgeable audience, was designed to amuse. The familiarity of the book names would have indeed charmed viewers, many of whom would not have realized, or cared, that *Pictures of Plowing and Weaving* was never published as part of the *Mustard Seed Garden Painting Manual*. To add a bit more extravagance to the composition, the artist added a gold coin—to invoke prosperity. A lizard meandering among the papers may have been intended to ward off evil spirits.

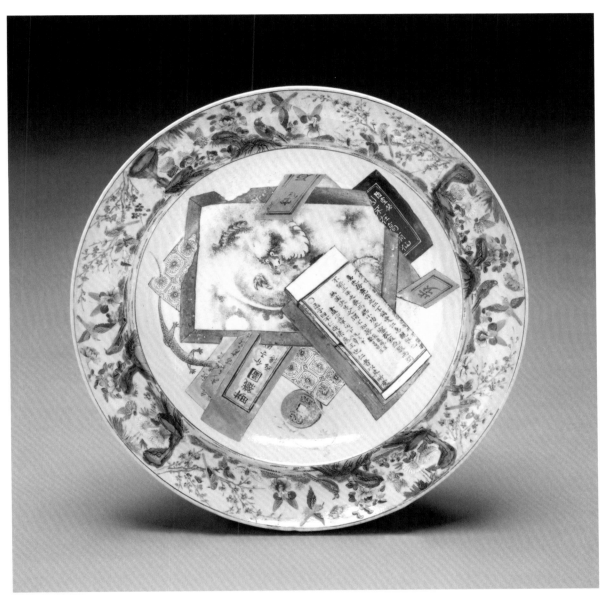

21

Pair of *famille rose* bowls decorated with bapo design, 1860s or later

Polychrome glaze on porcelain, each: diameter about 10.5 cm (4⅛ in.)
Asian Civilisations Museum, Singapore
From the Xiang Xue Zhuang Collection in memory of Dr Tan Tsze Chor, 2002-00102
Image copyright National Heritage Board, Singapore

The artists who helped create bapo-themed ceramics needed to go beyond producing scaled-down versions of their paintings. Their work would have to serve as a decorative element for a functional object while still appealing to relatively educated and sophisticated connoisseurs and consumers. For example, the entire exterior surface of this luxuriously produced pair of tea bowls, including the bowl covers, is decorated with overlapping rubbings, book covers, chess pieces, seals, bits of burnt pages from poetry books—and even a domino.

The glaze colors show no variation in hue. Gold edgings around the rims add a sumptuous accent. The burnt edges shown on some of the pages are the only efforts to create a sense of realism. However, the circular composition, made up of objects of varying angles, shapes, and colors, gives the bowl a dynamic appearance. A guest served tea in such a bowl—perhaps turning it in his or her hands—would have had a very different experience from looking at a painting hanging flat on a wall.

To enhance the scholarly sensation of viewing the bowls, the artist has brushed a poem on one cover—recounting a trip to the mountains:

> Having been to the mountains to pick tea leaves,
> I brag of the skill with which I cured the leaves.
> Originally I had only a jar of wine,
> Now I have several extra cups of tea.

Following the last line, the artist notes that he is imitating, in the artwork, a "gathering of antiquities." The poem is signed Bamboo Bower, a proper, humble dwelling name for a scholar.

The bases of the bowls and the tops of the covers display reign mark seals that read "Made during the Jiaqing reign of the Great Qing," the equivalent of 1796–1820. Though none of the poetry, books, or calligraphy displayed on the bowl date after the Qianlong period, the glazes and the painting style suggest a date at least thirty or forty years beyond the Jiaqing reign. It is possible that the overglaze bapo decoration was applied onto the blank surface of a Jiaqing mark and period bowl.

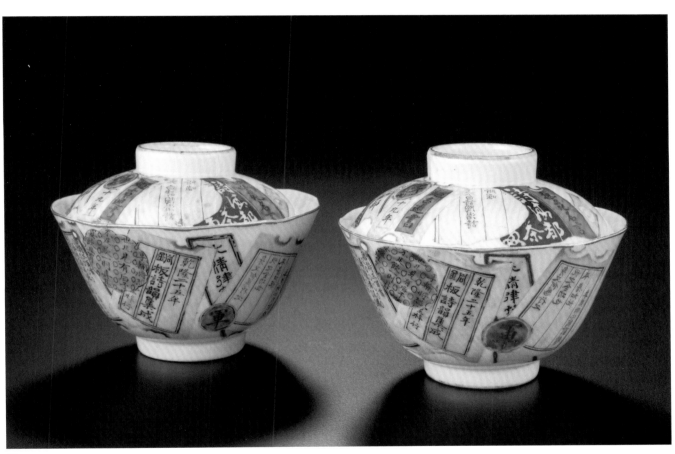

21

22

Attributed to Yang Weiquan (1885–after 1942)

Vertical scroll with bapo design forming a rock, 1934

Ink and color on paper, 106.2 x 44 cm (41¾ x 17⅜ in.)
Anonymous gift in memory of William W. Mellins, 2017.18

23

Attributed to Yang Weiquan (1885–after 1942)

Fan, 1942

Ink and color on paper, 31.8 x 49.5 cm (12½ x 19½ in.)
Anonymous gift in memory of William W. Mellins, 2017.14

24

Attributed to Yang Weiquan (1885–after 1942)

Horizontal scroll, 1931

Ink and color on paper, 32.1 x 79.3 cm (12⅝ x 31¼ in.)
Anonymous gift in memory of William W. Mellins, 2017.17

25

Zheng Zuochen (1891–1956)

Horizontal painting with bapo in the shape of a scepter, 1950

Ink and color on paper, 33.4 x 86.8 cm (13⅛ x 34⅛ in.)
Anonymous gift in memory of William W. Mellins, 2017.20

Yang Weiquan was the name most often heard in Shanghai in relation to *jinhuidui*, the name used for bapo in the Shanghai and Jiangnan region of China. Born in the port town of Minhou (modern-day Fuzhou) in Fujian Province, and trained as a painter, Yang (1885–1940s) had moved to Shanghai by the 1930s and proceeded to make a name for himself and his art.[61] Though surely talented and clever, Yang was less passionate about the art of calligraphy or painting, and more fervent about bapo's commercial potential. An astute businessman, Yang produced what he could sell. The clientele who purchased fans and scrolls in his gallery were interested in works that would display their erudition with classic texts and epigraphic rubbings.

Yang also made sure that articles, probably paid advertisements, appeared regularly in the leading Shanghai newspaper, *Shen Bao*, describing his paintings, workshop, connections with prominent members of society, prices for the paintings, and, of course, where the works could be purchased. On page 16 of the December 1, 1936, issue of *Shen Bao*, a notice announces the arrival of paintings by "the gentleman from ancient Min [Fujian] region, Yang Weiquan, a famous artist of recent times, who does the so-called *jinhuidui*. . . . Today's Yu Youren, Wang Zhengting, and various others have praised his work. . . . Each foot length is ten *yuan*; albums and fans are each 10 *yuan*. Available at Hua Jin ["Painted Brocade"] Pailou, Number 142, Yang Apartment, or through the *Shen Bao* inquiry offices."[62] Several days later, a new article was posted in the same paper notifying the public that prices for Yang Weiquan paintings would be increasing by 20 percent in the following year. The article explains that each painting takes from five to ten or more days of work. "Among those who love his works, there is no caring about the price, and they compete in requesting his paintings."[63]

Yang's prices were not minor amounts in the course of 1930s Shanghai life. For comparison, a

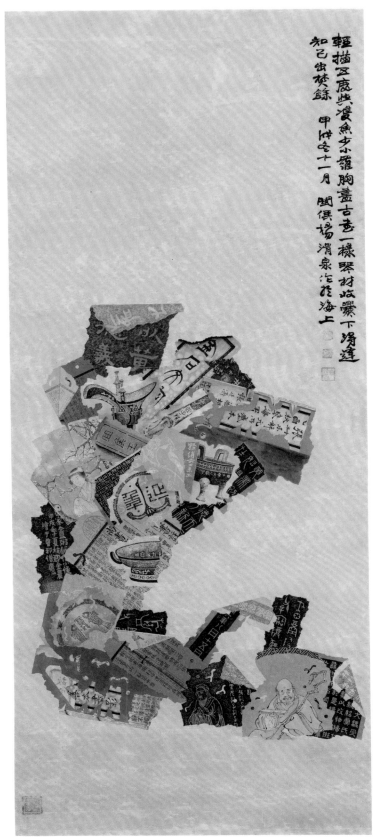

輕描五虎與淺魚
少不羈胸盡古來
一樣琴材收爨下
消遣知己出模餘
甲戌冬十一月
閩供楊消泉作於海上

22

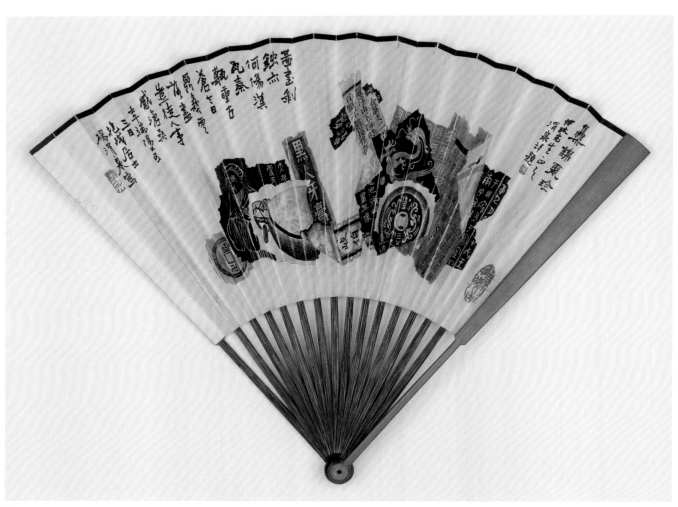

23

nurse's salary in 1935 was twenty yuan a month; a factory laborer earned thirty yuan a month.[64] His prices, however, were in line with other artists of the day. Xie Zhiguang, a painter influenced by European magazine illustrations, posted similar prices in *Shen Bao*.[65]

Hoping to make his work even more desirable, Yang publicized his associations with well-respected Shanghai and international personalities. Among the people praising his works was Yu Youren (1879–1964), a calligrapher, scholar, revolutionary, and official in the Nationalist government. Yu's passion for calligraphy led to his collecting rubbings, many of which he donated to museums. According to another *Shen Bao* notice, he also donated twenty to Yang Weiquan.[66]

Another admirer was Wang Zhengting (1881–1961), a diplomat, foreign minister, and ambassador to the United States under the Nationalist government, who also founded a brokerage house in Shanghai. The popular magazine *Libai liu* (*Saturday*) boasted of even more important personages linked to Yang. *Libai liu* was a Shanghai weekly focused on modern living. The front cover of the July 4, 1936, issue depicts a woman with an electric fan. The back cover depicts three paintings by Yang and a paragraph explaining that Ambassador Wang had purchased the three works and presented them to three prominent statesmen of the time: Franklin Delano Roosevelt, Cordell Hull, U.S. secretary of state from 1933 to 1944, and Adolf Hitler.[67] Yang's self-promotion did appear to bring his works to the public's attention.

In the heady Shanghai atmosphere of the 1930s, Yang's works were not mournful yearnings for the wisdom of the past but instead clever, optimistic visions that could be purchased as gifts. Creating paintings with auspicious messages was a perfect commercial avenue for an artist. The "deconstruction" of one assemblage of papers, created in the winter of 1934, offers an excellent example of how this artist employed bapo as an auspicious motif.

Longevity, progeny, and prosperity are evoked in the disguise of the more scholarly sentiments of mourning the disintegrating past.

The Chinese viewer—before even glancing at the details of this painting—would have immediately recognized that the assemblage is in the shape of a rock. Chinese connoisseurs have venerated and collected rocks for their aesthetic qualities and philosophical inspiration since as early as the Song dynasty. Rocks took on the auspicious symbolism of longevity because of their permanence, thus the auspicious quality of "piling" up paper scraps into the shape of a rock. On viewing the painting, viewers would have immediately understood that the work's overall meaning was a wish for longevity. Many of the details, slightly disguised as literary references, repeat the same message.

The top-most object in this "rock" is a fragment of the title slip of the book *Epigraphical Writings* (*Jin shi wen zi*), published in 1884, displaying rubbings and descriptions of the epigraphical collection of the official Zhang Shuwei (1768–1848). These would have been rubbings of characters molded or carved into ancient bronze vessels, mirrors, roof tiles, bricks, and any other possible inscribed remnant of the past. The fragment included in Yang's painting says: "The Collection of Provincial-Exam-Winner Zhang Shuwei." The similarity between the original book title slip and the calligraphy in Yang's painting is striking and demonstrates the artist's care and control over his brush. The visual quotation of this section of the book's cover is a reference to scholastic interest in calligraphy and perhaps an insinuation that the painting's recipient will become a high official. To the right of the title slip is a rubbing of an ancient bronze belt hook with three characters, *yi zi sun*, indicating a wish for sons and grandsons. Farther below is a rubbing of the Han dynasty roof tile of the flying goose (also seen in cat. 10) and the characters *yan nian*, "extending the years."

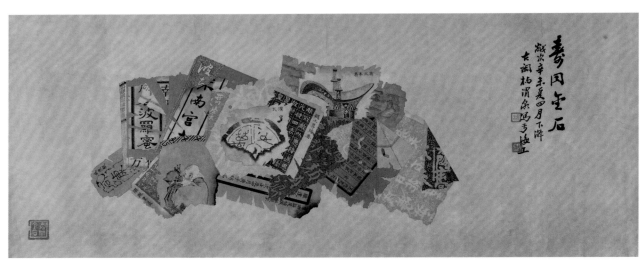

24

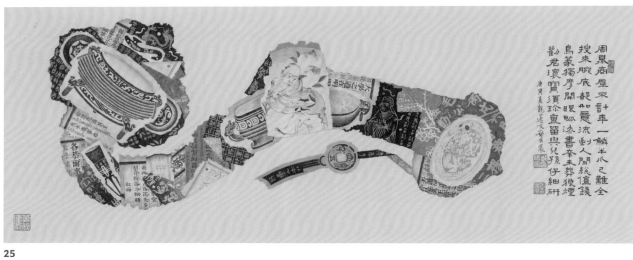

25

Yang titled another painting (cat. 24) *Shou tong jinshi*, "Longevity like Epigraphy," again drawing together a bapo painting and a wish for longevity. As a further propitious suggestion, the artist has included a painting of Laozi, often described as the Star of Longevity, carrying his longevity peaches. The artist intended these two paintings to be gifts for an older person, perhaps on a birthday.

A third work attributed to Yan Weiquan, a fan (cat. 23) that dates to 1942, again presents objects related to literati themes. A fragment from a printed page contains part of a poem on eating lychees by the great scholar Su Shi. A reader has punctuated the poem with brushed red circles to note his appreciation of the brushwork. There are rubbings of archaic calligraphy from ancient bronzes and stone carvings, as well as *quanxingta*, the rubbing technique invented in the early nineteenth century to depict ancient bronze vessels with a sense of three-dimensional volume. At the left of the assemblage a rubbing of an ancient round coin with a square center bestows wishes of good fortune, and with its molded *svastika* image (known in Chinese as the *wan*—meaning "ten thousand"—character), it ensures great prosperity.

But to reward the stealthy viewer, Yang slipped a surprise into his composition. What initially appears to be a rubbing of four ancient characters, white on black with a green border, is in fact the packaging from a toothpaste brand of the time. For today's twenty-first-century viewer, the packaging of this brand is offensive. The British firm Hawley and Hazel Chemical Company first marketed Darkie Toothpaste (Heiren Yagao) in Shanghai in the 1930s. The visual theme of the packaging was white writing on a black background to complement the offensive, smiling blackface character featured on the container. Yang placed the four Chinese characters with their black background and green border so that they looked like a traditional object, a rubbing, rather than a modern advertisement. No doubt the visual twist caught the attention of his viewers. Yang's inscription on the painting, dedicated to a Mr. Zhonglin, lists his inclusion of ancient Han roof tiles and bronze vessels, but he makes no mention of the toothpaste. This kind of gag is not common in Chinese painting but seems to have found a home in bapo.

A look at the many bapo paintings signed by Yang Weiquan shows that in most cases they are designed to evoke antiquity, with rubbings of ancient bronzes, paintings of Laozi, and pages from classical books. The paintings—fans, hanging scrolls, and large flat horizontal sheets—are distinguished by fine brushstroke work, quiet coloring, and a multitude of papers jumbled together in a haphazard composition, sometimes in the shape of an auspicious object. The papers presented are not necessarily scholarly puzzles or deep epigraphic commentaries. Many of the objects in Yang's paintings appear from a distance to be literati treasures—rubbings of bronzes and ancient inscriptions on tiles or bricks, or calligraphies. A closer reading usually reveals good wishes. More often than not, the paintings carry inscriptions promising the recipient longevity or good fortune.

Many objects appear and reappear in the works, confirming the commercial nature of his methods. The consumer demand drummed up by his self-promotion and the immense amount of detail in each work (each painting consisted of from ten to twenty dissimilar visual images) would have required repetition. The same painting of Laozi holding a peach on a tray, the same Buddhist scripture book cover, the same volume of calligraphic rubbings from Longmen, the same rubbing of a Han roof-tile end with the wan character implying hopes for longevity, and the same rubbing of an ancient mirror appear and reappear in his works.

Yang may have memorized these images, just as calligraphers would have studied ancient masterpieces, and alluded to them in their works. Or, possibly, like most professional artists and artisans in

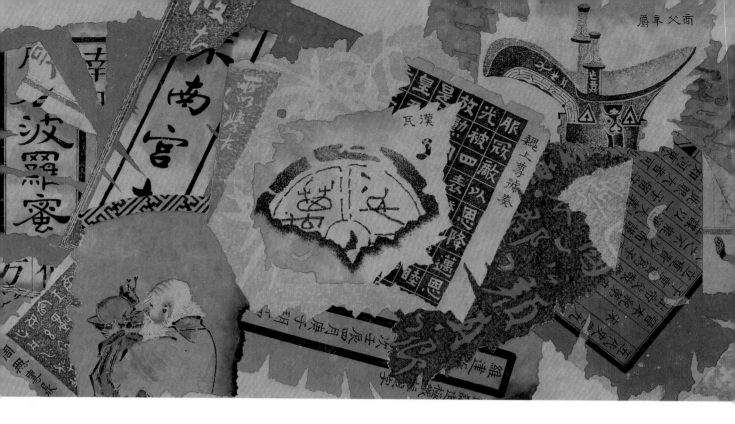

China, he kept a personal reference book of images, a *fenben*, from which he literally drew inspiration.[68] For a commercial artist, and particularly a bapo artist reproducing actual objects, such a fenben would have been a great help and supported a degree of consistency of style and appearance.

When evaluating the place of Yang Weiquan in the overall history of bapo, it is crucial to consider the question of whether he was an exceptional artist or merely a successful entrepreneur. Yang was not only popular, but also extremely prolific by the standards of bapo art. No other artists working with the bapo motif are represented by so many extant and known works.

There are more than thirty known Yang Weiquan paintings in private collections in the United States, China, and Europe. Reviewing this profusion of paintings gives us an opportunity to view and define an artist's style in the medium over time (two

decades) and, at the same time, perhaps shed further light on the murky history of the artist behind these works. The earliest known painting signed Yang Weiquan dates to 1930.[69] Now in Japan, in a private collection, it depicts a large number of commercially printed objects with very few of them referring directly to classical art history. Among the objects included in the work are a cover of *Children's Pictorial* magazine (*Ertong huabao*); a newspaper masthead beginning with the character *xin*, "new," and containing the English word "included"; European playing cards of the king of hearts and ten of spades; a page from a Western-style calendar with the English and Chinese for January 2; the cover of a textbook on learning the New National Language, published by Shanghai's Commercial Press; a ten-yuan horse-racing ticket; a page from a Chinese language book with a partial sentence reading "Great amounts of purchasing foreign . . ."; a Chinese playing card; a

paper reading "Yang Weiquan wishes you much happiness"; a letter in an opened envelope; and a photograph of a woman inside a frame that contains the English words "my dear." This style, with its proliferation of foreign and modern ephemera, is a distinct break from later bapo works that depicted only classical Chinese painting and calligraphies.[70]

Another work from 1930 (now in a private collection) and a horizontal scroll from 1931 (cat. 24) have all but disposed of these foreign and modern elements. Both of these images present rubbings of ancient calligraphies, rubbings of tiles, rubbings of bronzes, paintings of Laozi with a peach, book covers, and printed book pages—all more typical of the later works attributed to Yang.

Comparing the 1931 paintings with the 1930 work, an abrupt difference becomes apparent, both in the objects depicted and in the painting style. The earlier work shows far more concern with three-dimensional representation. The artist attempts to depict the thickness of a book's pages with a page curling back on itself. Shading further adds some sense of volume. None of this appears in the newer works. In the space of a year, Yang has dispensed with contemporary textual references and European-style three-dimensional illusionism.

How to explain this dramatic change? I do not completely rule out the possibility that Yang himself, in 1931, made a radical and, as we shall see, permanent shift in style. However, there is another possible explanation, based on the appearance of a second artist, Zheng Zuochen (1891–1956, also known as Zheng Dafu), on the Shanghai art scene.

The biography of this artist, active during the 1930s, 1940s, and 1950s, follows the pattern for many artists working in the bapo genre: a semi-educated, talented man from a poor background trying to eke out a living in the painting trade. In Zheng's case, two short written biographies exist. One is in a recently published county gazetteer from his hometown. The author of an earlier biography, Zheng Yimei (1895–1992), a journalist and essayist who interviewed the artist, describes how Zheng, a primary school teacher in the town of Zhenhai, in Zhejiang Province, south-west of Shanghai, was unable to earn enough funds to provide for his family and left home for Shanghai.[71] Zheng's hope was that his artistic talents might garner more income in the big city. Unfortunately, according to his biographer, upon arriving in Shanghai Zheng encountered a wily merchant, originally from the port city of Minhou in Fujian Province— none other than Yang Weiquan. Without friends or relatives to show him the way, Zheng fell under the powers of this allegedly exploitative character.

Yang sold Zheng's paintings, in particular his bapo paintings and fans, out of his painting shop in Shanghai. According to Zheng Yimei, Yang, eager to bring himself not only fortune, but also fame, insisted on signing the paintings in his own name! Zheng had become a "substitute brush," or *daibi*, for Yang. He received 40 percent of the revenues (although he still had to pay for his materials) but did not obtain any credit for the works. In time, Yang became known as the finest painter of the bapo or *jinhuidui* styles. As Zheng Yimei writes, "In Shanghai the famous *jinhuidui* artist, whom everyone knows, is Yang Weiquan. People consider him this genre's only capable master." Yang was so successful that it is his biography, not Zheng's, that appears in the *Dictionary of Chinese Artists' Names*: "Yang Weiquan (1885–?) [modern] native of Minhou, transplanted to Shanghai. Good at painting."[72] Once in Shanghai, Yang even joined a prominent artists' organization, the Association of Chinese Artists (Zhongguo Huahui), and took part in its exhibitions.[73] It is unknown if the paintings exhibited at the association were by Yang—or by Zheng.

While Yang's fame grew, Zheng languished. According to Zheng Yimei's biography, "This went on for more than twenty years. Yang Weiquan, cheating

the world and stealing a name, made a fortune. While Zheng, just as before, had a life of eating without getting full and being hungry without end."

The years of the civil war, in the late 1940s, slowly chipped away at Shanghai's economy and Yang found he had to close his shop. He sent Zheng back home. There, in Zhenhai, his original teaching post no longer available, Zheng was forced to chop wood and sell flat breads to support his family. After liberation, according to Zheng Yimei, the artist returned to Shanghai, joined an artists' association, the Hall of Literature and History (Shanghai Wen Shi Guan), and began painting under his own name. Unfortunately, Zheng Yimei's account of Zheng Zuochen's life cannot be corroborated by any other written text. The *Dictionary of Chinese Artists* did not include the unlucky man's name, and the Shanghai Cultural Hall did not have a record of his membership in 1992.

However, comparing paintings signed by Yang Weiquan with those signed by Zheng Zuochen seems to confirm the story.[74] The fine execution and the style of paintings shown here seem to indicate that Zheng painted them. There is a consistency in the painting style. Moreover, works signed by Yang—and then Zheng—continue to portray the same objects for almost two decades.

The pile of objects in a painting from 1950 (cat. 25) is in the shape of a *ruyi*, a Chinese scepter. The ruyi, a ritual object representing imperial power, physically modeled on the shape of the longevity-producing *lingzhi* fungus, is also a rebus in China's glossary of symbolism. The two characters referring to this type of scepter, *ru* and *yi*, carry the additional meaning of "may you receive all you desire." Thus, the painting, like the one in the shape of a longevity rock, offers a gracious wish to its recipient. As can be seen from this work, in comparison with others signed by Yang Weiquan, after the revolution Zheng continued working in the bapo format and style he had developed under Yang Weiquan's guidance.

The history of Yang Weiquan's and Zheng Zuochen's careers, though certainly not as well established as we'd like, offers a number of insights into the bapo genre—and some of the painters. The biographies of the two individuals involved in the production of these particular works both describe definitively commercial intentions. Though Zheng may have personally held sentimental feelings for Chinese aesthetic history, he did, according to Zheng Yimei, go to Shanghai with the primary purpose of making money with his painting skills. Yang, it seems, used Zheng's talents to make a living for himself. Neither of these men, from what we know, came out of literati families. Such elite backgrounds would have been mentioned in any, even brief, biographical sketch.

Zheng Yimei's story about Zheng Zuochen may or may not have exaggerated some details—as such tales often did in the post-liberation years—to emphasize the exploitation of a poor man by a member of Shanghai's capitalist class. The basic storyline, however, would have been grounded in truth.[75] The biography traces the life of a poor, semi-educated man with a talent for painting. Humble circumstances were not unusual among bapo artists. This biographical element is repeated in enough bapo narratives that it begins to define the motif as one practiced and enjoyed primarily by aspiring middle-class artists, and not by the elite literati.

Their imagery—with its playful, deceiving verisimilitude, easy employment for auspicious wishes, and pretense of literati sophistication—ensured a popular appeal and modest incomes for artists trying to gain a foothold in early twentieth-century China. Unfortunately, the commercial foundation and popular appeal also earned the genre a poor reputation in the eyes of the more sophisticated critics—who gave bapo barely a mention in their records.

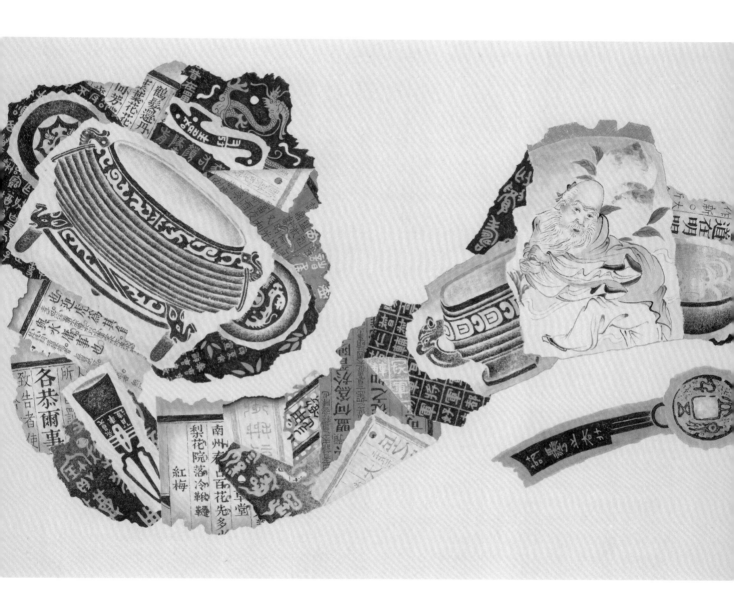

Li Chengren (dates unknown)
Burnt, Ruined, Damaged, Fragments, 1938

Ink and color on paper, each: 63.8 x 21.6 cm (25⅛ x 8½ in.)
Anonymous gift in memory of William W. Mellins, 2017.22.1-4

The artist Li Chengren did not leave many paintings for posterity—nor did he make much of an impression on the pages of recorded history. He did, however, produce a mournful set of four scrolls that both demonstrate a deep knowledge of Chinese scholarship and express grief during a terrifying moment in Chinese history. The inscriptions on the scrolls tell us his style name was Longevity Mountain (*shoushan*), indicating that perhaps he was aging when he did the paintings. He also notes that his home is in a place called Xia Huan, probably in the lower section of the Huan River, and that the date was the second lunar month of 1938 (the equivalent of March 1938).

During the last month of 1937 and the early months of 1938, the city of Nanjing was attacked by the Japanese—resulting in horrific scenes of carnage and devastation. Shanghai had also been attacked—and was reeling under a brutal occupation. A few brave witnesses recorded their shock in words or in art. For most people, though, the overwhelming political tension of the time meant that subtle reference—long the preferred approach in Chinese culture—was the safest means for expressing one's feelings. Li Chengren made use of the techniques he knew best—his talent in calligraphy, his skill in naturalistic depiction, and his wide knowledge of historic scholarly works—to quietly lament the devastation he saw around him.

Li's first allusion to the ruination around him refers to the burning of books by the cruel hegemon Qin Shi Huang, the first emperor of China, during the Qin dynasty. This emperor was determined to destroy Confucianism and other social ideologies. On the inscription that includes his signature and the date, Li writes:

> These singed fragments contain unfathomed depths.
> Words can never express the cruel tyranny of Qin.
> True relics of ancient times are hard to find.
> These shards I use to express the spirit of the past.[76]

On each of the four scrolls, Li presents an inscription in a different script type—seal (*zhuanshu*), regular (*kaishu*), clerical (*lishu*), and running (*xingshu*)—so the viewer could easily see his talent in reproducing the many forms of the Chinese written language. The poem Li wrote in seal script also refers back to the Qin ruler and the literature lost to his fabled rampage:

> The books were committed to the flames.
> The Qin tyrant's crime has resounded through
> the ages.
> If it were not for the connoisseurs of the past,
> How could we today know the men of yore?

This response to the Qin's destructiveness is not Li's only reference to violent and vicious devastation in China's history. He reproduced an official court

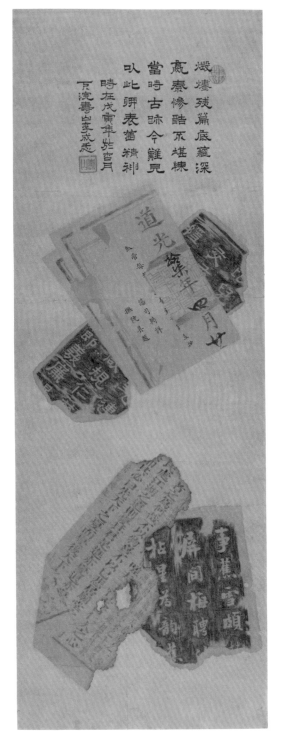

燼爛殘篇底蘊深
羸秦慘酷不堪諫
當時古跡今難覓
以此躬表蓋禎神
時在戊寅年於臘月
下浣壽山室戲成志

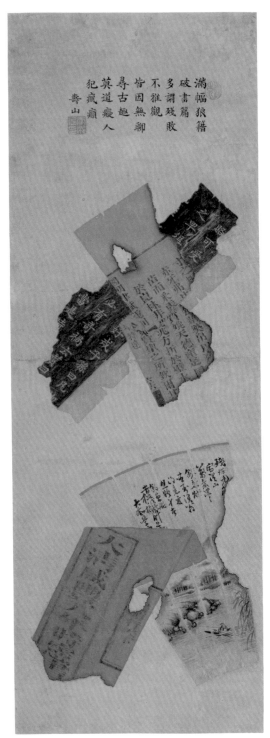

滿幅狼籍
破書篇
多謂殘敗
不雅觀
皆因無聊
尋古趣
莫道癡人
犯瘋癲
壽山

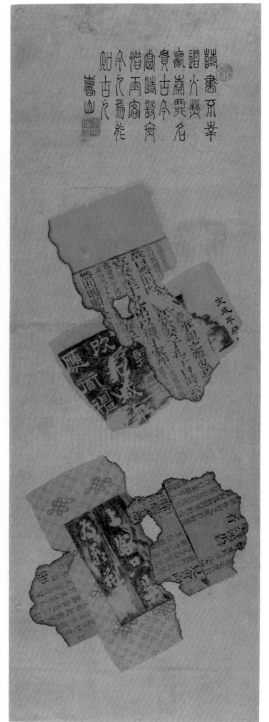

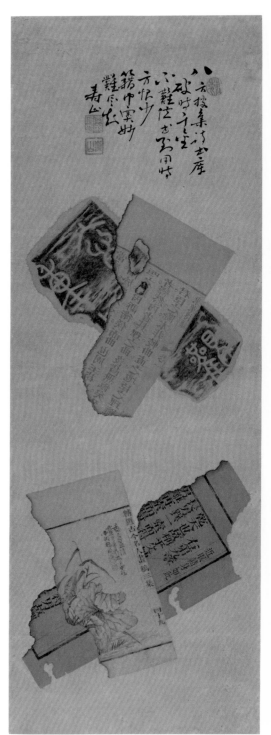

communication dated to the fourth month of the Daoguang reign period (1837)—a fold in the paper makes the exact day illegible. It may have been intended to remind his audience of the crisis brewing in Guangzhou at that time, which led to the first Opium War—after which China would be forced to turn Hong Kong over to the British.

At the bottom of one scroll is the bent and burnt front page of a government-distributed calendar for the eighth year of the Xianfeng era (1858). It represents another disastrous era for Chinese culture. Tensions between the Chinese and British had been growing again, and in 1857 the British occupied Guangzhou. In 1858, they sailed north and attacked Tianjin. Meanwhile, Russian troops were invading and occupying parts of northeast China, and the armies of the Taiping Rebellion were expanding the territory they controlled. Looking back on the century preceding his painting of these four scrolls, and looking around at the Japanese occupation of Chinese territory during the late 1930s, Li would have had much to mourn.

Though historic records provide no information about this artist and only one other painting has been located—providing no additional knowledge about his life story—Li's art indicates a very personal and genuine voice. Aspirations for prosperity and longevity were not part of his style. The erudition of the man behind these works is made clear not only by his abilities in all four calligraphic scripts, but also by his inclusion of a number of obscure calligraphic works.

One printed book page features the famous essay *Memorial to the Yueyang Tower* (*Yueyanglou ji*), written by Fan Zhongyan (989–1052). Fan wrote his work in honor of the rebuilding of an elegant monument overlooking Dongting Lake, originally constructed as a military lookout during the Three Kingdoms period (220–80) and damaged by wars over the intervening centuries. The landmark burnt down shortly after a Song-era reconstruction, and

was rebuilt over and over again. In time, Fan's much-loved essay became the primary source for the building's fame. The page of the text that Li depicts includes the most commonly quoted line of Fan's Confucian-influenced wisdom: "First feel concern for the concerns of the world. Defer pleasure until the world can take pleasure."[77] Was Li's inclusion of the *Yueyang Tower* intended to recall images of an ancient culture deteriorating during wartime? Or was he more focused on encouraging Confucian moral lessons during a difficult period in history? Perhaps he selected the text because it evoked both of these sentiments. An advantage of the bapo technique was the potential for this kind of layering of multiple meanings.

Confucian ideology was certainly not far from Li's mind. Elsewhere, he includes a page from the printed book *Family Sayings of Confucius* (*Kongzi jiayu*), Confucius's declarations on the family—containing information on ancient marriage and funeral rites. On another scroll, he includes a rubbing of a well-known work of calligraphy by the great Yuan artist and calligrapher Zhao Mengfu (1254–1322). The text, *Biography of Xianxie* (*Xianxie gong jia zhuan*), is a biography of Li Bingyi (1223–1287; also known as Xianxie)—a prodigy who became a high official—written by the earlier Yuan writer Zhou Chi. To represent the masterwork in fragmentary form, Li Chengren chose a passage with Confucian overtones, in which Li Bingyi cautioned his sons and grandsons that the ownership of rare and precious objects can lead to disastrous outcomes. In a final inscription, Li Chengren reminded his viewers that the most humble-looking scraps might be the most precious:

> A scroll of scattered fragments, broken books.
> Others may say these scraps of mine lack grace.
> I have sought the flavor of the past to fill a void.
> Pray take not this folly of mine for madness.

27

Chen Zhenyuan (dates unknown)
A Reincarnation of Ink Treasures, 1935

Ink on paper, 85.9 x 46.6 cm (33⅞ x 18⅜ in.)
Anonymous gift in memory of William W. Mellins, 2017.21

In 1935, Chen Zhenyuan sat down in his college dormitory to create a bapo scroll that followed the conventions of literati painting—restricting his use of color to primarily black ink and concentrating only on the refined art of calligraphy. Chen's composition, titled *Mo bao huashen* (*A Reincarnation of Ink Treasures*), includes objects from throughout the long history of Chinese literati culture—from the tenth century BCE to the late Qing dynasty. At first glance, his assemblage reflects the passions of a scholarly life. However, he has hidden auspicious symbols and good wishes for the recipient beneath his veneer of sophistication.

Chen includes a rubbing of a distinguished and famous calligraphic stone carving, the Lu Xiao Wang stone, now at the Confucius Temple in Qufu, Shandong, the ancestral home of Confucius. The characters were originally written in seal script by Prince Xiao of Lu (an ancient name for the Shandong region) in the year 56 BCE. Renowned for being the earliest example of characters carved in stone, the inscription was frequently reproduced through rubbings and publications of those rubbings. The imagery would have been easily accessible to Chen Zhenyuan—either in a published book or in a rubbing.

The most prominent image in the assemblage is a rubbing of four seal-script characters reading, "An auspicious day in the *kuiyi* cyclical year." The four ancient characters were first discovered on Tan Mountain in Hebei Province during the Song dynasty. They are believed to have been written by the Zhou dynasty king Mu in the tenth century BCE—nearly two thousand years earlier. The powerful lines of

the strokes and the elegant balance of the characters were highly praised by connoisseurs, and the work was deemed a *juepin*, a "peerless artwork." Rubbings of these characters circulated widely and were reproduced in printed books. Chen Zhenyuan most likely owned a copy of a copy of a copy. Chen's execution of the characters comes remarkably close to the original. Moreover, he creates an extra layer of authenticity by adding indications of age and damage to his rendering of the surface of the stone. Including this famous work of calligraphy announces his literati sensibilities, but the first word, *ji*, or "auspicious," indicates his secondary intentions.

Several other works in the composition follow this pattern of double meanings. A "rubbing" of seal-script calligraphy, inscribed in the style of Chen Hongshou (1768–1822), appears in the bottom left-hand corner of the composition. It reads, "Long life, good fortune, harmony, and good omens." Although it appears to have been taken from an ancient stone, it is probably a complete fabrication. A fictitious handwritten letter toward the bottom also includes the character for longevity. And in the top left-hand corner, Chen reproduces a fragment of a scholarly publication, the title slip of a book compiled in Japan called *Record of a Quest for Ancient Classics and Texts* (*Keiseki hōkoshi*, known in Chinese as *Jing ji fang gu zhi*).[78] Published in 1885, this is a bibliography and catalogue of Chinese rare books in Japanese collections, written by a Japanese doctor and scholar, Shibue Chusai (1805–1858). The inclusion of this work may have been an indirect comment on the growing encroachment by the Japanese on Chinese soil.

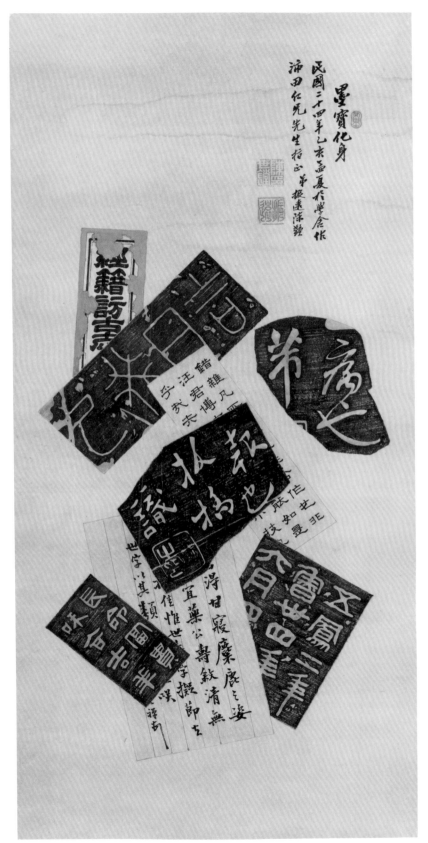

28

Zhang Fa (dates unknown)
Picture of Many Happinesses, late 19th– early 20th century

Ink and color on paper, 32.5 x 134.4 cm (12¾ x 52⅞ in.)
Anonymous gift in memory of William W. Mellins, 2013.579

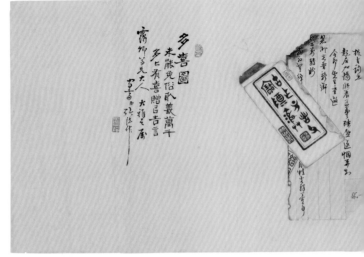

28

"I have chosen among the thousands of symbolic expressions. I wish you will receive their good fortune and blessings." Artists often used the bapo motif to carry auspicious messages. The inscribed title of the painting *Picture of Many Happinesses* (*Duo xi tu*) by the artist Zhang Fa hints that curious viewers should search for the multiple good wishes presented in the composition. The process of viewing the painting becomes a fun game of scholarly trivia—with wishes for good fortune as the reward.

At the far right of the horizontal scroll, the artist has painted a spider crawling across the surface. The word in Chinese for spider, *xi*, is a rebus for "happiness," also pronounced "xi." The spider is edging toward a title slip for a work written by the great Song calligrapher Huang Tingjian, *The Pavilion of Pines in the Wind* (*Song feng ge shi tie*). It's not clear why the artist chose this work as a symbol of

happiness—a mystery for future scholars to decipher. Interestingly, the artist—either intentionally or unintentionally—miswrote one character on this title slip, substituting one character *shi*, meaning "to attempt," for a different character *shi*, meaning "poetry."

Moving across the painting from right to left the viewer sees, partially concealed behind a fan painting, the title page of a woodblock printed book, *One Hundred Butterflies* (*Bai die tu*). The book contains one hundred paintings of butterflies alongside poetry about butterflies. The Chinese word for butterfly, *die*, sounds like the word for septuagenarian. Therefore, butterflies can promise longevity, just as the number one hundred implies that the recipient should live to be one hundred years old. Though the book was published in 1830, the artist has—again, either intentionally or unintentionally—changed the

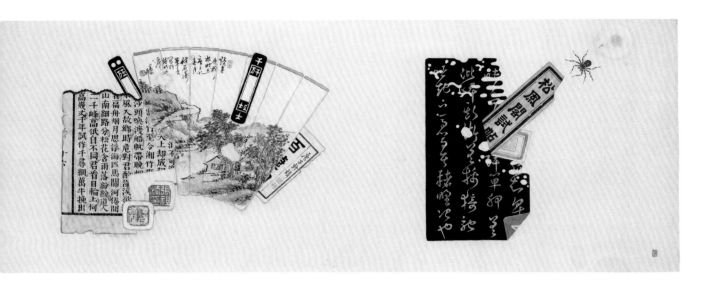

publication date on the title page to a cyclical date of *gengzi*, equivalent to 1840.

The remnant of a fan painting depicts a landscape scene that the inscription tells us is in the style of the famed early Qing dynasty monk artist Shitao (born Zhu Ruoji, 1642–1707). Like the book, the painting is also dated with the cyclical date of the gengzi year. Chinese two-character cyclical dates repeat every sixty years, and the repetition of the gengzi date in the painting may be a clue to the date the painting was created—perhaps 1900. But why a painting by Shitao? The character for *tao* in Shitao's name contains within it the character for longevity.

The artist has added several black and white Chinese playing cards—with high denominations—to further symbolize wishes for longevity or wealth. One reads fifty thousand, the other the improbable one thousand ten thousands. More "thousands" and "ten

thousands" characters appear in the partially burnt and deteriorating page from a book of poems that includes works by the Ming poets Li Zongren and Xu Juzheng.

Zhang also depicts several impressions of seals, the traditional Chinese form of a signature. The common character for seal is pronounced "yin," but an alternative character for seal is pronounced "xi." The seals Zhang depicts therefore are puns on the word for happiness, also pronounced "xi." The artist adds scraps of two seal imprints to symbolize even more happiness. One of these seals, to add to the humor, is a seal of the artist himself, "Zhang Zufa." A personal letter to the left wishes an elderly man good health, and alongside it is a Daoist amulet guaranteeing further beneficial properties. Zhang's intentions are clear—to use references to both ancient and popular culture to promote auspicious messages.

29

Tan Qinghuan (dates unknown)
Vertical scrolls with vases and bapo, 1936

Ink and color on paper, each: 126.3 x 31.4 cm (49¾ x 12⅜ in.)
Anonymous gift in memory of William W. Mellins, 2017.28.1-4

Most bapo works emphasize ancient objects as part of a meditation on Chinese history and culture. In this set of four works, Tan Qinghuan focuses on objects that represent the new century and the new culture that had been bubbling up since the fall of the imperial government. He also introduces political commentary—with details that allude to Japan's occupation and creation of the Manchu state in northeastern China.

A prominently displayed primary-school textbook for the New National Language (*Xin guo wen*) celebrates this postimperial era. Because of the size of China, its people had been speaking mutually incomprehensible languages and dialects for centuries. In an attempt to finally unify and modernize the country, a movement for a national language, *guoyu*, was started in 1909—the waning days of the Qing dynasty. After the overthrow of the imperial government, the Republic of China immediately adopted the campaign—and set out to spread a new national language through the education of young people.

Another symbol of this modernized society was the international Gregorian calendar that Tan depicts in the same grouping. However, a close look at the exposed page for March 29 reveals Japanese lettering—no doubt a reference to recent political changes within China's borders. In 1931, Japan had invaded Manchuria, the homeland of the Qing dynasty, and established a puppet state, Manchukuo (*manzhouguo* in Chinese), with the deposed last emperor of China, Puyi, as its puppet head of state.

Tan reinforces the theme of Japan's continental encroachment with another display of modernity—the postal system. He displays an envelope addressed to Zhang Shoufeng on Jixiang Street, in Shanghai, sent from the provincial government of Jilin at Changchun (today the capital of Jilin Province, at that time the capital of Manchukuo). Tan deftly painted a specific stamp on the envelope with a cancellation mark dated the first day of the third month of the first year. The stamp, according to its inscription, was issued by the Manzhou (Manchukuo) Empire Postal Service, and depicts the Liaoyang White Pagoda, said to have been built by an ancestor of the Manchu Qing dynasty rulers during the Jin dynasty (1115–1234). The stamp's political message was the legitimacy of the Manchukuo state and the Manchu right to govern the region. Underscoring that claim was the "first

year" postal cancellation, referring to the first year of the Manchukuo state.

Side by side with his references to the political situation, Tan punctuates his assemblages with auspicious wishes. Individual characters, incorporated into compound words on the envelope from Manchukuo, for instance, proffer good fortune. The *shou* in the recipient's name—Zhang Shoufeng—also means longevity. His address is Jixiang, "Auspicious" Street, in Shanghai. And the *ji* in *Jilin* denotes "lucky." An inscription on one of the set of four paintings clearly states the painting's propitious intentions: "Although this is not a priceless treasure it can still bring cheer and benefit for long life."

Good fortune also peeks out from less political objects. A bright yellow matchbox label with the woodblock-printed image of a flying insect pops out from one assemblage. The inscription on the label notes that the matches were made by the Zhong Fu company, one of the earliest matchstick companies in China, established in Yantai in 1915. The character for *fu* in *Zhongfu* designates a type of a water beetle—which is pictured on the label—but is also a type of ancient money in China. The presence of the bug here was intended as a wish for prosperity for the painting's recipient.

Into his collage of ancient wisdom, current politics, and good wishes, Tan also tosses a bit of humor. He includes the book cover for *Extensive Records from the Forest of Laughter* (*Xiaolin guangji*). This book of jokes, many quite bawdy, was first published during the late Ming dynasty, and then reprinted several times during the eighteenth and nineteenth centuries.[79] Tan depicts an edition with a blurb across the top proclaiming: "As soon as you see it, you laugh out loud." Humor, and certainly lewd jokes, were so frowned upon in proper Confucian society that the author of this book could not reveal his true name, calling himself only the "Master of Play." The presence of a humor book among the more serious literary ephemera highlights the flexibility of the bapo genre, which could incorporate not only modern life, but humor as well—a rare commodity in Chinese painting. Or was the humor a way to balance the harsher political commentary of the Manchukuo references?

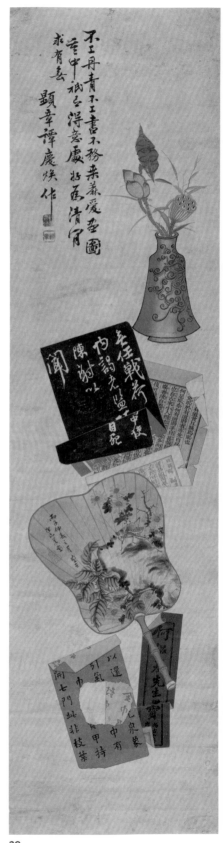

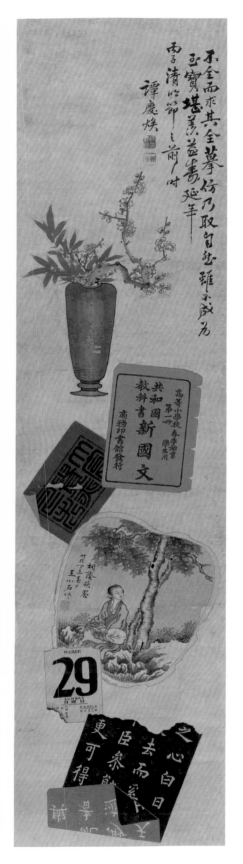

29

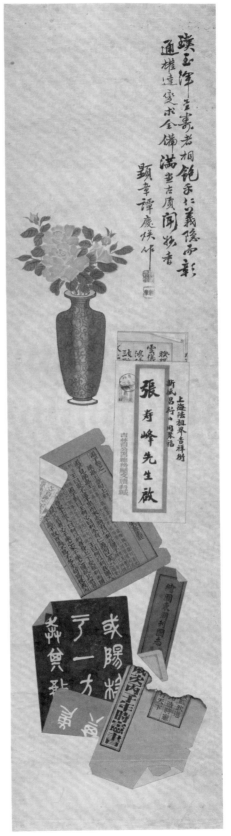
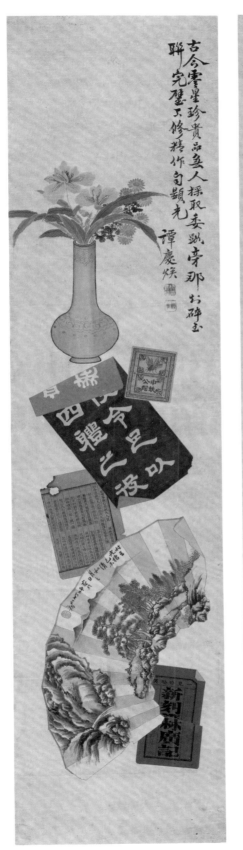

Wang Zhexiang (dates unknown)
Mounted flat folding fan with rubbings, printed pages, and cigarette paraphernalia, 1920

Ink and color on paper, 42 x 18 cm (16½ x 7⅛ in.)
Anonymous gift in memory of William W. Mellins, 2017.38

Wang Zhexiang was not an exceptional artist, but the fan he produced in 1920—filled with both traditional literati and fashionable contemporary items—reflected China's growing fascination with modern European and American influences. Alongside texts by the ancient philosopher Mencius—and an unconvincing copy of a calligraphic rubbing—are testimonies to new printing technologies and evolving graphic cultures in China.

A viewer of the fan would have noticed that the depiction of a landscape painting by the Ming artist Wu Wei had been reprinted by—as can be seen in large red letters on the page—the renowned Shanghai press Dianshizhai. In 1876, Dianshizhai had revolutionized Chinese visual culture by introducing European lithographic technology—initiating the mass reproduction of historical and contemporary imagery. The pages depicted on Wang's fan would have been photolithographic reproductions from an older woodblock-printed book, such as the *Mustard Seed Garden Painting Manual*. Just as woodblock-printed reproductions had been used to disseminate paintings once available to only the most privileged, lithographic reproductions made these works even more accessible. Bapo artists, often not well to do

themselves, were clearly influenced by the exploding accessibility of reprinted books, texts, and paintings made possible by lithography and collotype printing.

Wang's fan goes beyond the reproduction of classical works to present other aspects of changing lifestyles in China. He includes two cigarettes, labeled "Dragon Cigar" in English; a matchbox printed with the image of a phoenix; and a colorful printed cigarette card.[80] Tobacco had first come to China as early as the late sixteenth century, with European sailors and traders, and slowly spread through all strata of society. Tobacco companies in the United States developed prerolled cigarettes during the mid-nineteenth century—and these manufacturers soon turned their eyes toward China and its potentially enormous market.

James B. Duke, owner of the American Tobacco Company, reportedly looked at an atlas, saw that the population of China was 430 million, and said, "That is where we are going to sell cigarettes." The first commercial batches arrived in 1890. By 1905, British-American Tobacco Company factories were producing cigarettes in Shanghai. The promotion of cigarettes became incessant throughout China's cities and countryside. And the ephemera of cigarette

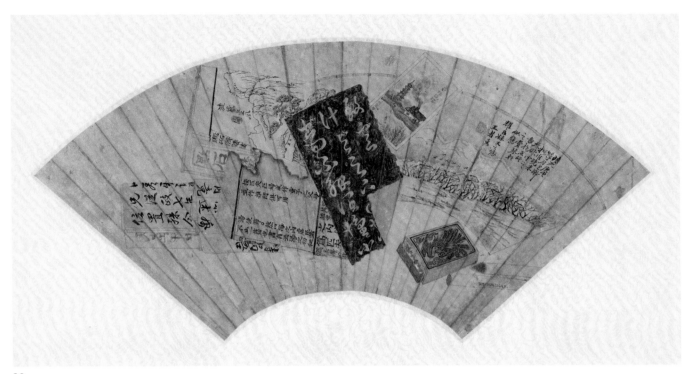

30

packaging—graphically compelling for commercial purposes—was everywhere. Colorful posters were used to sell cigarettes on the streets. Decorated cigarette cards—small illustrated cardboard inserts used to stiffen soft cigarette packaging—lured potential customers. Produced in a wide variety of series—from portraits of beautiful women to opera scenes, and from flowers to occupations—the cards quickly became collectors' items. The card Wang reproduces in his painting is titled *Yin yan rao ta*, or "Cooking smoke whirls around the pagoda," from a series of fifty scenic images produced in 1918 by the Guangdong Nanyang Brothers Tobacco Company.

The popularity of cigarettes also helped create a growing match industry. Though the Chinese can lay claim to having invented the first matches in the sixth century, the mass production of matchsticks began only in the mid-nineteenth century.[81] Chinese manufacturers started producing matches for the Chinese market in 1879. Mass production required mass merchandising, and graphically appealing matchboxes began to flood China by the end of the nineteenth century. While matchbox labels did not have the same scholarly significance as ancient calligraphy, collecting them became a popular pastime—and soon they provided a new source of material for bapo artists.[82]

31

Wang Chao (born in 1974)
Bapo Picture of a Pile of Brocade Ashes, 2006

Woodblock printed on paper, 68 x 46 cm (26¾ x 18⅛ in.)
Collection of Alfreda and Christian Murck
Reproduced with permission

With renewed interest in bapo slowly spreading in China over the past few decades, artists of nonpainting mediums have also been dabbling in the genre. Print artist Wang Chao is one example. He is known for his use of a traditional but sophisticated color-printing technique—using multiple wooden blocks—that was developed in the seventeenth century. His bapo print is an example of an accomplished artist working in his own style who, finding certain themes of bapo resonant with his own thinking, adopts the genre for a single work.

In *Jinhuidui bapo tu* (*Bapo Picture of a Pile of Brocade Ashes*), Wang uses printing techniques to create an imitation of an imitation—a virtual bapo painting in print. The print depicts a rubbing, book covers, letters, a page from a printed book, a tracing of a calligraphy, and the title slip of a seal manual from one of the great printing workshops of the

seventeenth century, the Ten Bamboo Studio (Shi Zhu Zhai). Wang, following the bapo model, combines a range of calligraphic styles with different types of printing and reproduction—rubbings, lithography, woodblock prints, and seals.

At first glance, the assemblage may appear to be, like much of bapo painting, about calligraphy and reminiscence. But Wang is not interested in the more typical messages of bapo—mourning the deterioration of the past or wishing good fortune upon a recipient. Instead, his work plays on his personal passion for the woodblock print media. Many of the titles and texts represented include the character *yin*—"to print." All of the objects are reproductions of reproductions. And the work offers his reflection on the concepts of replication, reproduction, and printing—his own medium and craft.

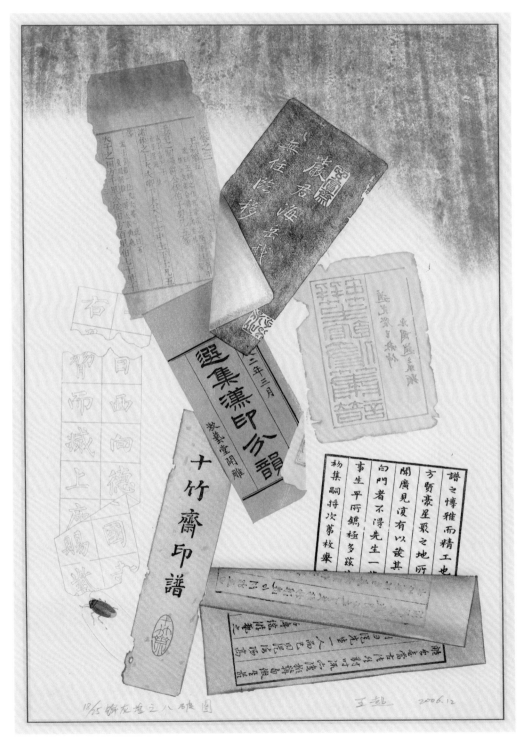

32

Geng Xuezhi (born in 1973)
***The Jade Rabbit Welcomes the Spring*, 2016**

Ink and color on paper, 140 x 50 cm (55⅛ x 19⅝ in.)
Collection of the artist
Reproduced with permission

33

Geng Xuezhi (born in 1973)
Painting depicting text from *Zeng Guang Xian Wen*, 2013

Ink and color on paper, 33 x 33 cm (13 x 13 in.)
Anonymous gift in memory of William W. Mellins, 2017.7
Reproduced with permission

Many of the artists who produced works of bapo during the late twentieth century were carrying on a tradition passed to them before 1949. A few artists have discovered—and adopted—the bapo theme more recently. Geng Yuzhou (born in 1945) and Geng Xuezhi (born in 1973), father and son artists from Zhou Village outside Zibo in Shandong Province, began painting bapo works in the early 2000s. They have become two of its most ardent advocates. In addition to enthusiastically spreading knowledge about bapo through newspaper articles and television documentaries, they have even convinced the postal system to issue a bapo stamp.

The elder Geng, the son and great-grandson of artists, enjoyed painting as a child, and spent his free time copying images from a reprint of the seventeenth-century *Mustard Seed Garden Painting Manual*. His practice paid off, and he was invited to attend the prestigious Zhejiang Art Academy (now the China Academy of Art), where he specialized in bird-and-flower painting. He returned to village life during the Cultural Revolution, but moved to Beijing in 1993.[83] He first encountered bapo there in 1999—when he met the artist Song Yiqing (1918–2007).

Song had learned bapo painting in Beijing—before 1949—from the bapo artist Liu Baojun (1901–1951). By 1999, Song was eager to find a talented artist who would study the technique and prevent it from disappearing. He pleaded with the elder Geng to study bapo—and carry on the tradition. Geng then studied with Song in Beijing for five years.

Geng Yuzhou's son, Geng Xuezhi, also born and raised in Zibo, confesses that as a child he did not attend to his schoolwork but instead studied painting with his father—following the styles of Shanghai-school artists such as Ren Bonian and Wu Chang-shuo. By 2006, he had adopted his father's commitment to bapo. Dedicated to preserving the art form, the younger Geng established the Zhou Village Jinhuidui Art Exhibition Hall and was instrumental in bapo's being recognized as a provincial-level Intangible Cultural Heritage.

The younger Geng creates dynamic compositions in his works, infusing them with a sharp graphic sensibility. This contemporary aesthetic is apparent in a work depicting a single object, rather than the usual collage of multiple items in bapo works (cat. 33). Geng presents the viewer with an

organically shaped burnt page from a classic ancient Chinese proverbs book. *Zeng guang xian wen* (*Expanded Writings of the Virtuous*) was a children's primer probably first assembled in the late sixteenth century. In rhymed couplets, the text proffers axioms, proverbs, and wisdom from the sages, focusing primarily on proper social behavior. Geng display his skill in reproducing with his brush the hard-edged characters carved in wood to make a printed book. He also creates a satisfying and engaging abstract shape that shows his modern eye.

Instead of only harking back to ancient Confucian or scholarly texts, he also includes modern material in some of his assemblages. A New Year's painting for the Year of the Rabbit (cat. 32) includes a Shandong village paper cut of a rabbit, contemporary newspapers with articles on the New Year, children's cartoons, and the cover of a children's book from the 1950s. All of the items are fragmentary. One scrap is a child's drawing of a rabbit, Geng's copy of a work by his own daughter. Unlike most classical bapo paintings, this scroll doesn't focus on ancient calligraphy—or nostalgia for ancient texts. The sentiment, however, is nostalgic for the 1950s, now imagined as an earlier, simpler time.

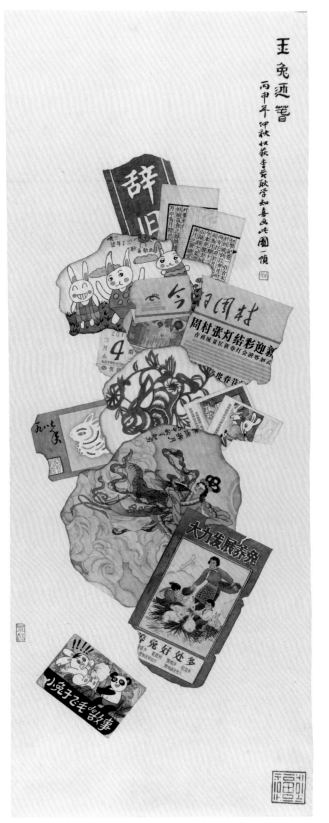

32

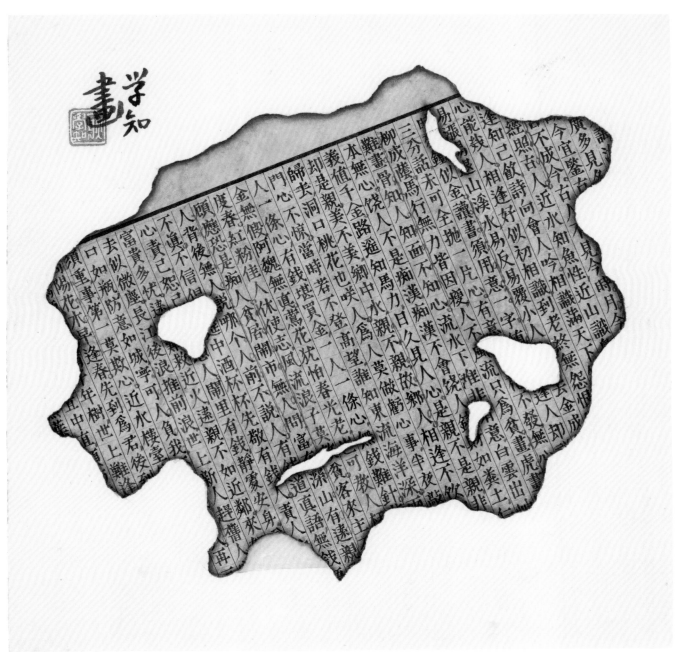

33

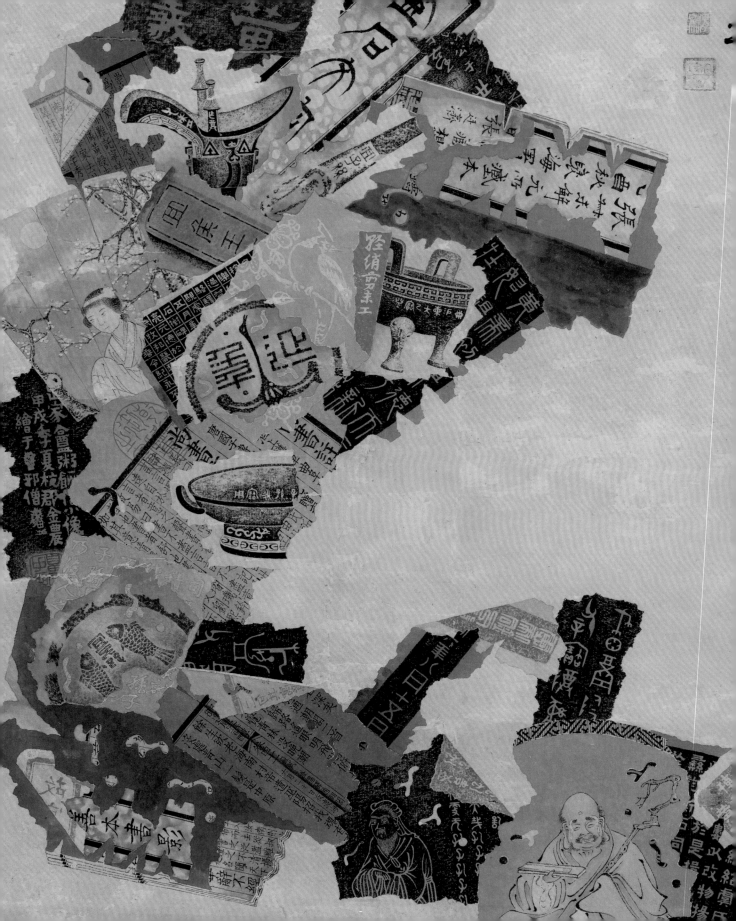

Notes

ROOTS AND BRANCHES OF BAPO

1 The essay by Zheng Yimei (1895–1992) titled "Bai Yang Jin" (One hundred types of brocade) was first published in the newspaper *Xin Ye Bao*; the exact date of publication is unknown, but the newspaper appeared between 1932 and 1936. The essay was republished in 1947, and again in 1991 in *Zheng Yimei xuanji* [Selections from Zheng Yimei] (Shanghai: Shanghai Shudian, 1991), vol. 3, p. 683.

2 There are many different names for this style of painting, indicating the absence of any consensus about the origins or development of the art form. Among these are *bapo* ("eight brokens"), *jinhuidui* ("a pile of brocade ashes"), *duanjian canpian* ("broken bamboo slats and damaged sheets"), *shipo* ("ten brokens" or "picking up brokens"), *dafan zizhilou* ("turned upside-down basket of inscribed papers"), and *buquetu* ("a picture of mending the damaged").

3 Chu Jun, "Xinghua feiwuzhi wenhua yichan zhanlan-guan zhi si" [The Fourth Xinghua intangible cultural heritage exhibition hall], posted on the You Duo Duo website: http://www.yododo.com/area/guide.

4 The painting is described in the 1745 catalogue of paintings and calligraphies in the Qianlong-period imperial collection, *Shiqu baoji chubian* (Collected treasures of the stony moat), p. 1049.

5 A work by the Tang dynasty poet Wei Zhuang (836–910), *The Lament of the Lady Qin* (*Qin fu yin*), describes the charred remnants of brocades and embroideries in the imperial storage after a violent military conquest of the palace—during the poet's lifetime.

6 See Martin J. Powers and Katherine Tsiang, eds., *A Companion to Chinese Art* (Sussex, UK: John Wiley and Sons, 2016), p. 467.

7 I am grateful to Wang Yifeng, curator at the Zhejiang Provincial Museum, for introducing me to the work of Liuzhou. His most recent publication on Liuzhou is *Guzhuan huagong: Liuzhou yu 19 shiji de xueshu yu yishu* [Ancient bricks accompanied by flowers: Liuzhou and nineteenth-century scholarship and art] (Hangzhou: Zhejiang Meishu Renmin Chubanshe, 2017).

8 A 1933 painting by Lu Zhongda in the collection of the Museum of Fine Arts, Boston, for instance—depicting only papers, rubbings, and copies of calligraphy—was titled *Bogu tu* (*Bogu Picture*) by the artist.

9 For a translation of *Gegu yaolun,* see Sir Percival David, *Chinese Connoisseurship* (New York: Praeger Publishers, 1971).

10 The mural is found in Cave 103. It is reproduced in Michael Sullivan, *The Arts of China*, 4th ed. (Berkeley: University of California Press, 1999).

11 Xu Hao (703–782), *Gu ji ji* [Record of ancient vestiges]. Recorded in Zhang Yanyuan (about 815–about 877), *Fashu yaolu* [Important records on model calligraphies], seventeenth-century Ji Gu Ge edition, vol. 3, p. 32. I am grateful to Professor Hui-Shu Lee for directing me to this and other Tang references describing this custom.

12 In Li Yu, *Xianqing ouji* [Enjoyment in leisure time], first published 1671; *Hangzhou zhejiang guji chubanshe* (1985), pp. 201–2. Translation based on Michael Sullivan, "Notes on Early Chinese Screen Painting," *Artibus Asiae* 27, no. 3 (1965), pp. 239–64. Li Yu describes elsewhere in his writings a design for wallpaper that seems to foreshadow bapo: "Take pea-green cloud-pattern letter paper and tear it into small pieces, some squarish, some asymmetrical, some short, others long, some with three corners and others with four or five, but none of the pieces round. Randomly paste these onto the soy-colored paper." Quoted in Jonathan Hay, *Sensuous Surfaces: The Decorative Object in Early Modern China* (Honolulu: University of Hawai'i Press, 2010), p. 306.

13 I am grateful to Suhyung Kim for her gracious assistance in researching this object. For a detailed study of this screen, see An Bora, "A Study of 'Baeknapdo Byungpung' in the Late Joseon Period," in *Misulsa Yeongu: Journal of Art History* 27 (December 2013): 323–51. The Korean term for these screens is *baeknapdo*, meaning "one hundred stitches (or patchwork) screen." In Chinese, the term *baina* originally

referred to the patchwork robes worn by Buddhist monks—and then to patchwork clothes created and worn with auspicious intentions. In Song China, the term *baina* was also employed to refer to books that were compilations of unfinished texts.

14 Europeans called these Chinese lacquer screens Coromandel screens because they were, with many other goods from China, transshipped to Europe and England from ports on the Coromandel Coast in southeastern India.

15 Chaves's essay was printed as the introduction to an untitled, undated catalogue published by Cedric Curien, owner of the gallery Art Asiatique in Marseille, France.

16 The screen is not unique. A Kangxi-carved lacquer screen at the Ashmolean Museum at the University of Oxford also displays paintings and calligraphies in a similar grid pattern.

17 See Zhu Yong, "Weishenme shuo shier meiren tu quanbu shi Yongzheng lixiangzhong de nuzi xingxiang?" [Why say that the Twelve Beauties are the Yongzheng ideal form for women?], published on June 5, 2014, on the Xinlang Blog: http://blog.sina.cn/dpool/blog/s/blog_a429b89d0101j0ol.html.

18 The history in Chinese art of playing with "paintings within paintings" goes back at least to the Five Dynasties period (907–60). The renowned handscroll painting *Night Revels of Han Xizai* (*Han Xizai Ye yan tu*) by Gu Hongzhong (937–975), at the Palace Museum, presents an evening gathering in a luxurious household, with several large screens decorated with landscape paintings. Even more clever, from the same time period is another painting in the Palace Museum attributed to Zhou Wenju (tenth century)—though probably a Song copy of the original—*Playing Chess before a Double Screen* (*Chong ping hui qi tu*), depicting men sitting on a platform engaged in a chess game. Behind them is a standing screen displaying a painting of people in front of yet another painted screen.

19 Susan Bush and Hsio-yen Shih, *Early Chinese Texts on Painting* (Cambridge, MA: Harvard University Press, 1995), p. 224.

20 *Shixue jingyun* (Beijing, 1735), translated by Nian Xiyao and Giuseppe Castiglione. A copy is held by the University of Glasgow Library.

21 For a thorough discussion, see Kristina Kleutghen, *Imperial Illusions* (Seattle: University of Washington Press, 2015).

22 The Household Registry (*huoji dang*) Imperial Household Department (*neiwufu*) of the Qing court includes numerous directives from the emperor to the imperial atelier, the Ruyi Guan, to create *tongjinghua*. For instance: On the twelfth day of the tenth month in the fortieth year of the Qianlong reign (1775) there is a request for "a *tongjing hua*

on the west wall of the central room in Yu Cui Xuan pavilion, to be painted by Yao Wenhan."

23 Translation from https://www.yellowbridge.com/onlinelit/hongloumeng-en.php.

24 The print is in the Umi-Mori Art Museum in Hiroshima, Japan. A second print, very similar to it and from the same year, is in the National Diet Library in Tokyo, published in Hiroyuki Takimoto, *Chūgoku kodai hanga ten* [Exhibition of Chinese woodblock prints] (Machida City: Shiritsu Kokusai Hanga Bijutsukan [Machida City Museum of Graphic Arts], 1988).

25 In his book *Zhuangzi: Thinking Through the Inner Chapters* (St. Petersburg, FL: Three Pines Press, 2014), Wang Bo gives numerous examples of the supremacy of people with disabilities or deformations.

26 "Chou fu fuhua wei shenqi" (The fetid and rotten are transformed into the ethereal and marvelous).

27 *Gegu yaolun*, p. 140; translation in David, *Chinese Connoisseurship*.

28 Discussed in an unpublished paper by Rachel Silberstein, "Shuitianyi: Patchwork in Chinese Dress Culture." The seventeenth-century critic Li Yu railed against the fashion. "What crime has the cloth committed that it should be subjected to death by dismemberment?" he wrote, as quoted in Patrick Hanan's *The Invention of Li Yu* (Cambridge, MA: Harvard University Press, 1988), p. 72.

29 Some scholars believe the custom goes as far back as the Song dynasty, but it probably did not become formalized and widespread until the mid-Qing; see Joseph McDermott, *A Social History of the Chinese Book: Books and Literati Culture in Late Imperial China* (Hong Kong: Hong Kong University Press, 2006), pp. 182–83. Though certainly rare, the custom does still exist. Tang Suguo, a Chinese artist, told me that he once saw an elderly Chinese man at the San Francisco airport wearing a bag marked with the four characters *jing xi zi zhi*.

30 *Wen Chang bao xun* (Wen Chang's precious teachings) states that those who protect inscribed papers will be rewarded. "Each and every leisure character, all are the same as in the scriptures and the sutras. The reason is since ancient times there have been people who cherished (*xi*) characters. Each time they are rewarded by establishing their names (in the civil examination system). Also they are rewarded by achieving long life, and by having many children."

31 This author has seen ceramic wall vessels labeled with the two characters *zi zhi*, and an older scholar reported that as a child *all* calligraphy practice papers were thrown into separate wastebaskets so as to distinguish them from ordinary garbage. This same scholar reported that though he was not superstitious, and was not a member of a *zizhihui*, he would never use paper with writing as toilet tissue. There have been numerous writings from nineteenth- and early

twentieth-century observers and historians of the practice. Among them are John MacGowan, *Sidelights on Chinese Life* (Philadelphia, 1908), pp. 249–50; H. Y. Lowe, *The Adventures of Wu* (Beijing: Peking Chronicle, 1940); Qian Cunxun, *Zhongguo Shuji, zhimo, ji yinshuashi lunwen ji* [A collection of articles on Chinese books, paper and ink, and printing history] (Hong Kong: Zhongwen Daxue Chubanshe [Chinese University Press], 1992), p. 92.

32 Zheng Yimei wrote about the connection between bapo painting and the "turned-over basket of inscribed papers" in an essay that was republished in *Qing yi man bi* [Pure entertainment unrestrained writings] (Shanghai: Shanghai shu dian yin xing, 1982).

33 See Wong Ching Him Felix, "The Images of the Taiping Heavenly Kingdom as Shown in the Publications in France, Germany, and Italy during the Second Half of the Nineteenth Century," *Journal of Chinese Studies* 55 (July 2012), http://www.cuhk.edu.hk/ics/journal/articles/v55p139.pdf.

34 As quoted in Vincent Yu-Chung Shih, *The Taiping Ideology: Its Sources, Interpretations, and Influences* (Seattle: University of Washington Press, 1967), p. 43.

35 Quoted in Shih, *Taiping Ideology*, p. 43. From the manuscript "Manfen huibian" (A compilation of savagery) by Yao Xianzhi, quoted by Xie Xingyao in his "Taiping hua," *Yijing* 3 (April 5, 1936), p. 24.

36 See David R. Knechtges, "Ruin and Remembrance in Classical Chinese Literature: The 'Fu on the Ruined City' by Bao Zhao," in Paul W. Kroll, ed., *Reading Medieval Chinese Poetry: Text, Context, and Culture* (Leiden: Brill, 2014), pp. 55–89. For more on *huaigu*, see Wu Hung, *A Story of Ruins: Presence and Absence in Chinese Art and Visual Culture* (London: Reaktion Books, 2012), p. 18.

37 Jiang Xingyu, *Yuan ou jiangshang cidian* [Dictionary of appreciating Yuan songs] (Shanghai: Shanghai Cishu Chubanshe, 1990), p. 555.

38 Li Yingsheng, "Tan Wen Tianxiang Deng Yan Chang He Ci 'Lei Jiang Yue'" [A discussion of Wen Tianxiang and Deng Yan's songs and Ci poems, Lei Jiang Yue], *Journal of Xuzhou Normal University* (Philosophy and Social Sciences edition) 2 (1982): 15–18.

39 Translation adapted from Yifeng Yao, *Nanjing: Historical Landscape and Its Planning from Geographical Perspective* (Singapore: Springer Media, 2016), p. 88.

40 I thank the great decorative arts scholar Wang Shixiang for first drawing my attention to Qian Xuan's use of this phrase. Wang himself used the expression as a title for a collection of his essays, thereby humbly describing his works as "mere ashes."

41 Translation from Robin Yates, *Washing Silk: The Life and Selected Poetry of Wei Chuang* (Cambridge, MA: Council on East Asian Studies, Harvard University, 1988), p. 254.

42 Popular wisdom today links the word *ba* ("eight") to the Cantonese pronunciation of *fa*, the first character of the compound word meaning "to prosper," but further research may reveal other reasons for favoring the number eight.

43 Zhang Cisheng, *Wenwu tu zhu* [Pictures and explanations of cultural relics] (Tianjin: Yangliuqing huashe, 1990).

44 Recounted in an interview at the Chinese History Museum in Beijing during the spring of 1992.

45 This author has been researching bapo in discussions with curators, art historians, artists, and painting dealers since the early 1980s. At that time, few were aware of the word *bapo* or had ever seen paintings in the genre.

46 Zheng Yimei, *Zheng Yimei xuanji* [Collected works of Zheng Yimei] (Ha'erbin: Heilongjiang ren min chubanshe, 1991).

47 Viewed at the home of Marianne Bujard in Beijing.

48 Information about Chen Bingchang is taken from writings about him by Li Guimei, "Wo jiao qingnian jiao zoufang xianxian Chen Bingchang Guju" [My school's young teachers travel to visit the home of the distinguished Chen Bingchang], published online on November 16, 2012, http://www.jygkcz.cn/Item/571.aspx; and on a blog written by Wang Xinglai, "Jiangyan Guohua Huiwang" [Looking back at Chinese paintings from the Jiangyan region], chapter 6, "Chen Erzhi," http://blog.sina.com.cn/s/blog_6028582b0100mxnj.html.

49 Information about Yang Renying is from a meeting with the artist in his home in 1992.

50 "Zhuanfang Nongmin huajia Sun Zhijiang: cong tianyuanhua dao bapo tu" [An interview with peasant artist Sun Zhijiang: From paintings of the fields to bapo painting]. Published on the internet February 25, 2013, http://info.jj.hc360.com/2013/02/251848587115.shtml.

51 As related to this author in conversation with Geng Yuzhou and Geng Xuezhi, October 17, 2016.

52 Xu Beihong studied at the École nationale supérieure des beaux-arts in Paris beginning in 1919, returning to Shanghai in 1927.

53 Zhang Peiyuan, "Xinghua ji Huajia Niu Chuanli zai Kangzhan shiqi de Chongqing" [Xinghua native artist Niu Chuanli in Chongqing during the anti-Japanese period], http://www.360doc.com/content/11/0315/09/6279336_101230322.shtml.

54 This information about Niu Chuanli is derived from the above article and a 2011 interview with his son published online in *You zai Taizhou* as "Niu Chuanli yu tade 'shipo hua'" [Niu Chuanlu and his *shipo* paintings], http://www.360doc.com/content/11/0315/09/6279336_101229857.shtml.

55 Interview with Niu Chuanli, http://www.mll5.com/4313799675/.

56 The print shown provides no publication information.

CATALOGUE

1 Both works by Wu Chunkui were acquired in Tianjin, potentially a clue to Wu's working location. A number of other artists, including Liu Lingheng, worked in Tianjin. This northern commercial port city near Beijing may have been a center for bapo painters.

2 The Shanghai lithographic printing establishment Hong Bao Zhai reprinted the collection of model calligraphies in 1897. The stones are still preserved in Beihai Park in Yuegulou—where the emperor installed them. During a February 2017 visit, the author confirmed that the Mi Fu block is still in fine, uncracked condition.

3 Yun Shouping paintings, for instance, were reproduced in lithographic printings by the Dianshizhai publishing outfit in the 1880s. See Roberta Wue, *Art Worlds: Artists, Images, and Audiences in Late Nineteenth-Century Shanghai* (Honolulu: University of Hawai'i Press in association with Hong Kong University Press, 2015), p. 100.

4 The gazetteer is posted online at http://lib.sdsqw.cn. Curators at the Palace Museum Calligraphy and Painting Department searched their inventories in 2014 and 2016 and did not find any records of paintings by Liu Lingheng.

5 On a 2016 visit to Liujia Xingwangcun—still a sleepy farming village—several residents told me they had a vague memory that such an artist had once lived there, but his fame had definitely faded.

6 At least one work done by the two of them—a set of four bapo vertical strips—is still extant. It sold at auction on May 26, 2014, at the Pacific Ocean International Auction Ltd. Company in Beijing. See http://news.pmv.cn/zp/950377.html.

7 Another work by Liu Lingheng, now in a private collection, includes an inscription by a buyer who describes the difficulty of obtaining Liu's work: "Liu Lingheng is from my hometown. . . . First he was in Tianjin and participated in exhibitions of famous people's paintings and calligraphies. The elder Wang Yingchen saw them and asked me to request a painting. But, meanwhile, Mr. Liu is getting old, his eyes cannot see well, so he cannot paint for him. When I asked him to bring out any older work, he could not find one."

8 Now in the collection of the Shanghai Museum.

9 There are at least four extant rubbings from the late nineteenth and early twentieth centuries. Two appear in a Chinese-language digital archive, at http://catalog.digital archives.tw/item/00/1b/c4/d6.html and http://catalog .digitalarchives.tw/item/00/1b/a6/e9.html. The third, created by the epigrapher Wang Shijing (1831–1918), was sold at auction in June 2017 and is reproduced in the auction catalogue, http://www.epailive.com/goods/8810632 (in Chinese). The fourth, by Chen Jieqi (1813–1884), was definitively made before Liu created his painting; image at https://www. blouinartsalesindex.com/auctions/--6611899. Many books

include rubbings or reproductions of the text on the *hu* cover, but only those published after 1911 reproduce rubbings of the object's surface.

10 Wuge Shouping, *Qing wen qi meng* [Qing language primer] (Beijing: Yinghua Tang, 1730).

11 See Chu-Tsing Li and James C. Y. Watt, *The Chinese Scholar's Studio* (New York: Thames & Hudson, 1987), p. 58, and Li-ling Hsiao, "Xue Tao Stationery: Delivering Love for a Thousand Years," *Southeast Review of Asian Studies* 33 (2011): 160–68.

12 Confirmed in discussion with Gao Jing at the Museum of Fine Arts, Boston.

13 Sun Mingqiu is in an early twentieth-century listing of artists by an unknown author, called *Tao yang zhai bi ji*, and subsequently in the *Zhongguo meishujia renming cidian* (which lists *Tao yang zhai bi ji* as the source for information on Sun). However, no copy of *Tao yang zhai bi ji* has been located in public collections. See Yu Jianhua, ed., *Zhongguo meishujia renming cidian* (Shanghai: Renmin Meishu Chubanshe, 1990). These reference books state that Sun's hometown was in Zhejiang Province, but that location is not probable. Sun often signs his paintings "South of Tianjin, [Jinnan] Sun Mingqiu," or "South of Tianjin, Old Gao City, Sun Mingqiu." A small city called Gaocheng is indeed located in Hebei Province, south of Tianjin. In numerous inscriptions on his paintings, Sun also refers to being in the north. He notes on the inscription of an 1892 painting, *Baisui tu*, that going to the Jiangnan region (which includes Zhejiang) opened his eyes. In an inscription on a fan painting within a larger composition (now in the collection of Wen-ti Tsen) he explains he has rendered a striking view he had seen almost forty years earlier, in 1853, when he would have been thirty years old, on his way home through Tongzhou—a town on the outskirts of Beijing.

14 Elderly painting dealers in Beijing's Liulichang, in conversation with the author in the 1980s and 1990s, repeatedly stated that Sun was the most important artist practicing bapo.

15 A round fan painting of a bird on a branch is evidence that Sun was also painting attractive and competent but routine decorative imagery in the late 1870s. The fan painting was sold at Poly International Auctions, Sale 32, October 31, 2015, lot 4098; http://polypm.com.cn.

16 This work is now in the hands of a private collector, Joseph Baruch Silver. In his inscription, Sun notes that the painting could be called "a picture of one hundred years (or fragments)" (*baisuitu*), "a picture of plentiful antiquities" (*bogutu*), or "encountering the void and immediately filling it" (*yuquejibu*). These multiple names suggest that bapo had not yet coalesced into a well-defined genre.

17 Several authors have identified the artist Yao Hua (1876–1930) as the first to make *yingta*. However, this and

other works by Sun Mingqiu demonstrate that the technique existed before Yao Hua was old enough to paint. See Zhou Xinfeng, "Yao Hua huihua yishu sixiang yanjiu" [Research on Yao Hua's Painting Art and Thought] (Master's thesis, Shandong Normal University, 2010).

18 In an inscription on one of his works Sun is explicit about his location in Beijing: "Written at Liulichang Song Zhu Zhai. Guangxu 19 [1893]." Song Zhu Zhai was a shop that for generations had specialized in fine painting and calligraphy paper and ink. In 1894, the owner faced financial troubles and closed his shop. Reopened under the name Rong Bao Zhai, the shop is the most respected purveyor of paper and ink on Liulichang today, as well as a publisher of fine artistic reproductions of Chinese paintings and stationery, and an art gallery selling contemporary and historic paintings. I am indebted to Mr. Sa Benjie, a master calligrapher, who worked as an authenticator at Rong Bao Zhai until his retirement, and whom I asked to help me read this inscription. He immediately recognized the name and significance of Song Zhu Zhai and suggested that Sun may have been, like Sa, an employee of the shop. This painting is now in the collection of Wen-ti Tsen and Alice Evans, acquired originally by his parents, the artist Fan Tchunpi and her husband, Tsen Tsen-ming.

19 Zhao Mengfu had come across a Song dynasty rubbing called the Dingwu Lanting. This rubbing had been made from a stone carved with the *Orchid Pavilion Preface* during the Tang dynasty. The stone had resurfaced during the Song and rubbings had been made of it. Subsequently the stone disappeared, but the rubbing remained and was considered an important treasure. In his colophon Zhao describes his profound thrill at seeing the famous rubbing.

20 See Shane McCausland, *Zhao Mengfu: Calligraphy and Painting for Khubiliai's China* (Hong Kong: Hong Kong University Press, 2011), p. 84. The work, *Thirteen Colophons to the Rubbing of "Preface of Lanting Gathering,"* is at the Tokyo National Museum; posted on www.tnm.jp, object number TB1351.

21 Including the Museum of Fine Arts, Boston; the British Museum, in London; and the Museum of Asian Art, in Berlin.

22 The reference reads, "Sun Yumei, Qing, *zi* Yuancun, Zhejiang person, son of Mingqiu. Also good at painting bapo jijin." As noted in Wu Xin'gu, *Lidai huashi huizhuan bubian* [Compendium of history of paintings, supplementary volume] (Beijing: Bao Wen Zhai, 1935). A work by him, painted before 1922, that appeared at auction in 2015 is evidence that he very much followed his father's later style of painting bapo works; Paragon International Auction, Hong Kong, November 28, 2015, http://auction.artron.net/paimai–art5079170192/.

23 The title of the fish painting is *Fish Leaping in the Deep Pool*, or *Yu yue yu yuan*. New Year's posters published by Yang Liu Qing in Tianjin displayed the same saying—an expression from the ancient *Book of Odes* that conveyed hopes for success.

24 See Yongming Zhou, *Historicizing Online Politics: Telegraphy, the Internet, and Political Participation in China* (Stanford: Stanford University Press, 2006), p. 43.

25 See *Yishu Baike* (Art Encyclopedia), https://baike.baidu.com.

26 Zhu's seals project the artist's sense of himself. His seals reveal either a man of great official ancestry or one trying to project that image. The seal "Descendant of the Twenty-Fifth Generation of Wengong" boasts of his very notable ancestor, the Song scholar Zhu Xi. After Zhu Xi's death, the emperor Ningzong gave him the posthumous name Zhu Wengong, "Venerable gentleman of culture." A second round seal with the two characters *zi yang* is also a reference to Zhu Xi, who in 1183 established the Ziyang Academy—and who was sometimes called Ziyang Xiansheng, or "Mr. Ziyang." Archaic dragon- and tigerlike creatures, symbols implying an imperial status, appear on either side of the two characters on this seal.

27 Zhu Wei's name did not appear in a review of the known documents listing successful examination candidates of the late Qing dynasty.

28 Zhu Hongshu and Zhu Yilou, eds., *Zhuxi Zhushi zupu* [Zhuxi Zhu family genealogy] (Zhejiang: Sicheng, 1877). Sichengtang woodblock edition.

29 http://blog.sina.com.cn/s/blog_722210b401013v4d.html.

30 On November 10, 2017, Poly Auction in Beijing sold a 1906 fan by Zhu Wei with a bapo painting on one side and landscape with monkeys on the other; https://www.epailive.com/goods/9338323.

31 See http://auction.artron.net/paimai-art5048670224/ and http://auction.artron.net/paimai-art67710044/.

32 Known as the Shi Ping Gong, this work is the most famous of all the calligraphies at Longmen, and the only one carved in relief.

33 The original calligraphy sold recently, so the entire work is visible online. The Zhu Xi text is known as the Zhu Hui'an Wei Nankang. Comparing Zhu's reproduction with the original, it is apparent that Zhu's replica of the replica is very close; http://auction.artron.net/paimai-art0035760812/.

34 Translation adapted from Yifeng Yao, *Nanjing: Historical Landscape and Its Planning from Geographical Perspective* (Singapore: Springer Media, 2016), p. 88.

35 The preface was written by another late Song poet, Lu You.

36 Lu Yi, "Shijue de youxi: Liuzhou Baisui tu shidu" [Visual puzzle: A case study on Liuzhou's *A Picture of One Hundred Years*], *Dongfang Bowu* 4 (2011): 6–16.

37 Zheng Qian was a Tang dynasty (eighth century) scholar, painter, and calligrapher, who due to poverty and lack

of paper wrote on persimmon leaves while living in a monastery.

38 Yuan was well known and respected enough that he is recorded in an article on Taizhou modern artists: Ye Dagen, ed., "Taizhou jin xian dai shuhua mingren zhi jian lu buyi huibian" [Compilation of records and addendums of Taizhou modern and contemporary famous painters and calligraphers], published in the magazine *Jiangsu wenshi yanjiu* and included in the Taizhou government's internet resources. The entry notes that Yuan was a native of Dafeng in Jiangsu Province, later moved to Xinghua, and then moved to Taizhou during the anti-Japanese movement.

39 A charming undated painting of a bird on a flowering branch by Yuan Runhe sold at Phoenix International Auction Company on December 21, 2014; http://auction.artron.net/paimai-art5065340592/. The second was sold at auction at Shapiro Auctioneers in Sydney, Australia, on May 9, 2012; http://www.askart.com/AskART/artists/search/Search_Repeat.aspx?searchtype=AUCTION_RECORDS&artist=11211464.

40 The exhaustive effort resulted in a 160-volume publication.

41 The slang for "handicapped" in Chinese is also pronounced *que zi*.

42 See "Who is Mr. Yusheng?" http://blog.sina.com.cn/s/blog_6a99eb1d0100mfi4.html.

43 I am grateful to Betty Tseng Yu-ho Ecke for this information.

44 Now in the collection of the Museum of Far East Antiquities (Östasiatiska museet) in Stockholm.

45 David R. Knechtges, "Wang Rong," in *Brill's Chinese Reference Shelf* (BrillOnline, 2018); http://chinesereferenceshelf.brillonline.com.

46 Information about Chen Bingchang is taken from writings about him by Li Guimei, "Wo jiao qingnian jiao zoufang xianxian Chen Bingchang Guju" [My school's young teachers travel to visit the home of the distinguished Chen Bingchang], published online on November 16, 2012 (http://www.jygkcz.cn/Item/571.aspx); and on a blog written by Wang Xinglai, "Jiangyan Guohua Huiwang" [Looking back at Chinese paintings from the Jiangyan region], chapter 6, "Chen Erzhi" (http://blog.sina.com.cn/s/blog_6028582b0100mxnj.html).

47 I am grateful to Beatrice Chan for having researched and deciphered the history of the Ju family surname, which made it possible to understand this seal.

48 Chen was not the only one to use this expression in a self-deprecating manner. In 1903, the writer, official, and amateur archaeologist Liu E (1857–1909) printed rubbings of the newly discovered oracle bone script under the name of the Studio of Baocan Shouque.

49 Two *yingta* (painted rubbings) by Chen Bingchang are in private collections; they appear in Wang Xinglai's blog, http://blog.sina.com.cn/s/blog_6028582b0100mxnj.html.

50 A bird-and-flower painting by Wu can be seen on the Bilian Blog, September 23, 2010, "Zhongshan Ji Shuhuajia Zuopin Xuan Si" [Zhongshan registry of artists and calligraphers], http://blog.sina.com.cn/s/blog_6abee55e0100lo4x.html. A figure and landscape work, dated 1911, that also reflects the Shanghai-style school's influence was sold at auction; see http://en.51bidlive.com/PreView/PreViewDetails/384253. It is signed with his literary name, Wu Ronggun, and contains the same seals found on his other paintings. For the Guangdong school, see http://www.zsnews.cn/EPaper/zssb/ShowIndex.asp?paperdate=20110306&part=5&article=3.

51 Translation from http://www.chinese-poems.com/y9.html.

52 Su Shi wrote the poem—about looking at the moon and thinking of others far away—while in exile. See a translation at http://www.chinahighlights.com/festivals/mid-autumn-festival-poems.htm.

53 Ma Shaoxuan's grandson has written his biography. Ma Zengshan, *Ma Shaoxuan* (Baltimore, MD: International Snuff Bottle Society, 1997).

54 In addition to the two bottles discussed here, they are (1) a bottle from the Marakovic Collection, http://www.eyaji.com/Marakovic_images/Mar_nar/8_later.asp; (2) a bottle from the Maxwell collection, http://www.snuffbottle.com/pdfs/The%20Maxwell%20Collection.pdf; (3) a bottle from 1901, sold at Bonhams on November 28, 2011, https://www.bonhams.com/auctions/19621/lot/40/; (4) a bottle sold at Wenboyuan Auction in Beijing on December 17, 2014, http://auction.artron.net/paimai-art0042185093/; (5) a bottle from 1910, sold at Sotheby's, Hong Kong, in November 2014, http://news.163ks.com/newsshow-2434.html; and (6) a bottle in a private Chinese collection, http://kph168899.blogspot.com/2013/02/blog-post_2832.html.

55 Zhang Yulin, "Han xian ji liu ti zhu taben ji qita xiangguan Beijing" [Cinnabar rubbing of the Meeting Immortal Friends inscription of the Han and other related background], *Shufa congkan* 5 (2005).

56 Zhang, "Cinnabar rubbing of the Meeting Immortal Friends inscription."

57 Seen by the author for sale at a Curio City antique shop in Beijing in July 2008, but sold soon thereafter.

58 Online at the Hunan Museum website, http://61.187.53.122/collection.aspx?id=1962&lang=zh-CN.

59 Other examples of bapo embroidery can be seen in the collections of the MFA and of the Peabody Essex Museum in Salem, Massachusetts.

60 My gratitude to William Sargent, Curator Emeritus at the Peabody Essex Museum, and Karina Corrigan, H. A. Crosby

Forbes Curator of Asian Export Art, for their insights on this work.

61 He is one of only two bapo artists to be included in the *Dictionary of Chinese Artists' Names*.

62 *Shen Bao*, no. 22841, December 1, 1936, p. 16. Yu Youren (1879–1964) was a well-known calligraphy scholar and politician; Wang Zhengting (1882–1961) was a diplomat and official in the Republic of China government. For price comparison, according to *All About Shanghai*, a guidebook dated 1934–35, "If one wishes to engage a rickshaw by the day make arrangements through your hotel. The charge will be about $1.50, or $1 for half a day." The same book notes that a double room at the Astor House Hotel—among the finest establishments in the city—was $20 in 1934. Also in 1934, renting a private boat with a motor cost $9 a day, according to E. S. Wilkinson's *Shanghai Country Walks*.

63 *Shen Bao*, no. 22845, December 5, 1936, p. 17.

64 Charlotte Cowden, "Wedding Culture in 1930s Shanghai: Consumerism, Ritual and the Municipality," *Frontiers of History in China* 7, no. 1 (2012): 61–89.

65 Ellen Johnston Laing, *Selling Happiness* (Honolulu: University of Hawai'i Press, 2004), p. 155.

66 *Shen Bao*, no. 22909, February 16, 1937, p. 16. "The famous artist Yang Weiquan, who dominates the *jinhuidui* painting technique, because he has been esteemed in the world for a long time and is especially appreciated by the head of the academy Yu Youren, who recently gave him more than twenty famous and valuable rubbings, supplying them to help him make *jinhuidui*, clearly a noble deed, and with his famous and valuable painting technique these make them even more desirable to see."

67 *Libai liu* 647, July 4, 1936. This photograph was first mentioned in an article by Tsurutu Takeyoshi, who mistakenly called the publication *Li Bai* instead of *Libai Liu*; "Yang Weiquan no papie kore sakuhin" [Papier collé works by Yang Weiquan], *Bijutsu Kenkyu* 359 (March 1994): 28–29.

68 James Cahill discusses the use of *fenben* in *The Painter's Practice: How Artists Lived and Worked in Traditional China* (New York: Columbia University Press, 1995), p. 90.

69 See Nancy Berliner, "Questions of Authorship in Bapo," *Apollo* 167, no. 433 (March 1998): 17–22.

70 The only other Yang Weiquan work to include a photograph is in the Mei Lanfang Memorial Hall in Beijing. Unpublished—and as yet unseen by this author—its date is uncertain. The painting is discussed in Tsurutu Takeyoshi, "Papier Collé Works by Yang Weiquan."

71 See Hong Junjie, ed., *Zhenhai Xianzhi* [Zhenhai County gazetteer] (Beijing: China Encyclopedia Publishing Company, 1994). The text in the gazetteer seems to have been derived from the Zheng Yimei article. Zheng is also mentioned in his hometown's gazetteer, the *Zhenhai Xianzhi*.

72 Yu Jianhua, ed., *Zhongguo meishujia renming cidian* (Shanghai: Renmin Meishu Chubanshe, 1990), p. 1192.

73 According to Michael Sullivan, the Zhongguo Huahui was "the most important association of traditional painters. Founded in Shanghai in 1931 by Zheng Wuchang, Xie Gongchan and Sun Xueni." Michael Sullivan, *Chinese Art in the Twentieth Century* (Berkeley: University of California Press, 1959), p. 85. *Zhongguo huahui huiyuan lu* (A record of members of the Zhongguo Huahui), a document published in 1937 and now at the Shanghai Library, notes that at the time Yang was fifty-two, from Fujian, Minhou County, and that his address was Chengnei (within the city) Hua Jin ["Painted Brocade"] Pailou, number 142.

74 In November 1991, the author saw a second painting signed by Zheng Zuochen in the mounter's studio at the Shanghai Museum. The painting was one page of an album that was otherwise only filled with rubbings. The work depicted a painting of Laozi with a giant peach, a rubbing of seal-character calligraphy, a rubbing of a tile end, a rubbing of a bronze vessel, a title slip of a book called *ren* ("man") *shou* ("longevity") *jin* ("gold"), a rubbing of a portrait of Confucius with characters, a red rubbing of plum blossoms, a title slip for a book on tiger skin paper, and a printed book page with red punctuation. The inscription on the painting noted that the artist was from the village of Long Shan, in Zhejiang. Without having yet read about Zheng Zuochen, the author recorded that "the style is similar to works by Yang Weiquan."

75 Not everyone agrees with this conclusion. A Master Ma at the Shanghai Cultural Relics shop, who was in his eighties in the 1980s, and had been a dealer in Chinese paintings in Shanghai before the liberation, told the author that he believed that Yang Weiquan had painted all of the works himself. Luo Qing, the Taiwan poet, calligrapher, and collector of Yang Weiquan paintings, asserts in an article on Yang that Yang painted all the works but his style changed over the years. Luo Qing, "Luanshi mocai hua wange: yong huabi pintie da shidai de Yang Weiquan" [An elegy on ink and color paintings during a time of turmoil: Brushwork collages of Yang Weiquan], pt. 1, *Wenwu tiandi* 9 (2017): 103–7, and pt. 2, *Wenwu tiandi* 10 (2017): 86–94.

76 With appreciation to Geremie Barme for the translations of Li Chengren's inscriptions.

77 Translation from Richard E. Strassberg, *Inscribed Landscapes: Travel Writing from Imperial China* (Berkeley: University of California Press, 1994), p. 157.

78 Shibue Chūsai and Mori Tatsuyuki, *Keiseki hōkoshi* [Bibliography of rare Chinese classics in Japan] (n.p., 1885).

79 Divided into twelve parts, including sections on officials, Daoists, and Buddhist monks, the complete text can be found online at http://www.chineselovestory.com/xlgz/. Analysis of the book can be found in Huang Kewu and Li Xinyi,

"Mingqing xiaohuazhong de shenti yu qingyu" [Joking about sex and the body in late imperial China: An analysis based on the jest book *Xiaolin Guangji*], *Hanxue Yanjiu* 19, no. 2 (2001): 343–74. Available at http://ccs.ncl.edu.tw/Chinese_studies_19_2/343_374.pdf.

80 Zhu Jiajin identified these as a Peony brand matchbox and a card from Great Wall Cigarettes.

81 Tao Zongyi (about 1329–1410) records in *Chuo Geng Lu* that court women used pinewood sticks soaked in sulfur to light lamps during the northern Qi dynasty (550–77).

82 The author and journalist Zheng Yimei describes his own collection of matchbox labels in an essay, "Huochaihe zhi jicang" [Collecting matchboxes], in *Zheng Yimei Xuanji* (Harbin: Heilongjiang Renmin Chubanshe, 1991), vol. 3, p. 657.

83 This information is based on the author's conversation with Geng Yuzhou and Geng Xuezhi at the Peninsula Hotel, Beijing, October 23, 2014. The Geng father and son often outline their artistic "lineage." Song Yiqing was from a small town in Hebei Province where he had studied literature, calligraphy, painting, and seal carving. He learned bapo painting from Liu Baoyun (1901–1951), who had coincidentally been a neighbor of Qi Baishi. Liu Baoyun had learned the art of *yingta*, paintings that imitated rubbings of ancient objects, from the artist Yao Hua (1876–1930). Thus the Geng father and son see themselves as the third and fourth generations in a line of bapo painters, the art having descended in the line from Liu Baoyun to Song Yiqing to Geng Yuzhou.

List of Artist Names

Chen Bingchang (1896–1971) 陳炳昌

Chen Zhenyuan (dates unknown, active 1930s) 陳振遠

Geng Xuezhi (born in 1973) 耿學知

Hua Jifu (dates unknown) 華吉甫

Li Chengren (dates unknown, active 1930s) 李成忞

Liu Lingheng (1870–1949) 劉淩衡

Ma Shaoxuan (1867–1939) 馬少宣

Niu Chuanli (1921–2005) 鈕傳禮

Sun Mingqiu (1823–after 1903) 孫鳴球

Tan Qinghuan (dates unknown, active 1930s) 譚慶煥

Wang Chao (born in 1974) 王超

Wang Xueyan (dates unknown, active 1890s) 王學彥

Wang Zhexiang (dates unknown, active 1920s) 王者香

Wu Chunkui (dates unknown) 吳春魁

Wu Zhuohua (1873–1941) 吳灼華

Xi Rui (dates unknown, active 1890s) 錫瑞

Yang Weiquan (1885–after 1942) 楊渭泉

Yuan Runhe (1870–1954) 袁潤和

Zhang Fa (dates unknown) 張法

Zhang Xuecong (dates unknown, active 1980s) 張學聰

Zheng Zuochen (1891–1956) 鄭佐宸

Zhu Wei (1836–after 1908) 朱緯

Timeline

Shang Dynasty	about 1600–1046 BCE
Western Zhou Dynasty	1046–771 BCE
Spring and Autumn Period	770–476 BCE
Warring States Period	475–221 BCE
Qin Dynasty	221–206 BCE
Western Han Dynasty	206 BCE–9 CE
Eastern Han Dynasty	25–220 CE
Six Dynasties	220–589 CE
Sui Dynasty	581–618 CE
Tang Dynasty	618–907 CE
Five Dynasties and Ten Kingdoms	906–60 CE
Liao Dynasty	916–1125
Northern Song Dynasty	960–1127
Southern Song Dynasty	1127–1279
Jin Dynasty	1115–1234
Yuan Dynasty	1271–1368
Ming Dynasty	1368–1644
Qing Dynasty	1644–1911
Shunzhi Emperor	(1644–61)
Kangxi Emperor	(1661–1722)
Yongzheng Emperor	(1723–35)
Qianlong Emperor	(1736–96)
Jiaqing Emperor	(1796–1820)
Daoguang Emperor	(1821–50)
Xianfeng Emperor	(1851–61)
Tongzhi Emperor	(1862–74)
Guangxu Emperor	(1875–1908)
Xuantong Emperor (Puyi)	(1908–12)
Republican Period	1912–49
People's Republic of China	1949–present

Note on Pronunciation

The text in this book uses the *pinyin* system of transliterating Chinese characters into Roman letters. *Pinyin* (literally "spelling sounds") was officially accepted as the Romanization system by the People's Republic of China government in 1958, and by the Republic of China government in January 2009. Many of the consonants and vowels in *pinyin* are pronounced like their English equivalents; however, there are some exceptions, noted here.

X sounds like the "sh" in *she*

Q sounds like the "ch" in *cheer*

C sounds like the "ts" in *beets*

Zh sounds like the "dg" in *fudge*

Ai sounds like "ie" in *pie*

Ang sounds like "ong" in *ping pong*

Ao sounds like "ow" in *how*

Ei sounds like the "ay" in *say*

Ia sounds like *ya*

Iu sounds like *yo*

Ou sounds like *oh*

Ua sounds like *wa*

Ue sounds like *weh*

Ui sounds like *way*

Figure Illustrations

1

Liuzhou (1791–1858)
Picture of One Hundred Years, 1831
Rubbings of metal objects, ink on paper,
136 x 61.6 cm (53½ x 24⅓ in.)
Zhejiang Provincial Museum, Hangzhou

2

Lin Fuchang (died after 1877)
**Rubbings from bronzes with painted flowers,
about 1860**
Ink and color on paper, 119 x 45.6 cm (46⅞ x 18 in.)
Museum of Fine Arts, Boston
Gift of the Wan-go Weng Collection, 2016.534.3

3

Wang Fu (1079–1126), *Zhida Chongxiu Xuanhe
Bogu Tulu* **(Illustrated Catalogue of Plentiful
Antiquities of the Xuanhe Period, Revised in
the Zhida Period [1308–1311]), Jiajing 7 (1528)
edition, volume 1, page 22**
Museum of Fine Arts, Boston, 2018.112; source unidentified

4

Unidentified artist
Bogu **bookshelf painting, before 1778**
Ink and color on paper, 58 x 104 cm (22⅞ x 41 in.)
Gustavianum, Uppsala University Art Collections
Photograph: Tommy Westberg

5

Unidentified artist
**"Jingji, Ximen's Son-in-Law, Flirts with Gold Lotus
at the Time of the Lantern Festival"**
From an album of illustrations to *The Plum in the Golden
Vase* (*Jin ping mei*), 18th century
Album painting, ink and color on silk, 38.7 x 31.3 cm
(15¼ x 12¼ in.)
The Nelson-Atkins Museum of Art, Kansas City, Missouri
Purchase: the Uhlmann Family Fund, F83-4/2
Photograph: Tiffany Matson

6

Sin Heon (Korean, 1810–1884)
**Ten-panel baeknapdo byungpung folding screen,
about 1880–83**
Ink and color on silk, 188 x 450 cm (74 x 177 in.)
Museum of Fine Arts, Boston
Charles Bain Hoyt Fund, 1994.881

7

**Ten-panel folding screen, Kangxi period
(1662–1722)**
Kuancai carved lacquer, 200 x 600 cm (about 79 x 236 in.)
Private collection
Photograph: Art Asiatique HK Ltd.

8

**Beaker vase with decoration depicting paintings,
mid-18th century**
Porcelain with overglaze famille rose enamels,
36.5 x 18.4 cm (14 x 7¼ in.)
Widener Collection
National Gallery of Art, Washington, 1942.639

9

Unidentified artist
From *Twelve Beauties*, Qing dynasty, Yongzheng period (1723–35)
Ink and color on silk, 184 x 98 cm (72½ x 38⅝ in.)
Palace Museum, Beijing
Image provided by the Palace Museum, Beijing

10

Nian Xiyao (died in 1739), illustration from *Shixue jingyun* (Beijing, 1735; translation, by Nian Xiyao and Giuseppe Castiglione, of Andrea Pozzo, *Perspectiva pictorum et architectorum*, 1693–98)
University of Glasgow Library, Special Collections, Sp Coll Hunterian Chinese 45
Reproduced by permission

11

Garniture set of two vases and a censer, imitating cloisonné
Qing dynasty, Qianlong mark and period, 18th century
Porcelain with overglaze enamel, vases: each, h. 14 cm (5½ in.)
Museum of Fine Arts, Boston
Gift of Paul and Helen Bernat, 1973.514

12

Yao Wenhan and others
Interior scene, about 1776
Ink and color on paper, 317 x 366.5 cm (124¾ x 144⅜ in.)
Palace Museum, Beijing
Image provided by the Palace Museum, Beijing

13

Unidentified artist
New Year's print, 1744
Hanging scroll, woodblock print, ink on paper,
92.5 x 55.5 cm (36⅜ x 21⅞ in.)
Umi Mori Museum, Hiroshima
Okada Collection, 2000-014-014

14

Unidentified photographer
Daoist monk, northern China, about 1930
Image: Thomas H. Hahn docu-images, Berkeley, California

15

Niu Chuanli (1921–2005)
***Picking Up and Gathering Damaged Treasures (Jianqu Canzhen)*, 1988**
Ink and color on paper, 101 x 34 cm (39¾ x 13⅜ in.)
Museum of Fine Arts, Boston
Anonymous gift in honor of William W. Mellins, 2017.33

16

Zhang Xuecong
Pair of New Year's posters, 1983
Photomechanical color lithographic print on coated paper,
33.4 x 100.2 cm (13⅛ x 39½ in.)
Museum of Fine Arts, Boston
Anonymous gift in memory of William W. Mellins,
2017.23.1-2

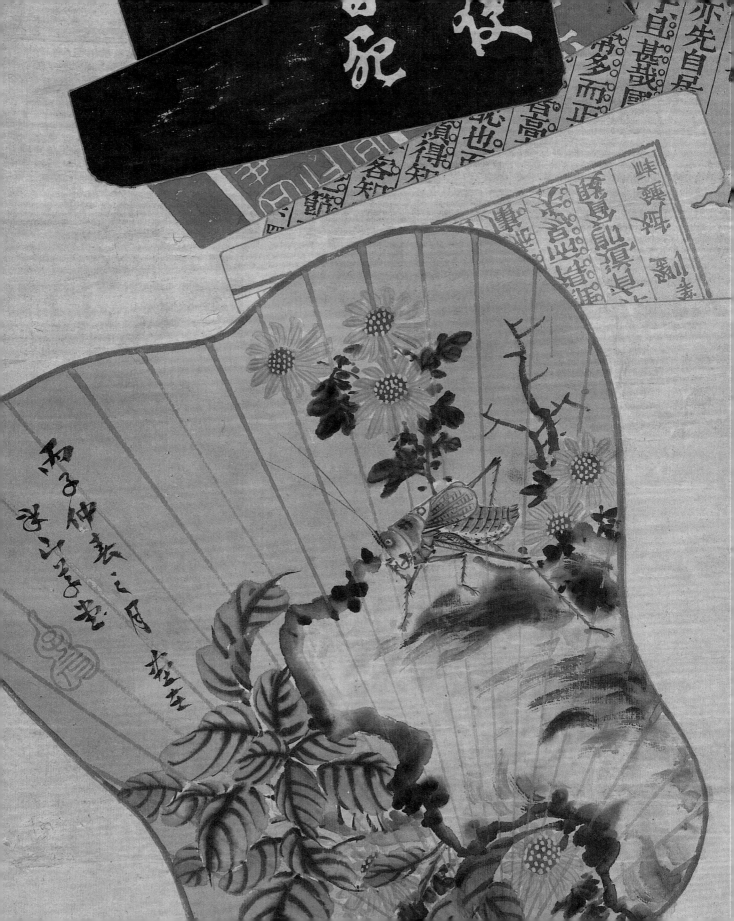

Acknowledgments

My *bapo* journey—with all of its bumps and nicks—began on a sticky summer day in Taiwan, as I was strolling through a ramshackle hive of fruit sellers and junk stalls with a new friend, Lawrence MacDonald. A darkened, creased Chinese painting—looking like a Braque collage, but clearly a Chinese scroll—caught my eye. Our shared moment of exhilaration over something so striking and yet so mysterious set me on a path of exploration that has led many years later to this book and to the exhibition it accompanies. I have always been grateful to Lawrence for his enthusiasm at that moment, and for his continued cheer and interest through all these years.

On my return to Boston, I sought out museum curators and historians of Chinese art, none of whom could tell me about the painting. Back in China a few years after the fateful Taiwan encounter, scholars and curators also shook their heads. Eventually, one candid elderly scholar told me that art historians—including herself—looked down on such art. Still, I wanted to know more. I would visit state-owned antique stores, where I would shuffle through stacks of paintings and try to describe to bewildered clerks behind the counters, in my stilted Chinese, the collage-like imagery. Most looked at me quizzically. But occasionally a flicker of recognition would pass across the face of an elderly clerk who remembered such works.

I wish I could thank one particular man today—the first to tell me that these paintings had a name: *bapo*, "eight brokens." From there I went forth. Usually, at the mention of bapo, shop clerks at the antique stores would utter the oft-heard word "meiyou"—no, they did not have any such works. I would comb through their entire inventories and once in a great while, I would discover one at the bottom of the pile. As the economic reforms changed society, flea markets and private enterprises popped up, providing other finds. An ever-resourceful Beijing scroll mounter, Zhu Chengxiang, to whom I am so indebted, joined me in the hunt, sending out the word to all his contacts. Zhu brought me paintings—often in tattered condition, which he then carefully mended and remounted—and sent me to pay calls on older mounters who might have clues to bapo's lost history. These generous informants and their memories were critical in my quest to piecing together bapo's development.

While few scholars in the United States or China had seen or heard of bapo paintings when I first began asking questions, some of the great thinkers in our field encouraged my quest, offering their thoughts, theories, and memories of the early twentieth century. Among them were James Cahill, Tseng Yu-ho (Betty Ecke), Wang Shixiang, and Zhu Jiajin, none of whom, sadly, lived to see this publication or the exhibition. I am deeply grateful to them for indulging a curious young woman who was insistent on going beyond the classics. Other scholars—Lothar Ledderose, Rudolf Wagner, Wu Hung, Eugene Wang, and Geremie

Barme—were also critical in cheering me along on this ever-twisting path of discovery. Wang Yifen, who first translated my first article on bapo into Chinese, became an enthusiast of the subject and went on to uncover the bapo precedents created by the monk artist Liuzhou.

Interns, volunteers, and research assistants over the years have contributed enormously to making sense of the bapo paintings: Beatrice Chan, Chen Xiao, Liu Ziliang, Ling Tang, Lu Hui-wen, Yu Leqi, and Bruce MacLaren. The devoted and thorough Ying Fei'er has been indispensable in the research, organization, and promotion of both the exhibition and this book.

Since my incessant pursuit to unravel the mysteries of bapo began, dear friends—Andre Kneib, Ross Miller, Zeng Xiaojun, Zhu Chuanrong, David Chien—sympathetic to my attraction to "the beauty of the broken" and to the spirit of innovation sprinkled with heterodoxy, have unyieldingly urged me along. *Bapo xiaojie*, Miss Bapo, they called me. Their generosity went beyond mere words: over the years David and Xiaojun have passed along any bapo works they came across, in flea markets or elsewhere.

Here at the MFA, Jane Portal, the former Matsutaro Shoriki Chair, Art of Asia, Oceania, and Africa, and Malcolm Rogers, Ann and Graham Gund Director Emeritus, first supported the exhibit; and Matthew Teitelbaum, the current Ann and Graham Gund Director, readily embraced the project. I am also grateful to Chris Newth and Adam Tessier for being unwavering and always optimistic partners, to Chelsea Gaurunay for her bold and elegant exhibition design, and to my fellow Art of Asia department-mates, daily sources of intellectual stimulation and warmth. The MFA Publications team of Emiko Usui, Anna Barnet, Jennifer Snodgrass, Terry McAweeney, Anne Levine, and Hope Stockton, along with editor Ed Walters and designer Anjali Pala, have carefully tended to shaping the manuscript and its images into a book we can all hold in our hands and share with others.

The exhibition would not have been possible without the generosity of lenders including William and Prudence Crozier, Alfreda Murck, The Herbert F. Johnson Museum of Art at Cornell University, The Crane Collection, Peabody Essex Museum, and the Asian Civilizations Museum in Singapore.

Anne and Edward Studzinski have been patient, stalwart, and ever-encouraging friends and supporters of this project for many years. I am humbly obliged and deeply grateful to them for their sponsorship of the publication.

My late husband, Bill—who supported me in any and every endeavor I desired to undertake, and who gave me the courage to march on without him—was a constant cheerleader on the bapo mission. His face would have lit up to see the fruits of his loving support.

In more recent times, Jamil Simon has indulged me with patience, glowing support, and guidance. His presence has been refreshing, invigorating, and invaluable to the completion of this book as well as to my daily life.

In the beginning, my parents taught me about art, abstraction, and collage, about creativity, and about looking, exploring, and venturing outside the box. To them I am entirely indebted, and hopeful that their exhortation to creativity will continue to echo for generations.

Last, I am grateful to the many bapo artists, named and unnamed, who delighted in the depths of ancient Chinese culture and dared to explore the possibilities of a new aesthetic. To them I indebted for this edifying journey into the beauty of the less-than-perfect.

Despite all the support, wise advice, and good guidance of the inspiring people named here—and many more—I take entire responsibility for any mistakes, lacunae, or misrepresentations in this text. This volume is only an initial presentation on the subject of bapo, and there are still myriad questions about this art form's emergence and development: What is the relationship to Japanese art? Did someone in China see an early eighteenth-century British medley print? How many of these artists knew each other and influenced one another? Like bapo paintings themselves, I hope these puzzles will continue to attract, endure, and enrich those who contemplate them.

Nancy Berliner
Wu Tung Senior Curator of Chinese Art
Museum of Fine Arts, Boston

Index

MFA Publications
Museum of Fine Arts, Boston
465 Huntington Avenue
Boston, Massachusetts 02115
www.mfa.org/publications

Published in conjunction with the exhibition *China's 8 Brokens: Puzzles of the Treasured Past*, organized by the Museum of Fine Arts, Boston, from June 17 to October 29, 2017

Exhibition presented with generous support from the Tan Family Education Foundation, with additional support from the Dr. Lawrence H. and Roberta Cohn Exhibition Fund, the Joel Alvord and Lisa Schmid Alvord Fund, the Rodger and Dawn Nordblom Fund for Chinese Paintings in Honor of Marjorie C. Nordblom, and The June N. and John C. Robinson Fund for Chinese Paintings in Honor of Marjorie C. Nordblom

Generous support for this publication was provided by Edward A. Studzinski and Anne G. Studzinski

For a complete listing of MFA publications, please contact the publisher at the above address, or call 617 369 3438. Illustrations in this book were photographed by the Imaging Studios, Museum of Fine Arts, Boston, except where otherwise noted.

Edited by Edward Walters and Jennifer Snodgrass
Copyedited by Dalia Geffen
Proofread by Nancy Sullivan
Designed by Anjali Pala, Miko McGinty Inc.
Typeset in Mallory by Tina Henderson
Production by Terry McAweeney
Photography research and permissions by Anne Levine
Printed on 135 gsm GardaMatt Kiara
Printed and bound at Graphicom, Verona, Italy

Details: p. 2, cat. 10; pp. 4–5, cat. 9; p. 6, cat. 26; p. 8, cat. 12; p. 136, cat. 22; p. 150, cat. 29

Distributed in the United States of America and Canada by
ARTBOOK | D.A.P.
75 Broad Street, Suite 630
New York, New York 10004
www.artbook.com

Distributed outside the United States of America and Canada by
Thames & Hudson, Ltd.
181A High Holborn
London WC1V 7QX
www.thamesandhudson.com

FIRST EDITION
Printed and bound in Italy
This book was printed on acid-free paper.